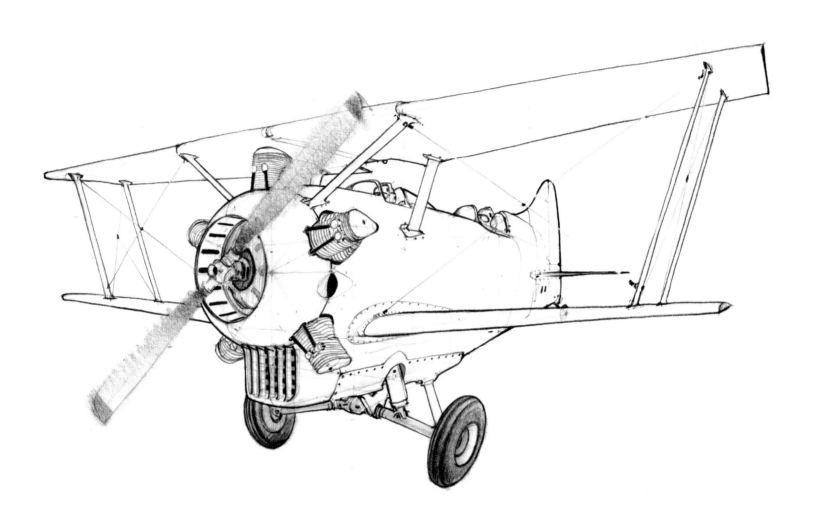

LIFT OFF »

air vehicle sketches & renderings from the drawthrough collection

designstudio|PRESS

dedication

This book is for everyone who likes vehicles.

contact info

Scott Robertson can be reached by email at: **scott@drawthrough.com**.

To see more of Scott's work visit: **www.drawthrough.com**

Art Direction: Scott Robertson
Graphic Design: Fancygraphics
Web site: www.fancygraphics.net
Layout Production: Marsha Stevenson
Text Editor: Kevin Brown

Published by Design Studio Press
8577 Higuera Street
Culver City, CA 90232
Web site: www.designstudiopress.com
E-mail: info@designstudiopress.com

10 9 8 7 6 5 4 3 2

Printed in China
First edition, September 2006

Hardcover ISBN 10: 1-9334-9216-3
Hardcover ISBN 13: 978-1-933492-16-2

Paperback ISBN 10: 1-9334-9215-5
Paperback ISBN 13: 978-1-933492-15-5

Library of Congress Control Number: 2006922889

FSC
Mixed Sources
Product group from well-managed forests and other controlled sources
Cert no. SGS-COC-003563
www.fsc.org
© 1996 Forest Stewardship Council

CONTENTS »

Scott Robertson was born in Oregon and grew up in the country. When he was a child, his artist father, Richard, taught him how to draw and design the toys in his imagination. Fascinated by speed, he and his father designed and built soapbox derby cars. At the age of 14, Scott finished sixth in the world at the annual All-American Soap Box Derby race in Akron, Ohio. In 1984 he attended Oregon State University, where he studied a variety of subjects and rowed on the crew team in the bow position.

After two and a half years at Oregon State, Scott transferred to Art Center College of Design in Pasadena, California where his father had attended as an illustration student. After many all-nighters and skin-thickening critiques, he graduated in 1990 with honors and a B.S. degree in Transportation Design. He immediately opened a consulting firm in San Francisco, where he designed a variety of consumer products, the majority being durable medical goods and sporting goods. In 1995, he began teaching at Art Center College of Design, first with a year-and-a-half stint at Art Center Europe in Vevey, Switzerland (now closed), and then in Pasadena, California.

In the years since returning from Europe, Scott's clients have included the BMW subsidiary Designworks/USA, Bell Sports, Raleigh Bicycles, Mattel Toys, Patagonia, Scifi Lab, 3DO, *Minority Report* feature film, Nike, Rock Shox, Universal Studios, OVO, Black Diamond,

Angel Studios, Rockstar Games, Sony Online Entertainment, Buena Vista Games and Fiat to name a few.

Dedicated to art and design education, he founded the publishing company Design Studio Press in 2002. The company's first book, *Concept Design 1*, released in 2003 and now out of print, is a collection of original artwork by seven of the top concept artists working in Hollywood. *Concept Design 2* will be released in mid-2006. Other books published by Design Studio Press are listed on the last page of this book.

In addition to working as a design consultant for the entertainment, sporting goods, and transportation industries, Scott continues to teach at Art Center College of Design. In 2004 he art-directed 240 illustrations for Mattel's Hot Wheels AcceleRacers collectible card game. He also authored *How to Draw Cars the Hot Wheels Way*. Furthering design, drawing and rendering education, Design Studio Press has teamed with The Gnomon Workshop to create a library of "how to" DVDs. Scott himself has instructed on nine DVDs, focusing on drawing and rendering techniques for industrial and entertainment designers. He has co-produced an additional 41 DVDs with various top artists, designers, and instructors, including Syd Mead. To view all the titles currently available, visit www.thegnomonworkshop.com.

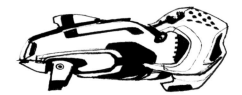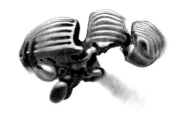

drawthrough:
The practice of drawing through an object as if the entire surface of the object were transparent, allowing you to see through to the other side.

It is with a great sigh of relief, after launching a publishing company several years ago, that I am finally offering to you my first two books, *Start Your Engines* and *Lift Off*. I plan to follow these books with the step-by-step instructional books: *How to Draw Vehicles* and How to Render Vehicles.

This book represents a selection of sketches and renderings of surface vehicles that I have done over the last ten years. The work is collected from three distinct art and design disciplines: personal work, professional work, and educational examples. In organizing the personal and educational work, I have grouped the artwork into chapters based on the types of vehicles depicted. In the case of the professional work, you will find several different vehicle types within the same chapter.

I have purposely done my best to show a full range of artwork: from the loosest small thumbnail to the tightest photo-real rendering. With the anticipation that this book will be used primarily by other designers and artists as a reference book, I think it is important to see another designer's "working sketches" even more than the finished pieces; sketches which are really taken to higher and higher levels of finish, not so much as a function of skill, but as a function of the increased amount of time spent at the board or computer picking away at the rendering for hours on end.

I consider myself first a concept designer, then a teacher and third an artist. Most of the work presented here is heavily influenced by my education at Art Center College of Design as an industrial designer. The drawings I have chosen to include are more about the design and building of the objects themselves, versus the illustrative quality of the drawings and renderings. This is because in the world of industrial design, the sketches and renderings are done as the fastest way to see the final product before committing the resources needed to realize that object three-dimensionally, which is the ultimate goal of most design projects.

By presenting this two-book set of vehicle sketches and renderings, I hope to inspire the next generation of concept designers to imagine and draw their objects of interest for the future. With pride, optimism for tomorrow, and sore wrists and elbows, I hope you enjoy the work!

Scott Robertson

Scott Robertson
Los Angeles, Spring 2006

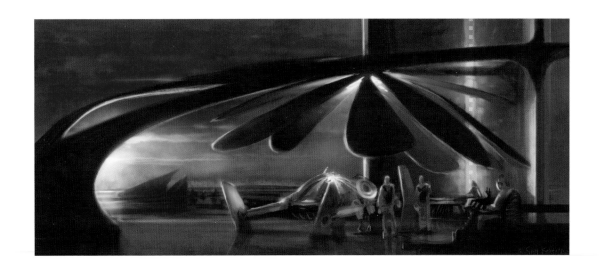

CHAPTER »01

spaceships

Exploring the great void—the final frontier. What concept designer doesn't have hour after hour of fun dreaming up new and interesting spaceships to sketch and render? Unlike the car sketches and renderings found in *Start Your Engines*, where the proportions of the car are so very sensitive and the entire world knows what a cool car looks like, spaceships offer greatly increased design flexibility. Consider that if the spaceship never has to fly into a planetary atmosphere and is always in outer space, then it needs no aerodynamic control surfaces or landing gear and the basic shape of the craft can be quite different from that of modern-day space shuttles. Of course it is even more fun to dream about spaceships designed and built by other life forms. This topic lets the imagination run wild, sketching and rendering whatever can be imagined. In this chapter I have drawn a large variety of spaceship designs using a wide range of media. From a chisel-point, felt-tip calligraphy pen, to graphite pencil, to finishing using the computer, I hope you enjoy the scope of spaceship designs gathered here.

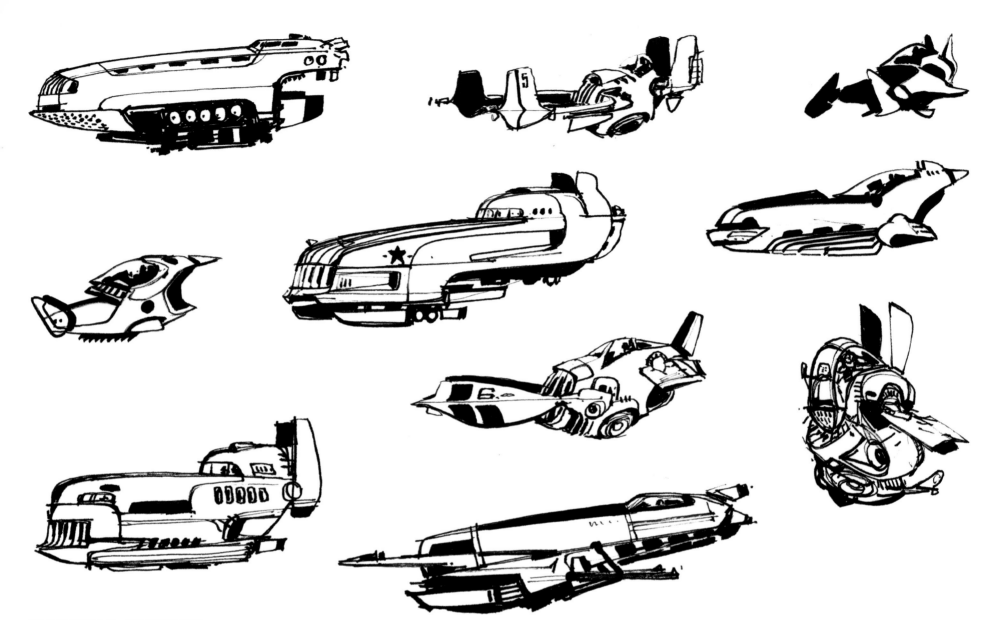

THUMBNAIL SKETCHES »

On this page and the following five pages you will find a collection of random spaceships I had originally drawn for *Concept Design 2*. The goal of this exercise was to try to design as many ship styles as I could. There are some themes running through the sketches, which I allowed myself to explore fully before trying to find more variations. Each design-sketch usually takes about five to ten minutes. I drew with a chisel-point, felt-tip calligraphy pen.

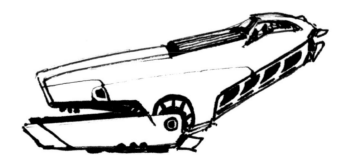

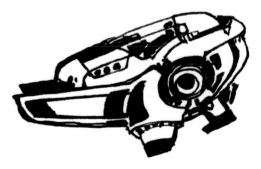

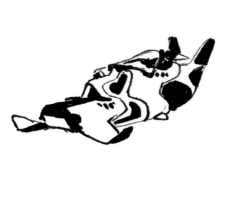

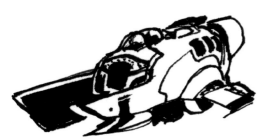
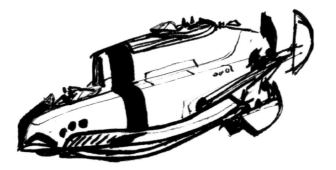
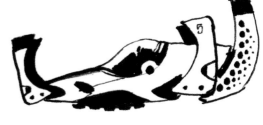

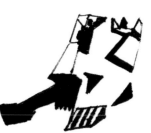
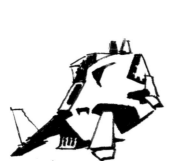
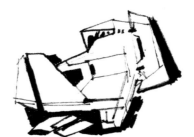
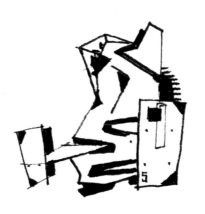
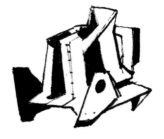

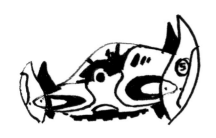
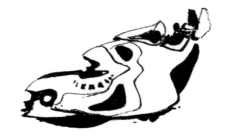
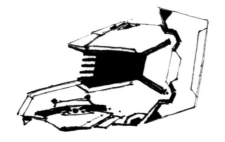
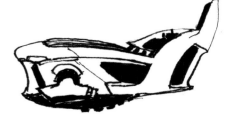

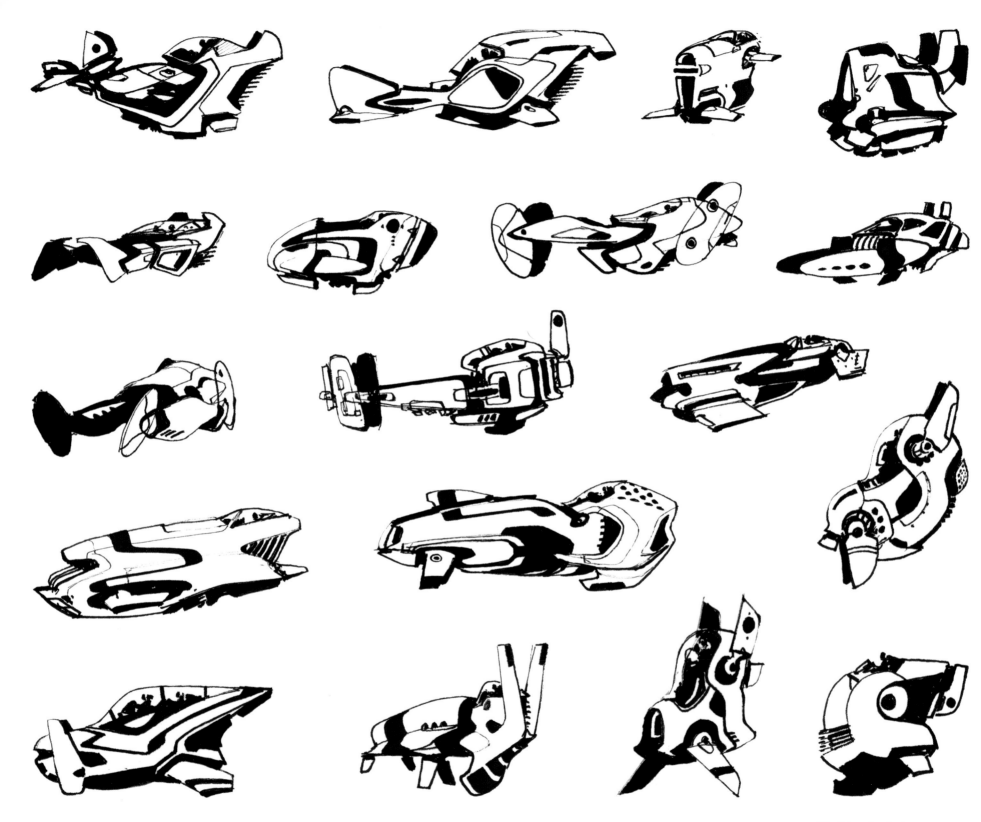

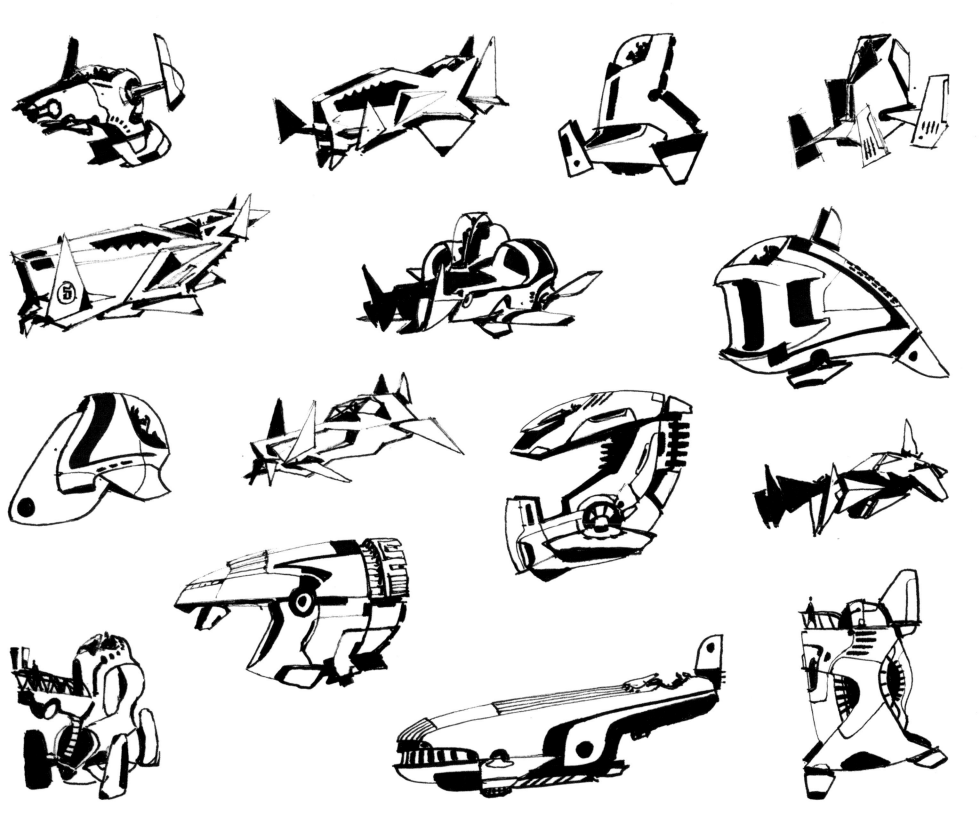

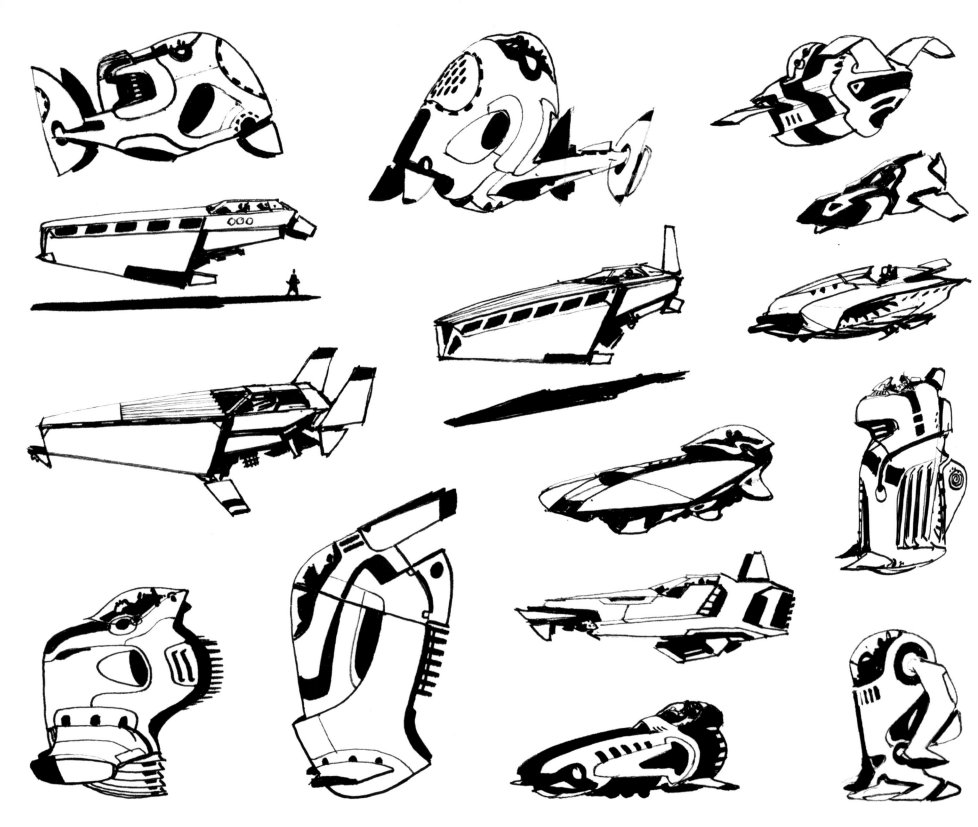

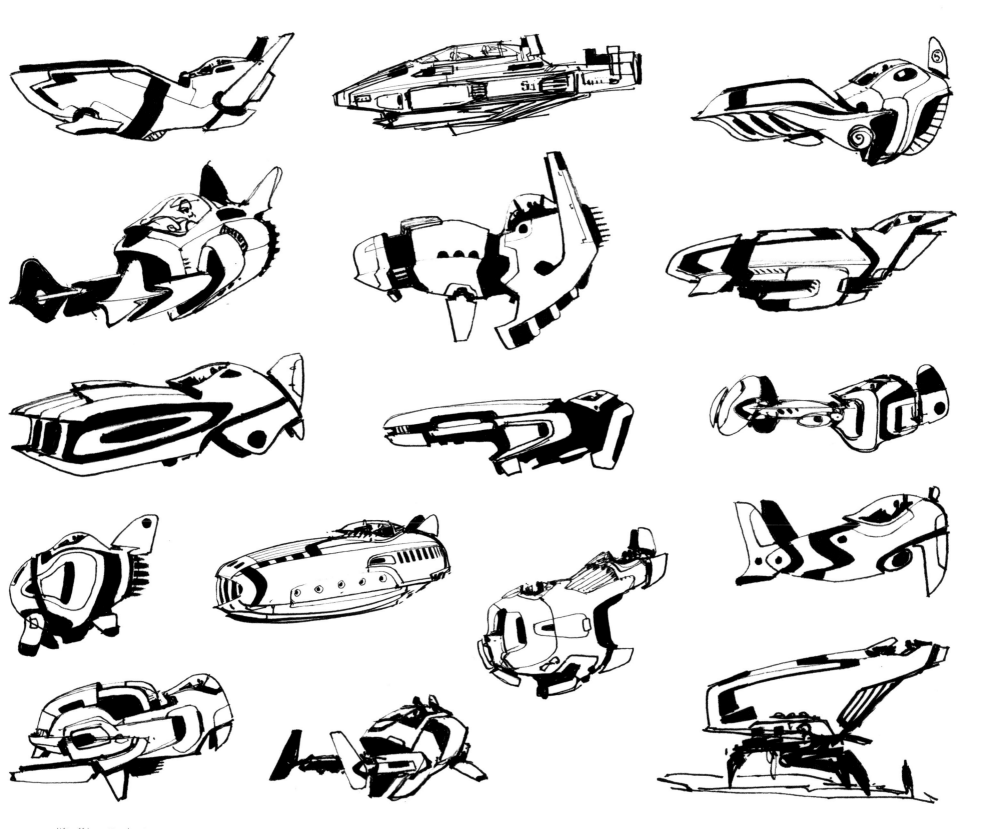

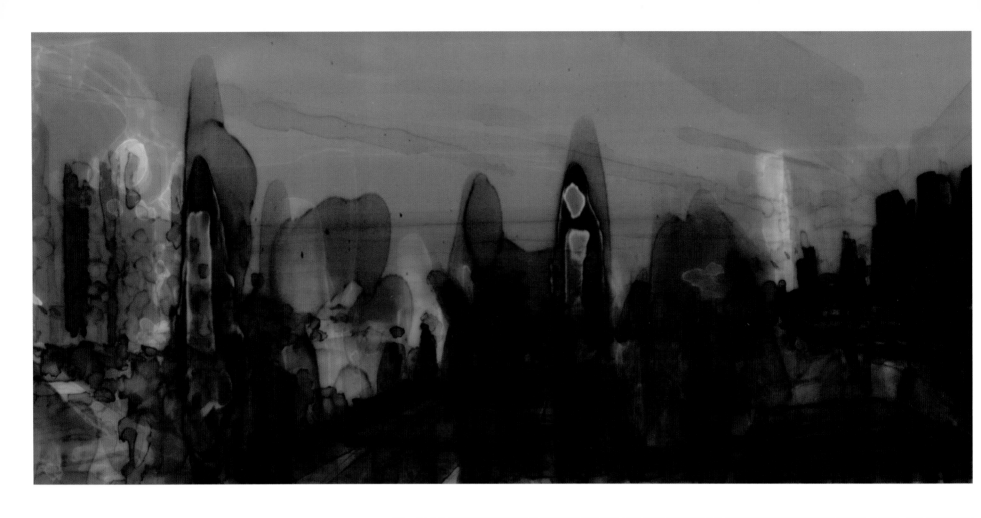

LANDING, MARKER SKETCH »

During the process of developing some environments for *Concept Design 2*, I started to experiment with a technique of loosely sketching abstract shapes with marker on vellum and Mylar. Once I finished several sketches, I scanned them into Photoshop and experimented with different compositing methods to achieve the sketch you see above. This method proved a way to generate more interesting building forms for the background of my rendering. Once the background was established, it was time to introduce the spaceships. By grabbing ships from the previous pages it was easy to include a lot of different designs. After adding the ships into the marker sketch, the color rendering of each ship began. I placed the ship sketches into the environment where they would match the perspective.

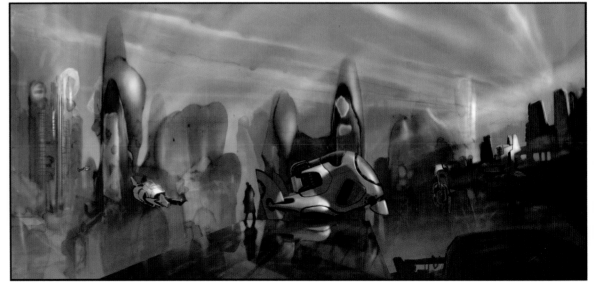

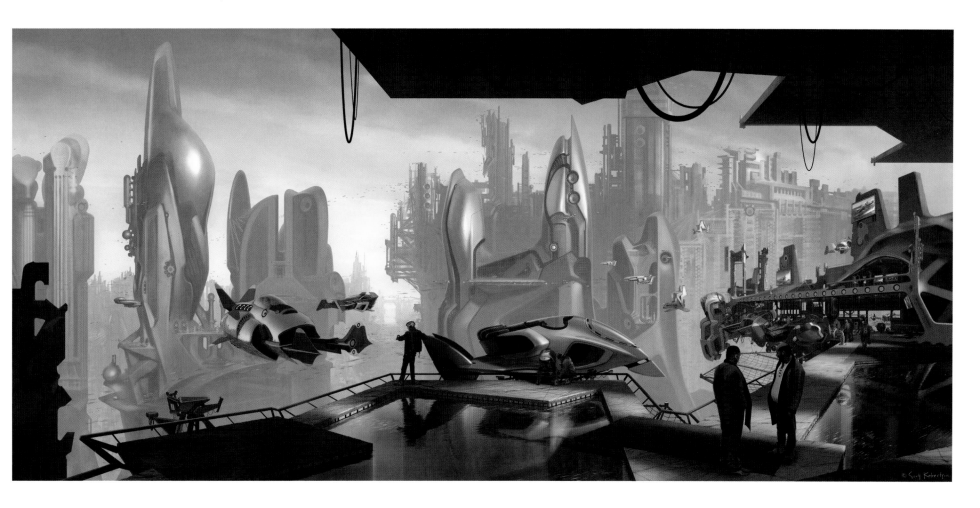

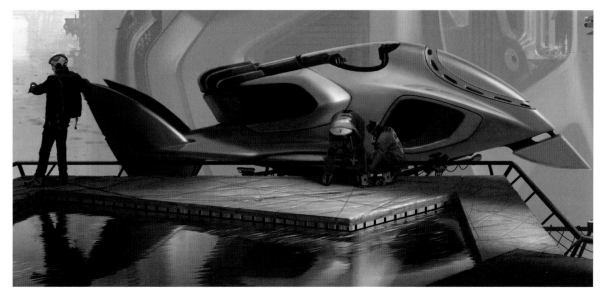

THE LANDING RENDERING »

One thing I like about this piece is that you can still recognize the building forms that came from my original marker sketch. A rendering like this is really about having the patience and determination to sit for about a week at the computer and pick away at it. The most enjoyable part was the painting of each ship and the addition of the figures. The process of adding the figures was a fun project. At our studio, there is a decent-sized parking lot. One morning I took a ladder outside, climbed up to match the eye level of my rendering with a camera and then asked my studio partner, Neville Page, to walk to different parts of the parking lot and pose in different positions. The photos were added to the rendering and then painted over to change the clothing and characters.

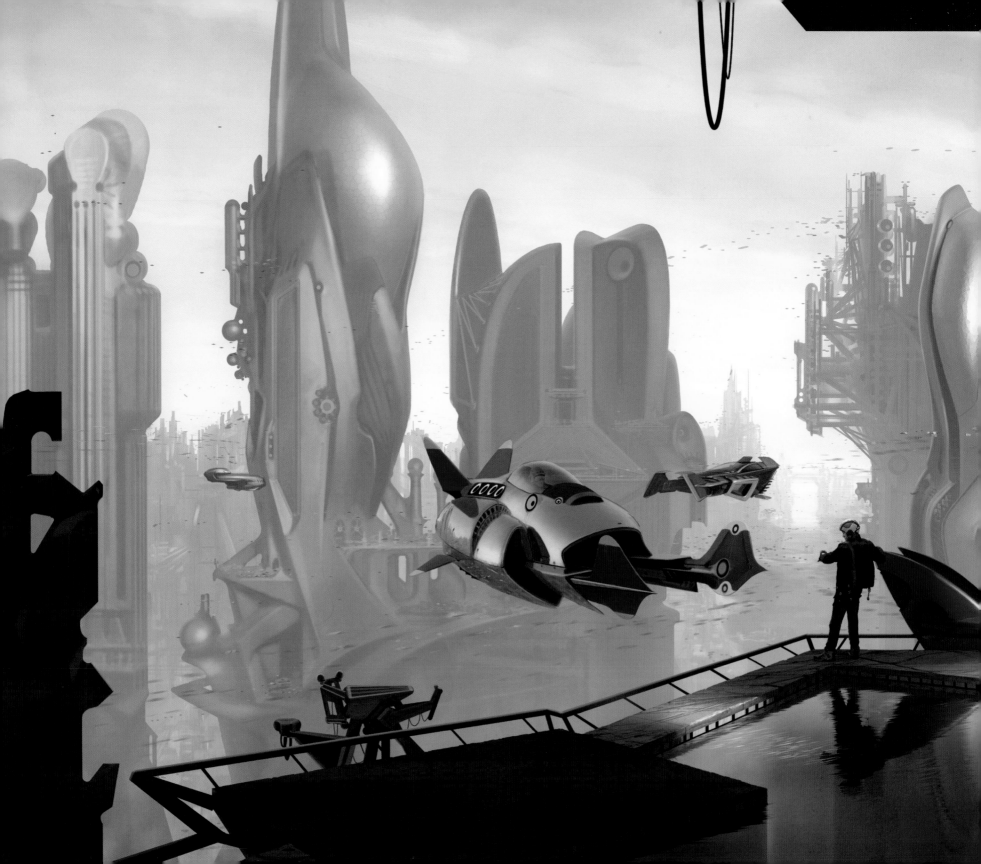

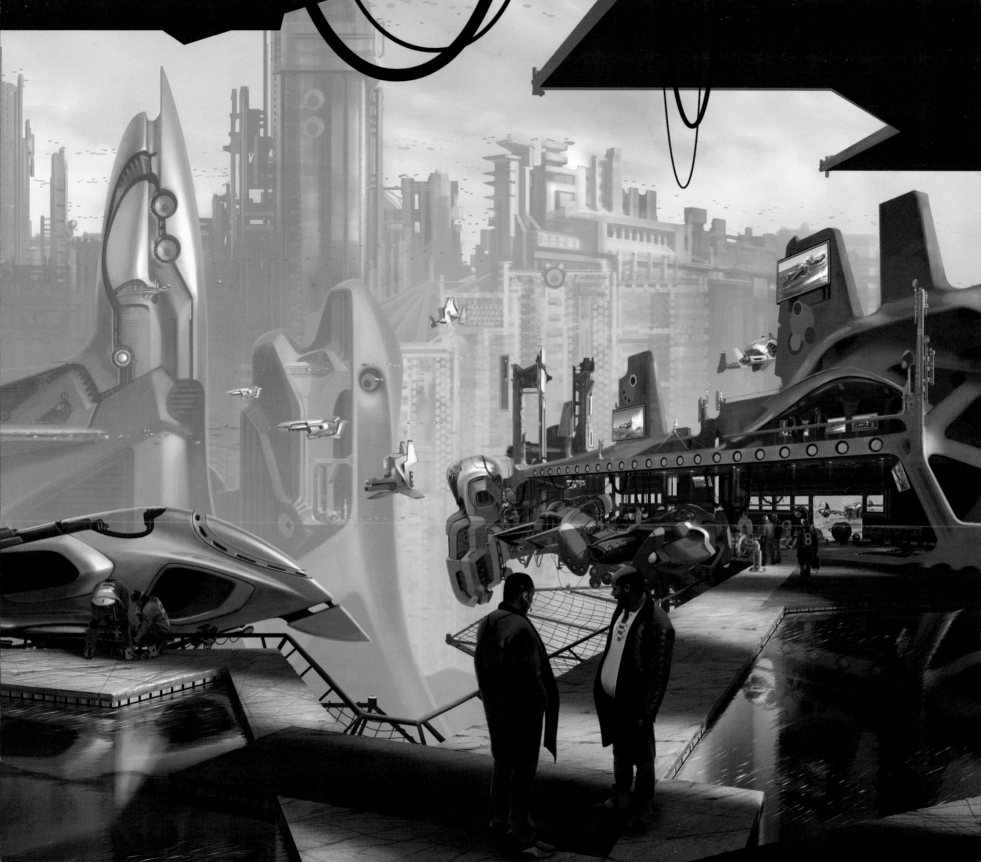

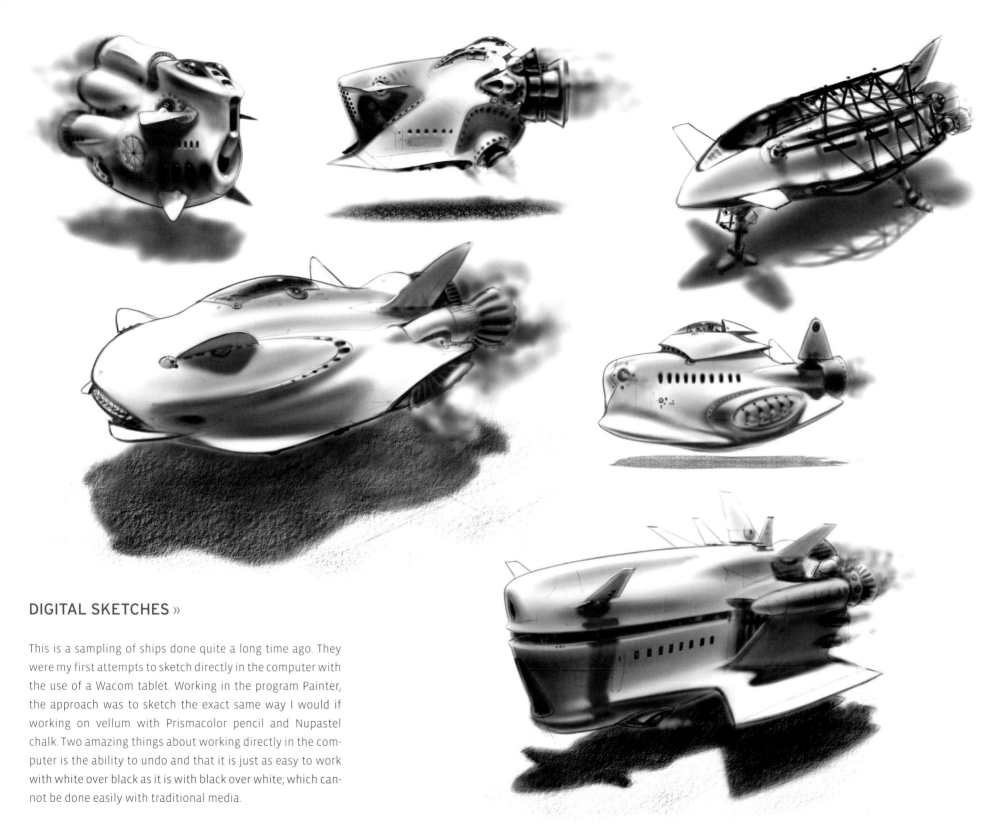

DIGITAL SKETCHES »

This is a sampling of ships done quite a long time ago. They were my first attempts to sketch directly in the computer with the use of a Wacom tablet. Working in the program Painter, the approach was to sketch the exact same way I would if working on vellum with Prismacolor pencil and Nupastel chalk. Two amazing things about working directly in the computer is the ability to undo and that it is just as easy to work with white over black as it is with black over white; which cannot be done easily with traditional media.

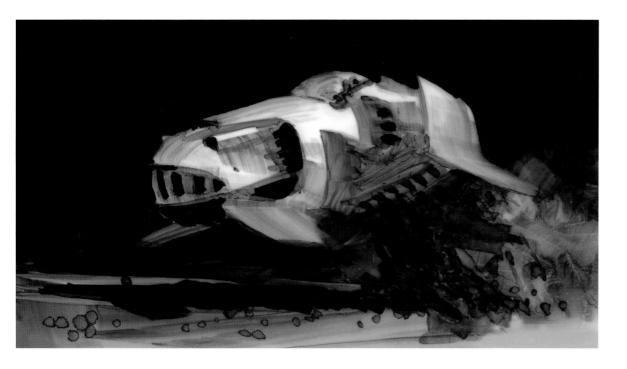

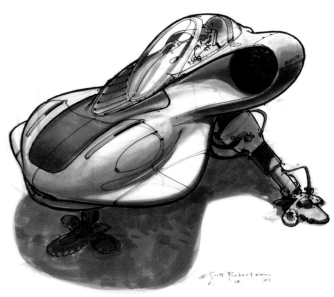

MARKER SKETCHES »

One of my favorite illustrators is John Berkey. The sketch to the left was inspired by one of his pieces where a spaceship is lifting off from the surface of a moon. My technique is different from his though, in that it continues the marker-sketching experiments that were done on Mylar for the environment sketches in *Concept Design 2*. Using wide Copic markers, the ship was loosely sketched out to add a lot of texture to the exhaust and the surfaces of the ship. Next, the sketch was scanned into Photoshop where, through dodging and burning spots here and there, the sketch was completed. An effort was made to maintain as much of the loose marker work from the original as possible. It is very easy to zoom into the details and over-render a sketch like this. As a comparison, the top sketch is a traditional media Prismacolor marker and Prismacolor pencil sketch-demo done for my students.

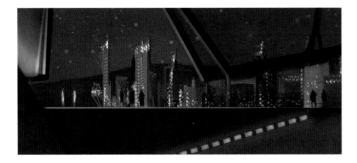

ABOVE CITY »

This piece started as a collection of loose marker sketches, then was scanned and composited in Photoshop. Originally done for *Concept Design 2*, but not included in that book, the idea was to feature an interesting ship having just set down on a landing pad well above a futuristic city. On the platform to the right you can see the pilot being greeted by someone, and waiting just up the stairs is a crowd of what looks to be zombies!

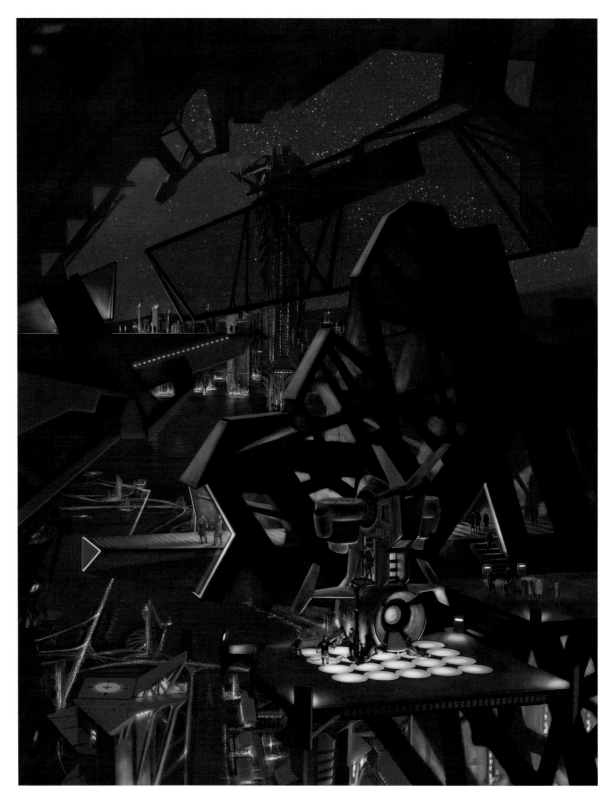

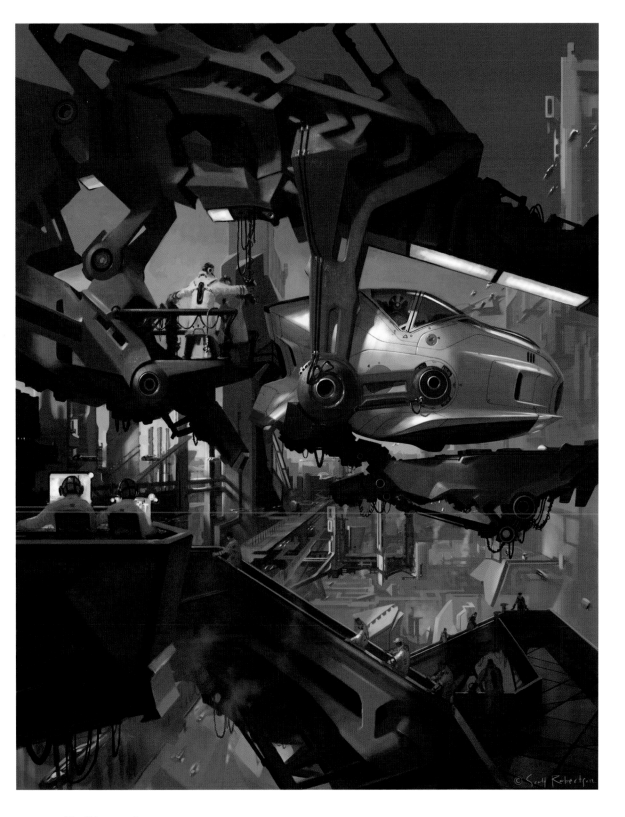

LAUNCH CRANE »

This was a really fun piece to do because it came together so easily. The value sketch above was done first, by compositing some photographs I had taken. I looked at the value collage for some time and found what I thought could be an interesting composition, and then I roughed out the forms. Since I started with a value collage, I already had a hint of depth due to atmospheric perspective. I simply found the shapes that were already in the piece. When I went to the color stage on the right, I fell back into one of my favorite color palettes, orange and blue. I love the look of late afternoon sun on rusted steel. You can see a lot of the first sketch remains in the finished piece. The little ship with the pilot in it on the crane was a fun challenge, rendering part of the ship in direct sunlight and the front shadow area illuminated by the artificial light coming from the crane above the nose of the ship.

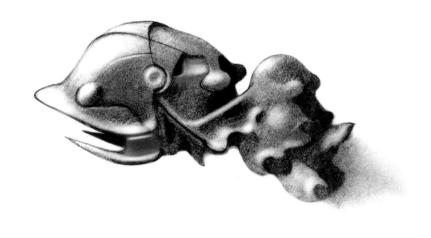

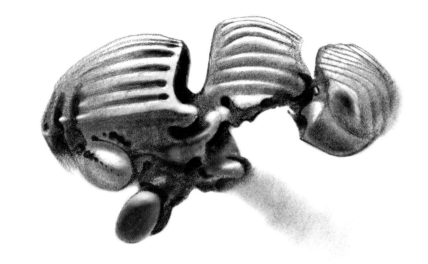

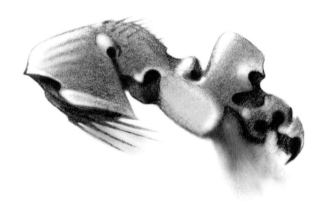

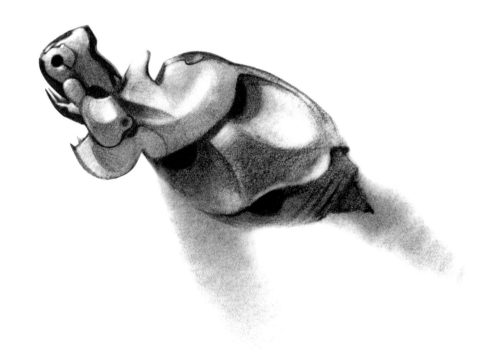

ANT SHIPS »

Having been educated as an industrial designer, I have an ingrained desire to create new and interesting object forms. Nature truly is a never-ending source of design inspiration, and the idea for these graphite sketches came to me while perusing a book on the scientific classification of ants, illustrated with beautiful black and white photographs.

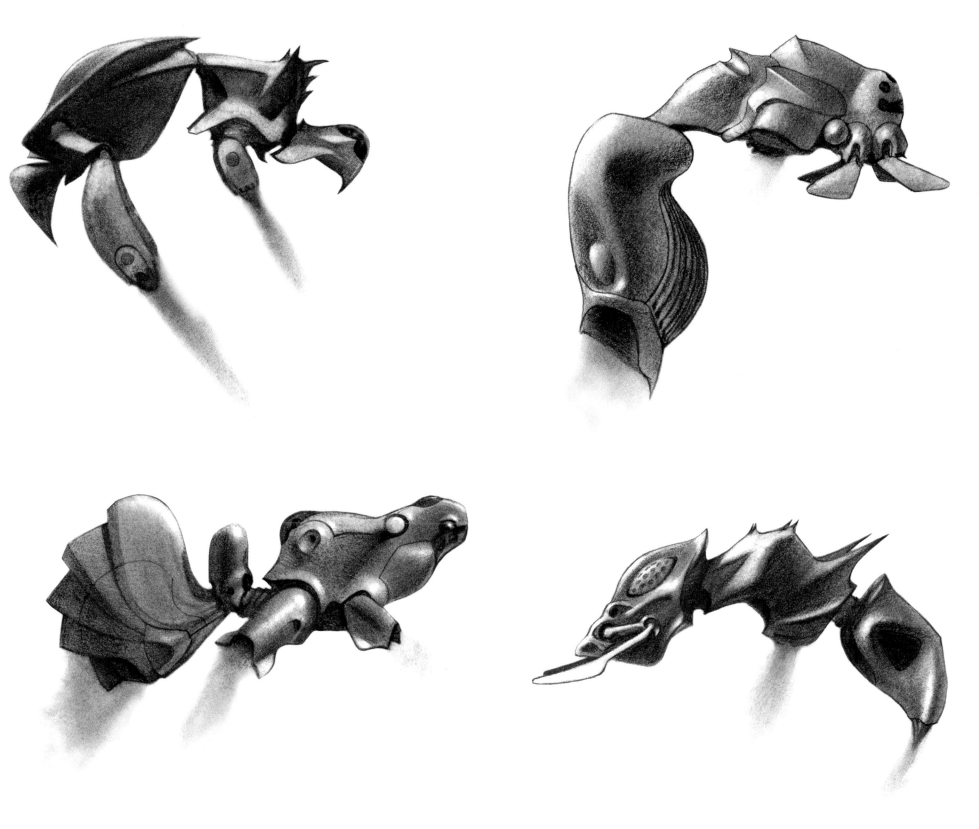

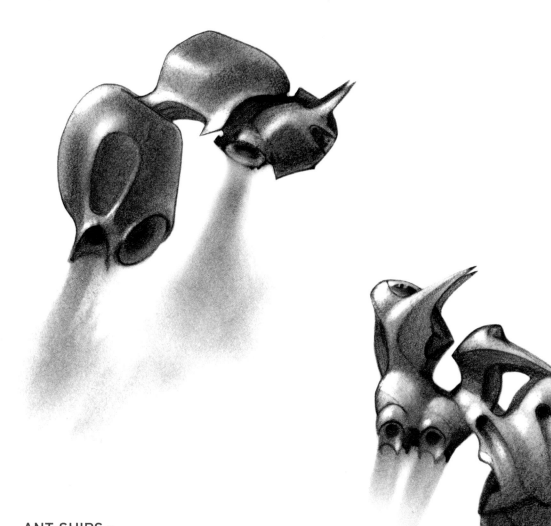
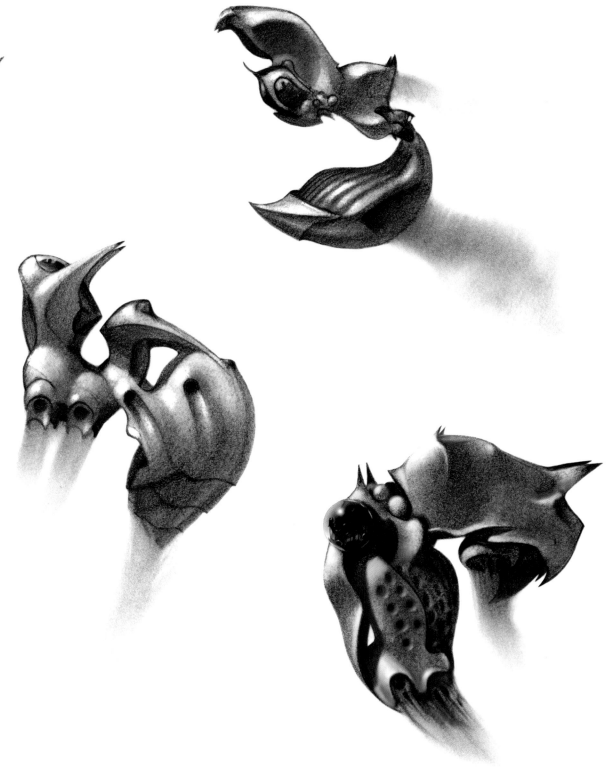

ANT SHIPS »

Imagining designs in a simple, one-point perspective is probably the easiest way to start to design a vehicle. After a few dozen sketches like those seen here it's fun to render up a few of the designs (as you will see in the coming pages). Or in most cases, if it were a real design job, the next step would be to do more sketches of the desired vehicle rotated in different perspective views to give the viewer a more comprehensive idea of the entire design. In the ant ship sketches, the addition of a human head and shoulders, or at least a hint of a body through a cockpit window, is the reference most viewers will use to help establish scale and gauge in their minds the size of the ship. This is needed here more than in familiar designs because the vehicle forms are so foreign to us.

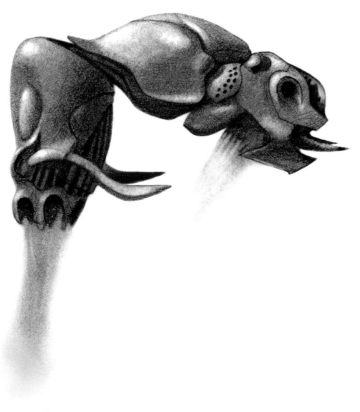

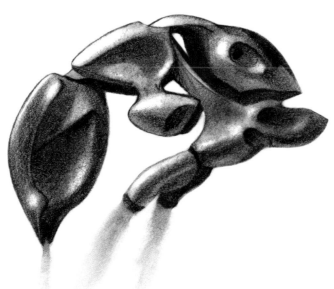

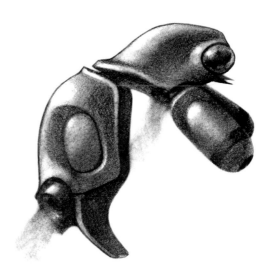

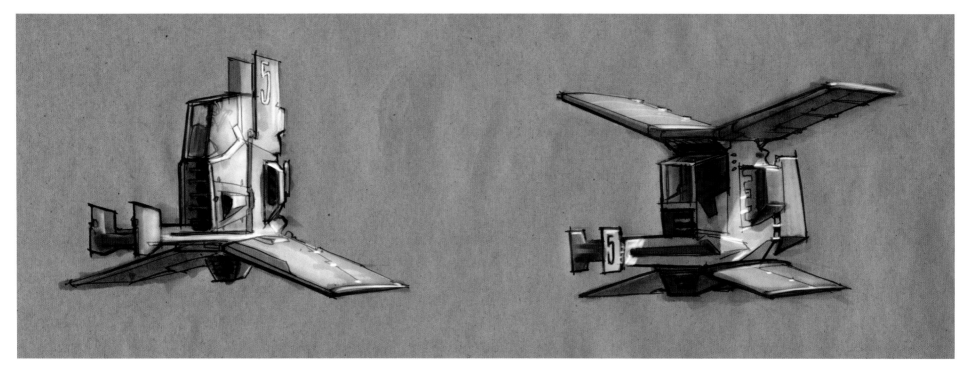

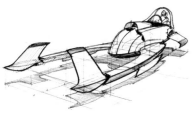 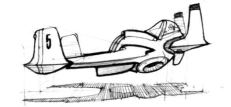 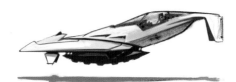

RANDOM SKETCHES »

At the top of this page are a couple of quick marker sketches done on newsprint and then scanned. I was experimenting with what I like to call the "Ryan Church lighting technique." This technique first involves duplicating the layer that has the original sketch on it before you start to render the forms. In Painter, you then use the glow brush to add the light on your object on this duplicated layer. When this is done you erase where you want the cast shadows to go, exposing the original sketch below, giving you the result above. To the right are some quick, digital color sketches, which started out as tradi-tional media hand sketches. On the next spread you will find the Photoshop rendering from the cover of this book with a detail to help show the scale of the vehicle.

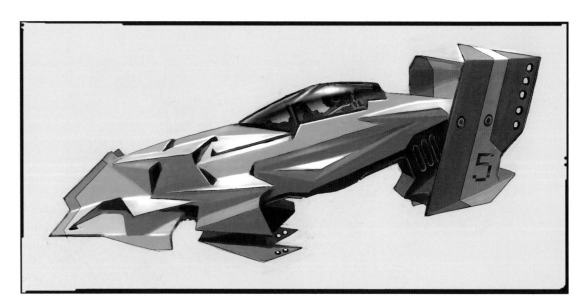

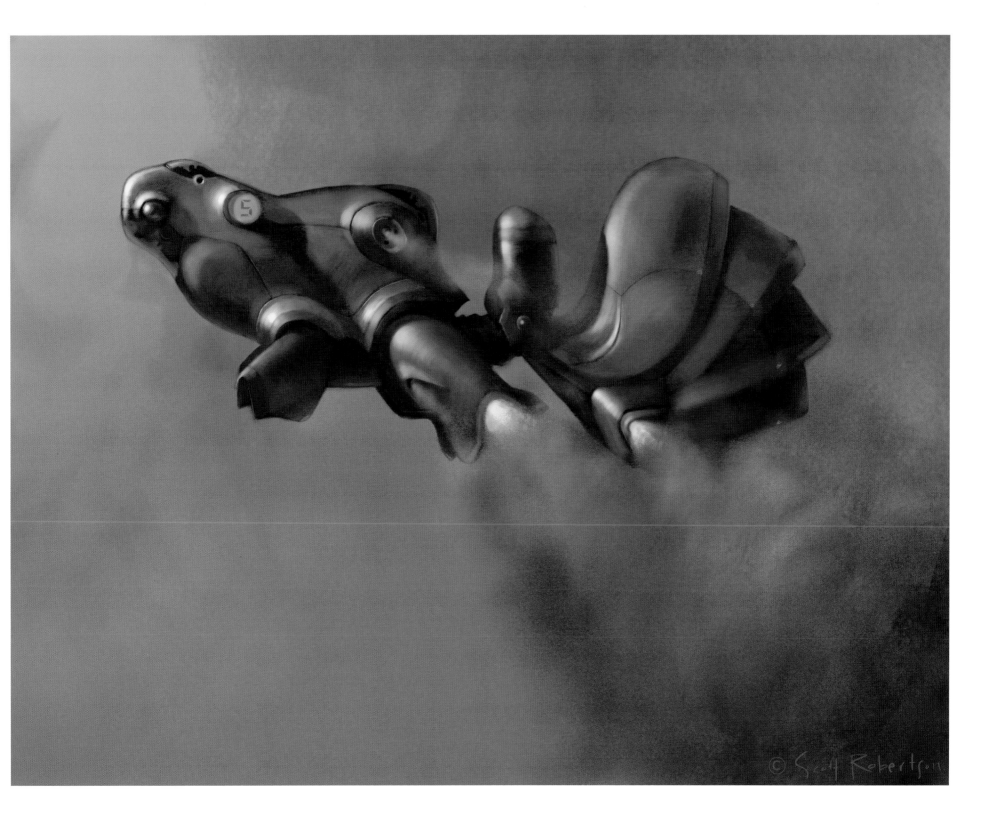

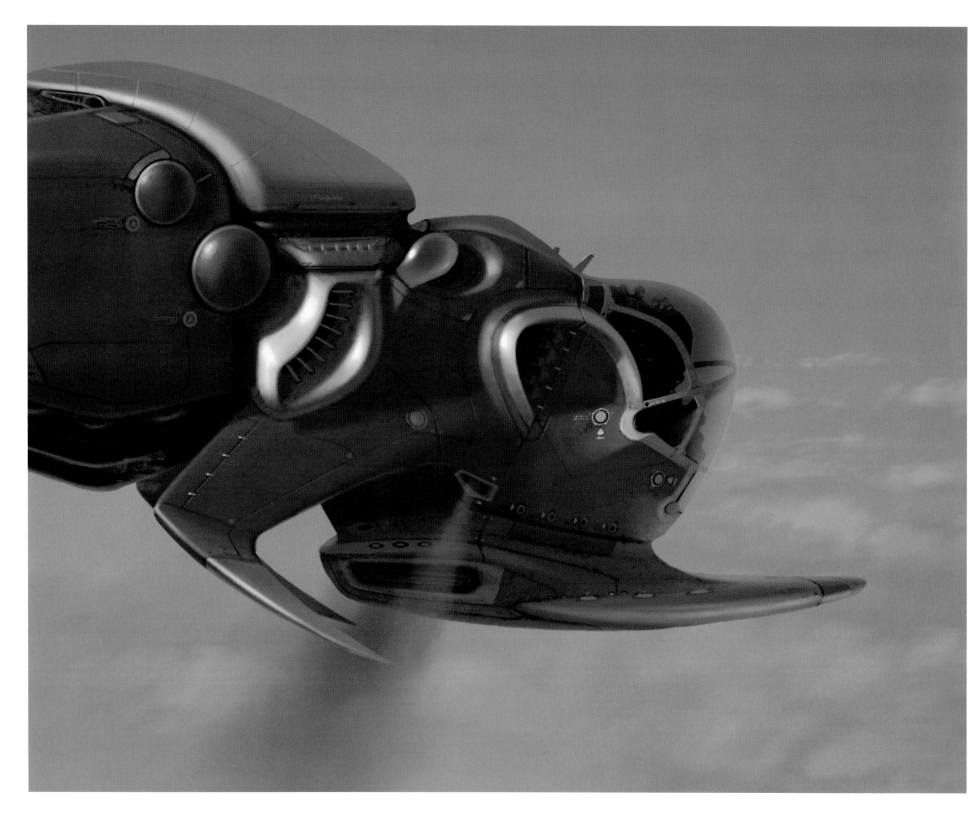

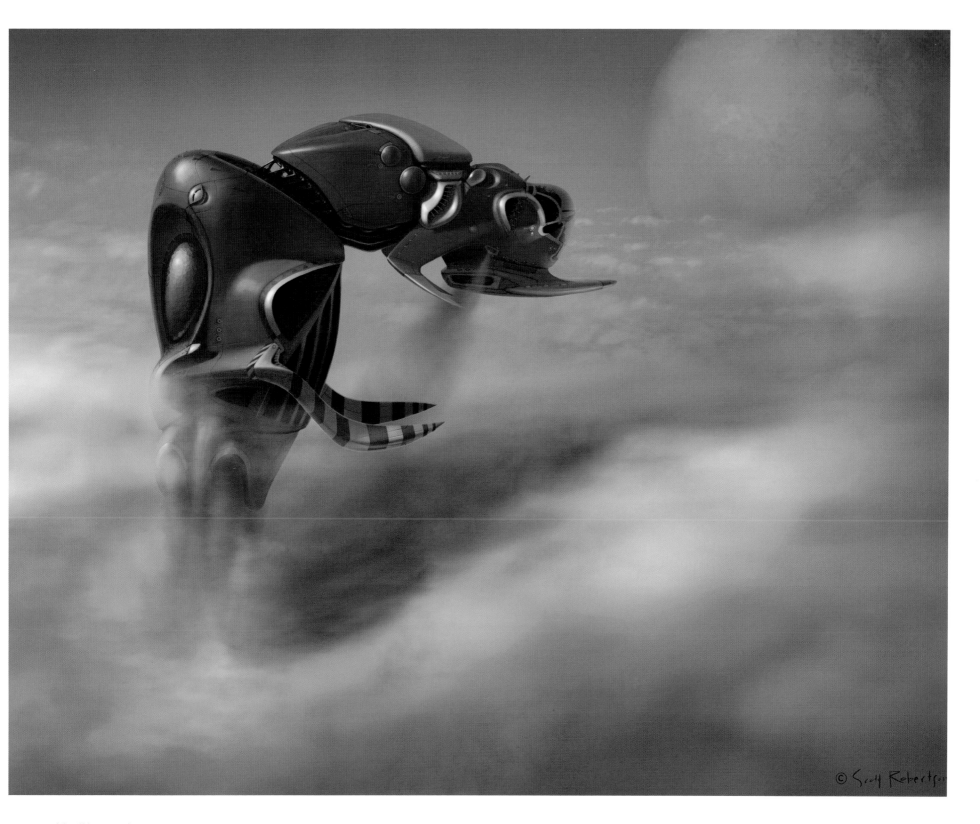

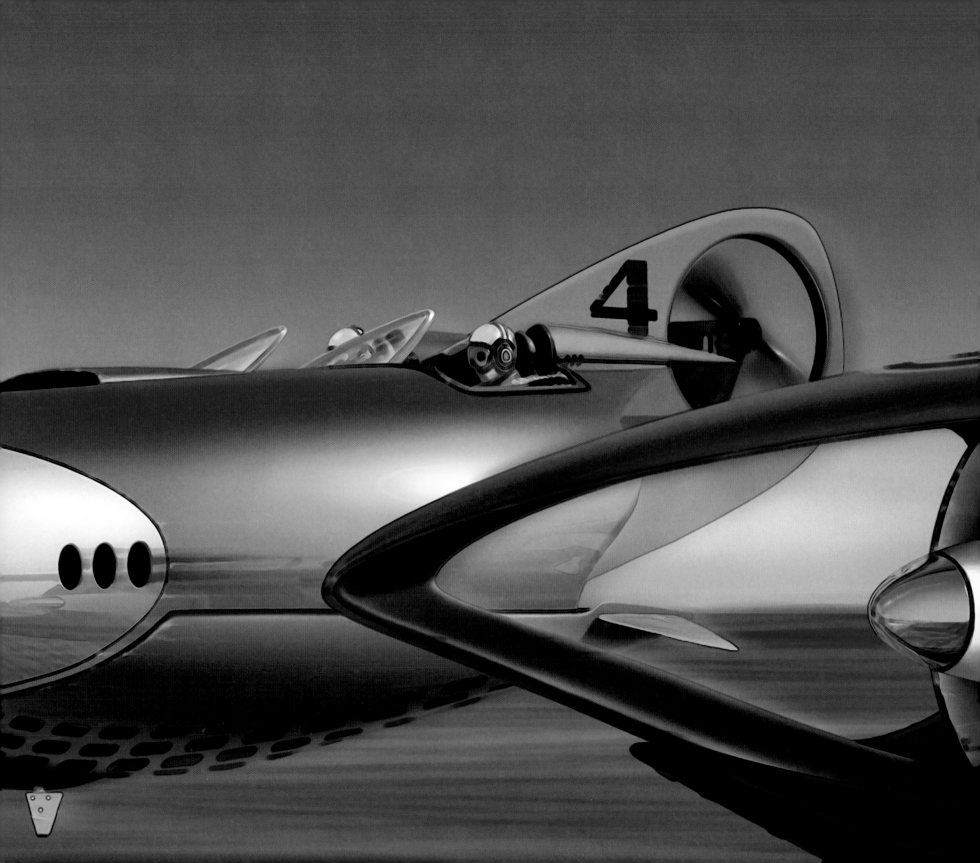

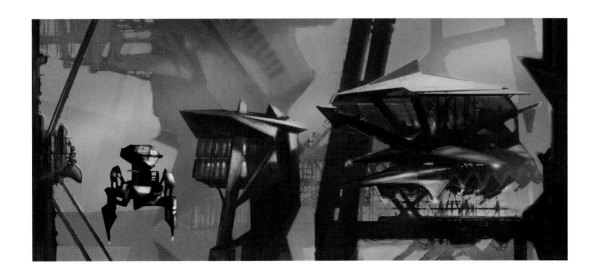

CHAPTER »02

hovercraft

If I were pressed to pick a favorite vehicle subject to design, this would be it. With thanks to George Lucas for popularizing anti-gravity devices in the *Star Wars* movies, everyone in the world now easily accepts the "speeder" or flying car. What a gift for concept designers! They are readily available, affordable, small and never-in-need-of-fueling anti-gravity devices! Let the fun begin! So it is with the acceptance of these devices' existence that I have, over the years, liberally enjoyed the design, sketching and rendering of the hovercraft. I always like to think of them as flying cars. I imagine that they all have a certain limitation to the altitude they can easily achieve, which generally keeps them in close proximity to the ground. I like to consider the ground as a part of the vehicle, that

when indicated with a shadow, helps me to "set" the stance of the hovercraft. A lot of the designs from the spaceship chapter could work in this chapter as well. I think of the two vehicle types as somewhat interchangeable; with some minor design modifications, each can easily be made into the other. I'm a big racing fan so the activity I most like to imagine for my hovercraft renderings is racing. The card collection chapter, which is the final chapter, is another extension of the hovercraft-spacecraft dream but I saved the best for last; so skip ahead if you must.

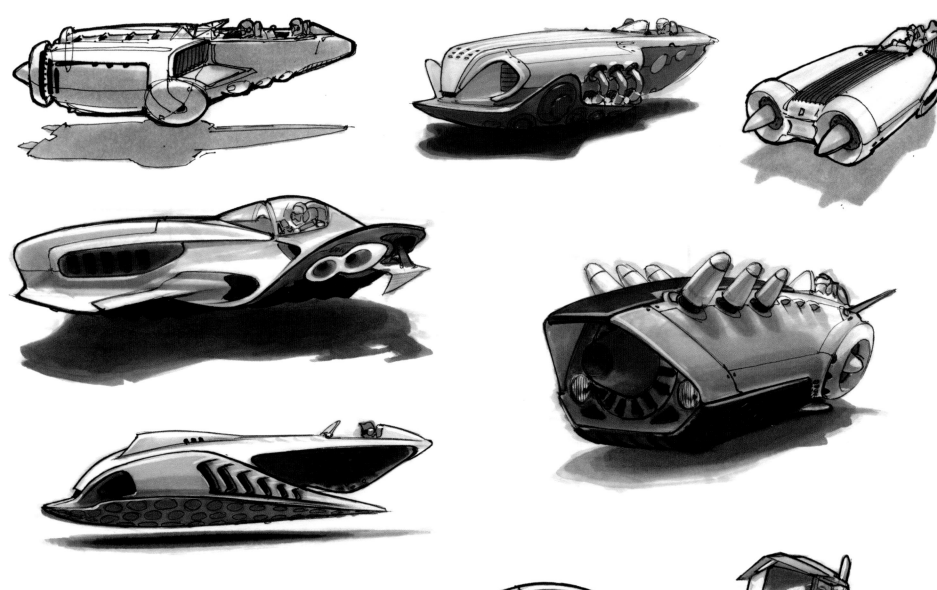

MARKER SKETCHES »

Originally done for *Concept Design 1*, the marker and pen sketches on the next six pages show what I usually do when trying to develop a range of vehicles for any number of purposes. In this case the intention was to stage a couple of these hovercraft in a racing scene rendering. As a designer I find that the pages I most like to look at in these types of books are those with the development sketches on them. This is why I have included all of the development sketches here.

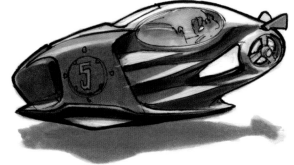

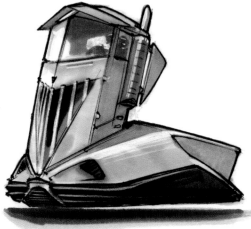

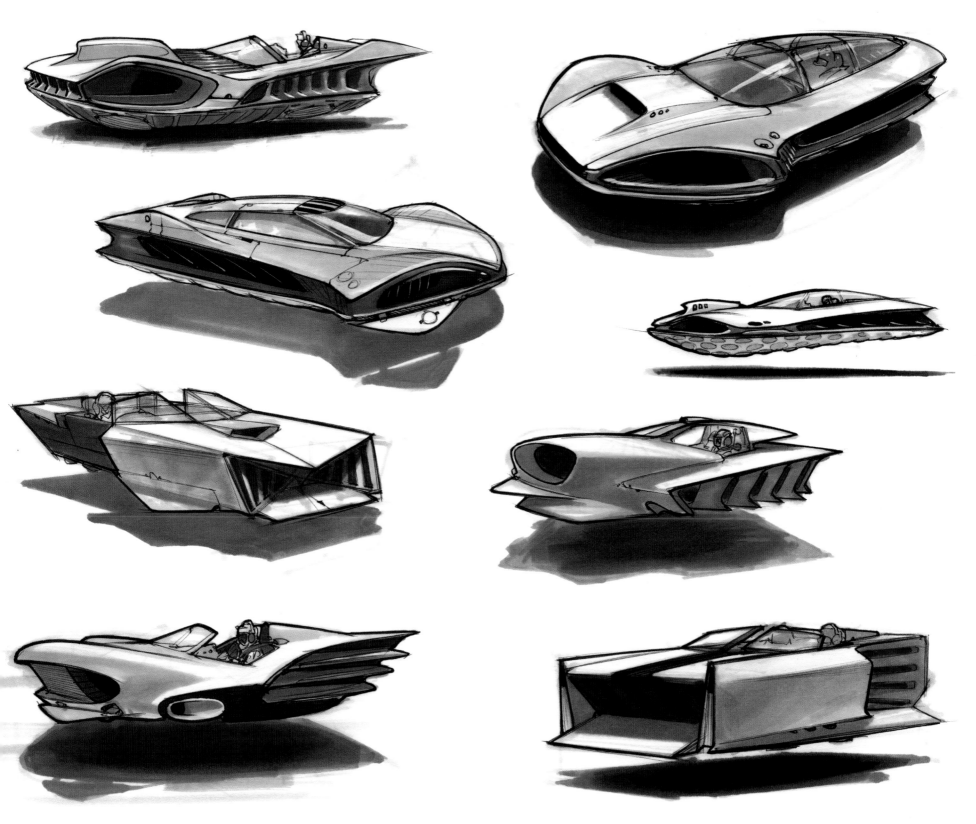

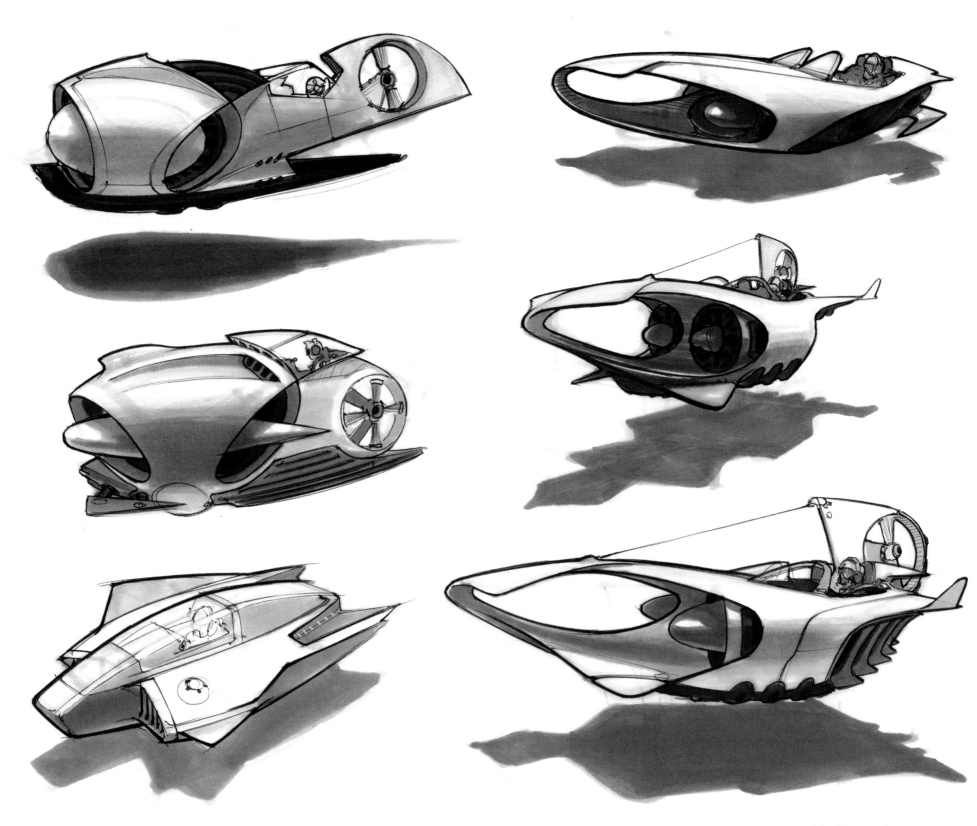

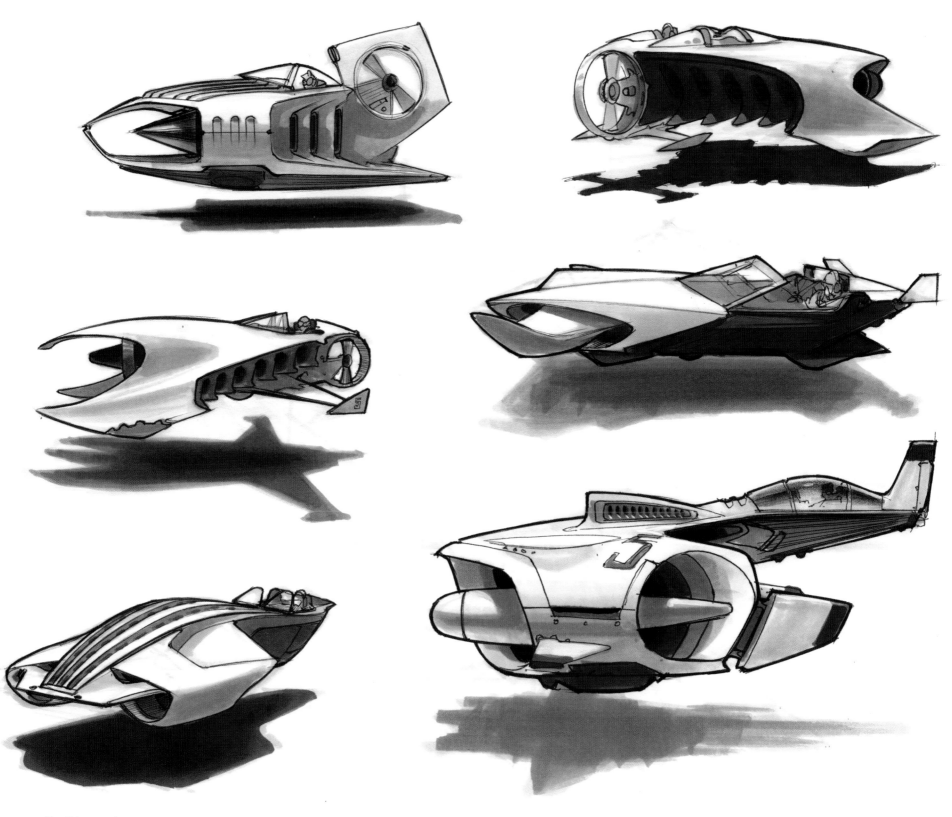

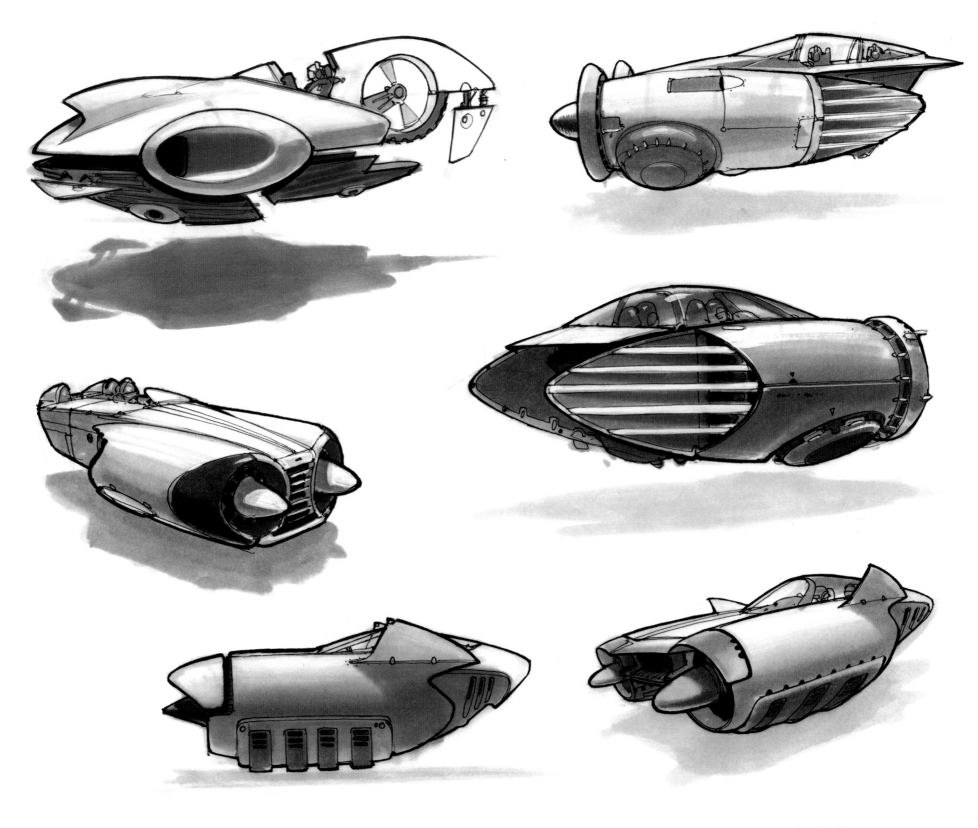

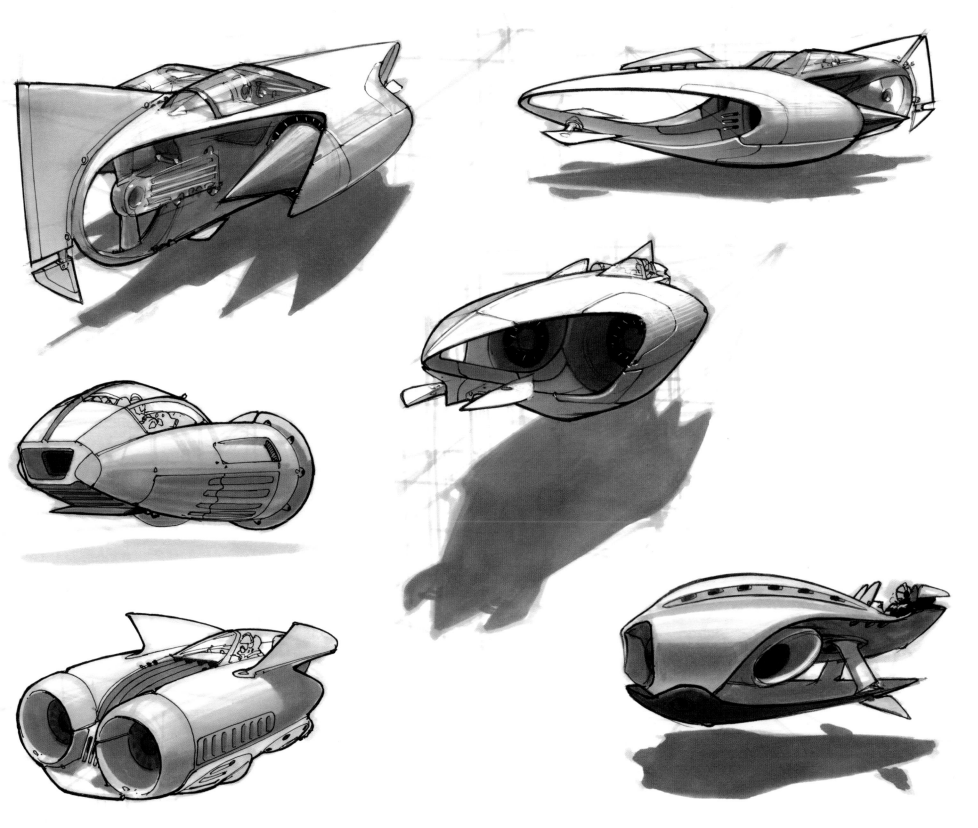

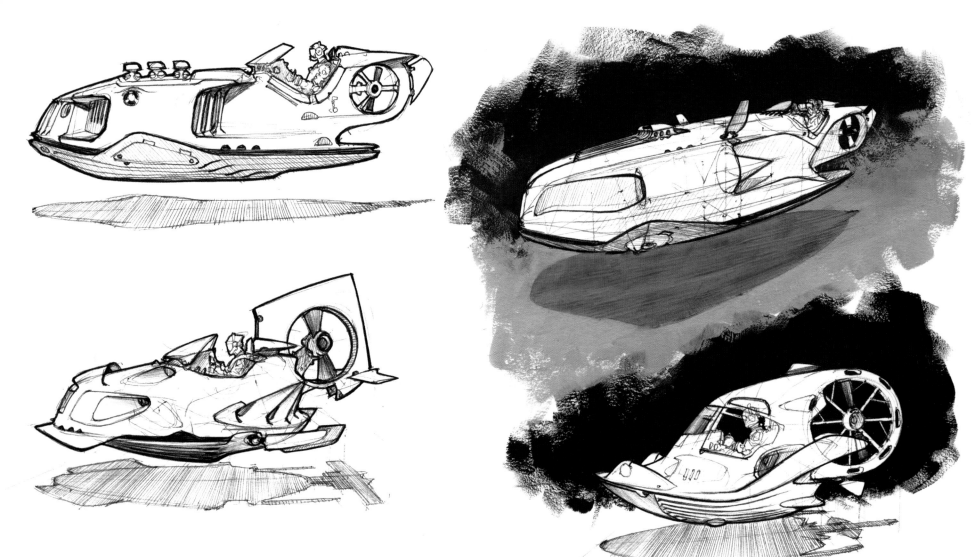

BALLPOINT PEN SKETCHES »

I enjoy working in almost any media, but ballpoint pen is one of my favorites when doing accurately drawn, small, vehicle sketches. When working on paper with just the right amount of tooth, it is much faster to use a pen that provides a nice, fine line, rather than a pencil that needs to be sharpened often. The backgrounds seen here were done with gouache paint. This was possible because the sketches were done on a thick Bristol paper which does not warp easily.

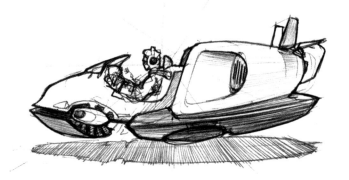

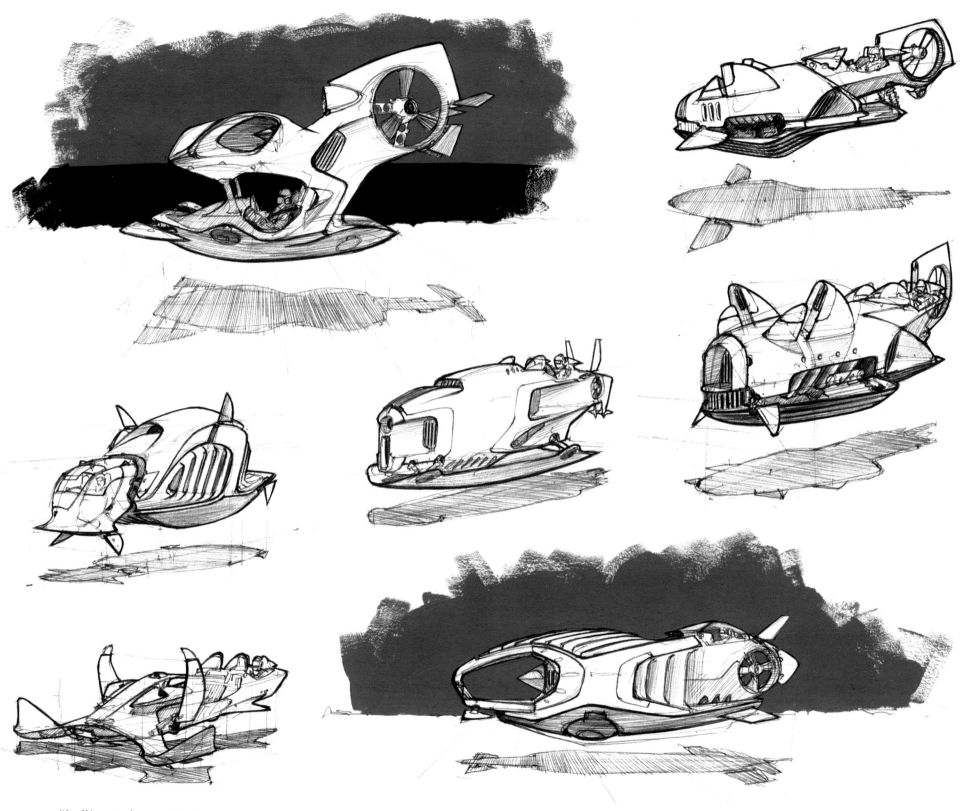

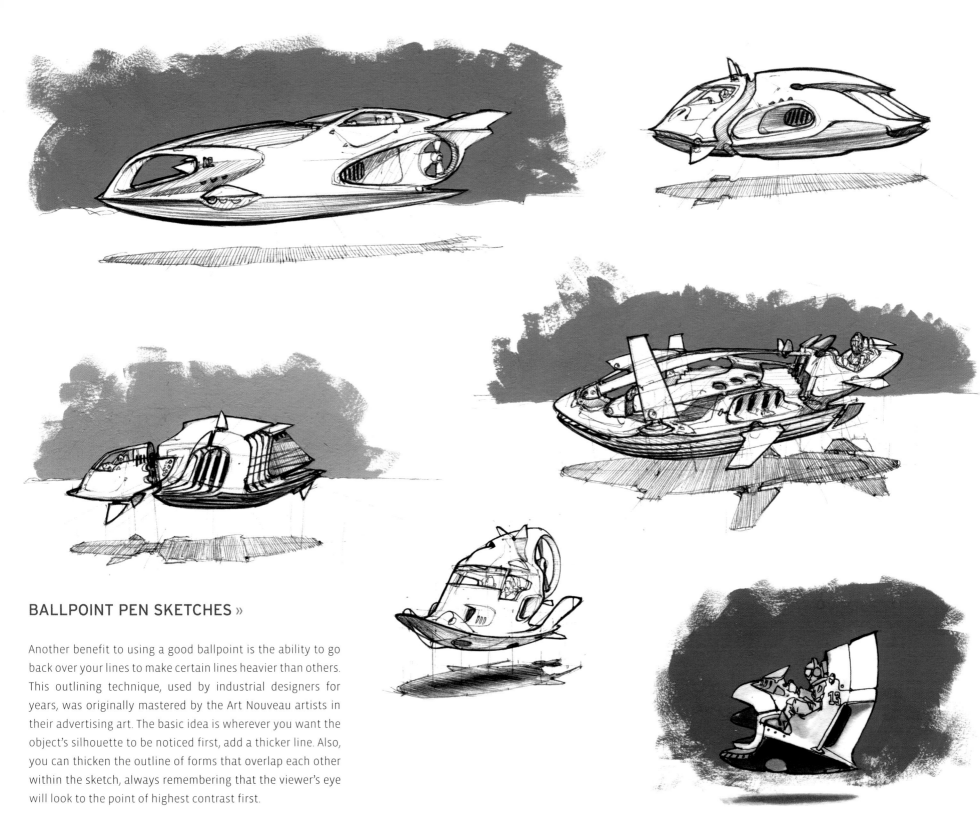

BALLPOINT PEN SKETCHES »

Another benefit to using a good ballpoint is the ability to go back over your lines to make certain lines heavier than others. This outlining technique, used by industrial designers for years, was originally mastered by the Art Nouveau artists in their advertising art. The basic idea is wherever you want the object's silhouette to be noticed first, add a thicker line. Also, you can thicken the outline of forms that overlap each other within the sketch, always remembering that the viewer's eye will look to the point of highest contrast first.

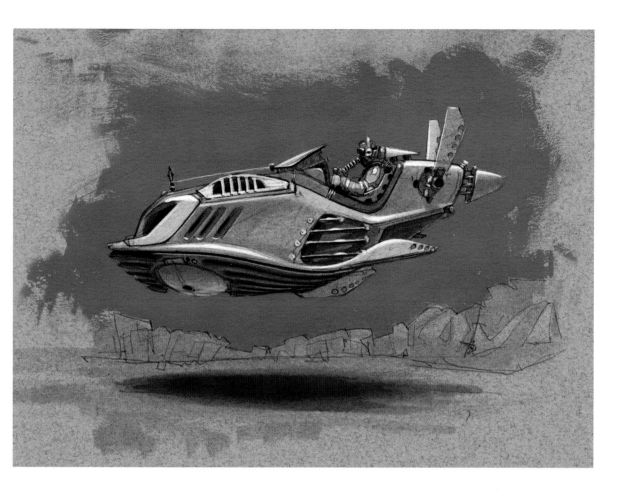

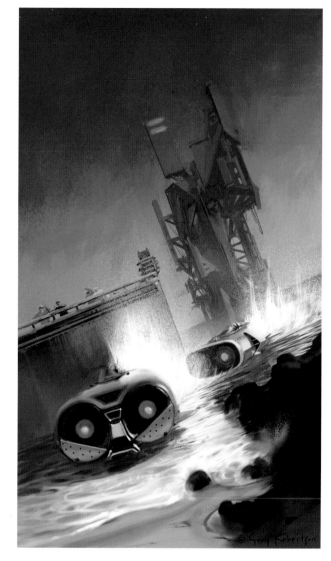

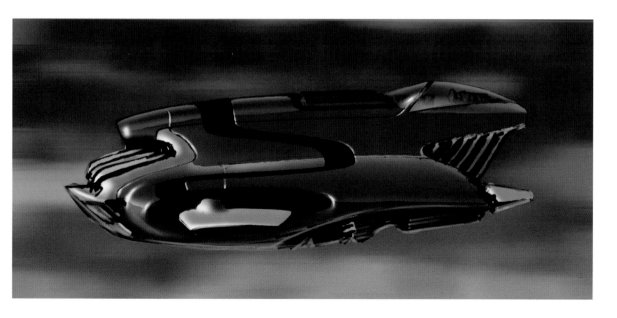

IN ACTION »

The top left sketch was done with ballpoint and marker on a toned Canson paper. Gouache was added last for the background, hiding the stray marker that was there. The color sketch to the left was done in Photoshop as a quick demo. The original ship sketch can be found on page 12. The piece above was an attempt to see what I could accomplish within the program Painter Essentials 3. The sketch started as a marker sketch that was then painted over.

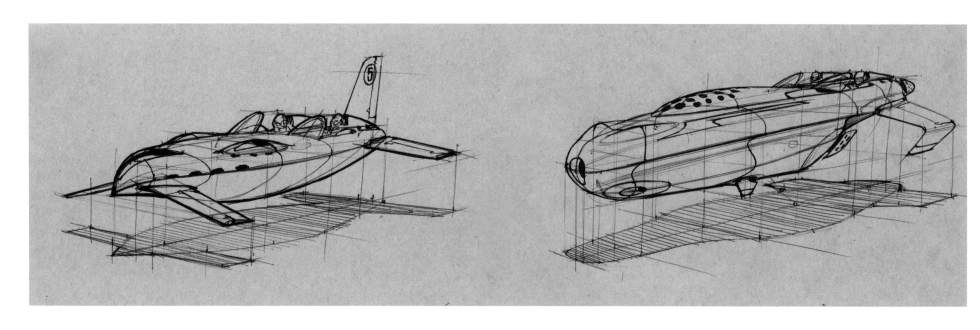

DVD + COLOR SKETCHES »

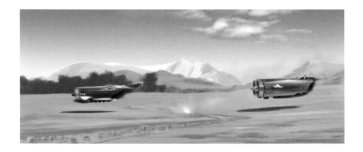

Above are a couple of ballpoint pen sketches from one of my instructional DVDs. To the right is an experiment from *Concept Design 1* where I mixed indoor product rendering techniques (as seen in the bicycle chapter of *Start Your Engines*) and the random "lasso tool" shaped-based form development ideas a lot of us are using now. On the facing page is another crack at developing a technique for working within Painter Essentials 3. I'm getting closer with this sketch and I'm sure the next version of the program will be even more fun than it already is now.

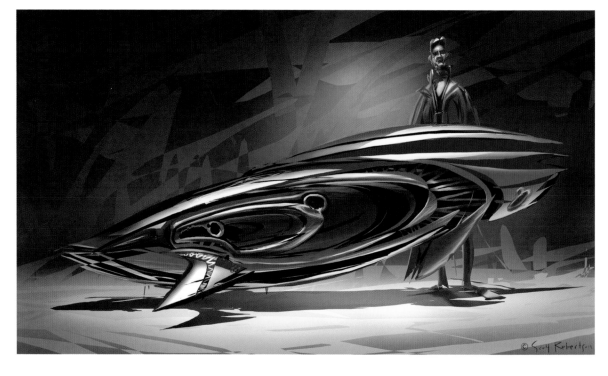

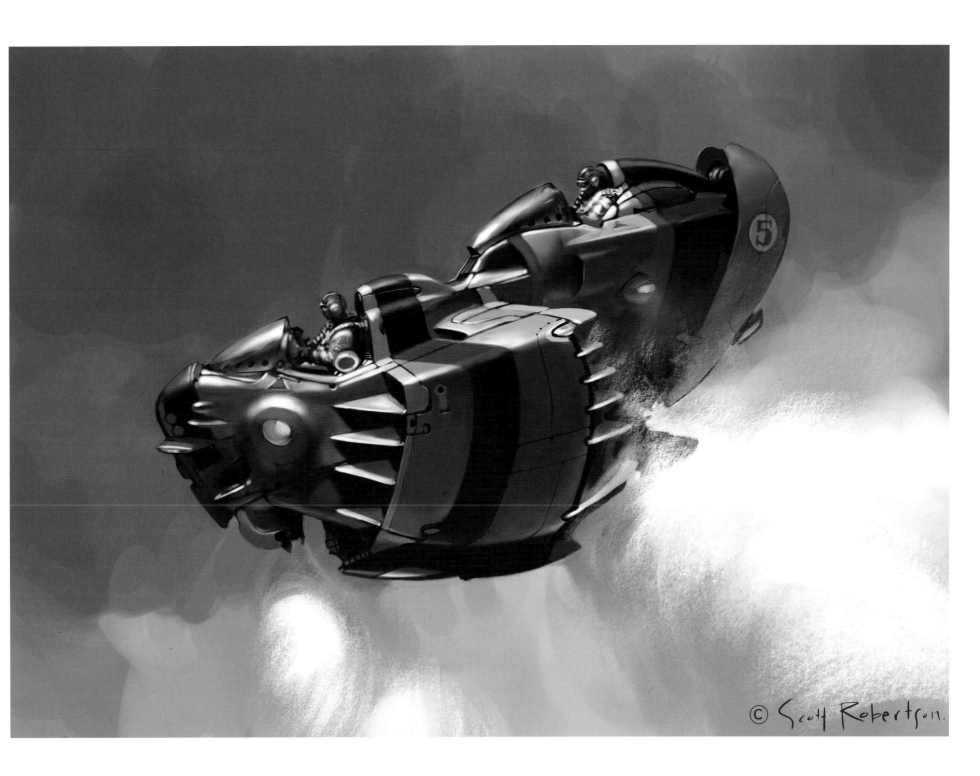

© Scott Robertson.

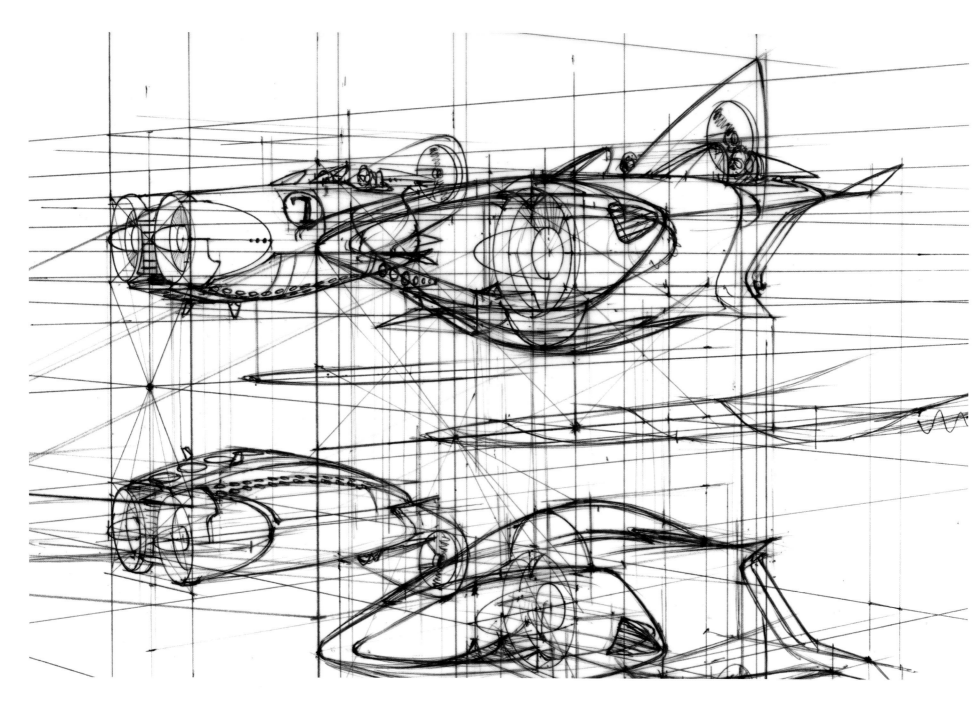

LOS AERODESLIZADORES »

You might recognize this one from the cover of *Concept Design 1*. Having another opportunity here to present this work I thought you might enjoy seeing the finished line drawing for the rendering. The drawing above is about 10 x14 inches and done in ballpoint on tracing paper.

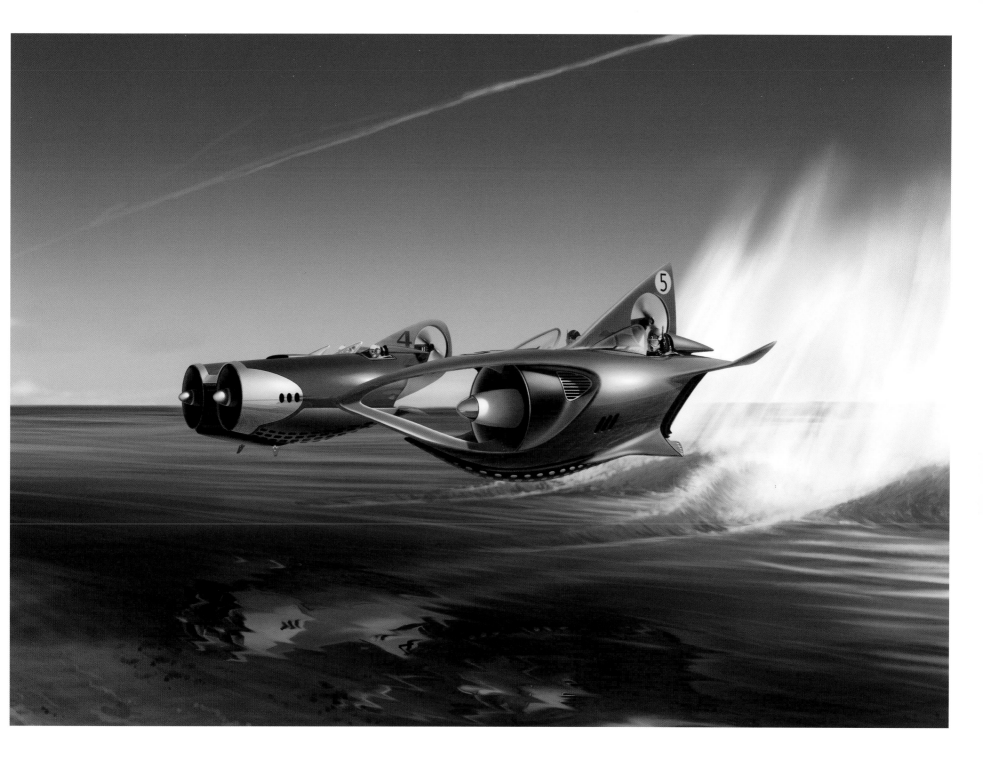

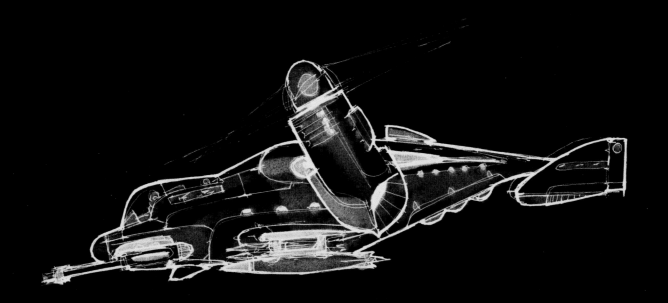

game vehicles

I am fortunate enough to have been granted the reproduction rights to the vehicle design work I did for the game *Spy Hunter 2* with Midway Games under the creative direction of Steven Olds, and for *Field Commander* with Sony Online Entertainment under the creative direction of Phelan Sykes. I greatly appreciate that these leading game companies granted me the rights to include this work. I feel they are both making strong contributions here to help with the education and inspiration of tomorrow's concept designers.

The first sketches and renderings I'll share with you in this chapter are from *Spy Hunter 2*. Steven Olds is one of the most talented concept artists I know of, and to work with him over an 11-month period was both challenging and rewarding. Being that we are both what you would term "old school" when it comes to our design acumen, we got along great and have become good friends. The general brief was to design a variety of air-

craft vehicles, both as bad-guy bosses and as support craft for the hero car in the form of a VTOL craft. From a very small solo copter to a mega "ground effect" transporter, designing these vehicles was a lot of hard work, but in the end, a very satisfying experience to push my drawing and design skills to higher levels with the creation of each new vehicle.

The task involved in working for Phelan Sykes on the vehicles for *Field Commander* was to establish the aesthetic direction of the vehicles for two opposing forces. Each team needed its own form language and a recognizably different silhouette for each vehicle. This was most important due to the lower resolution requirements of the game being developed for the Sony PSP. In this book you will find the helicopters and VTOL craft design directions. In book one, *Start Your Engines,* the jeeps and tanks may be viewed.

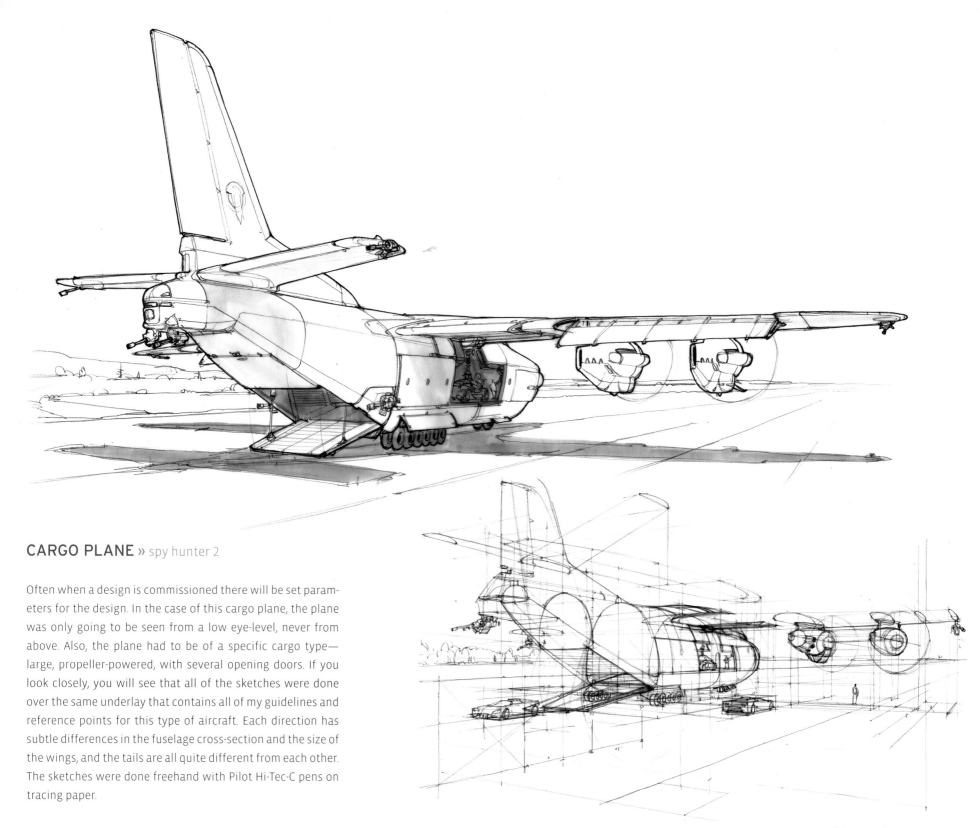

CARGO PLANE » spy hunter 2

Often when a design is commissioned there will be set param-
eters for the design. In the case of this cargo plane, the plane
was only going to be seen from a low eye-level, never from
above. Also, the plane had to be of a specific cargo type—
large, propeller-powered, with several opening doors. If you
look closely, you will see that all of the sketches were done
over the same underlay that contains all of my guidelines and
reference points for this type of aircraft. Each direction has
subtle differences in the fuselage cross-section and the size of
the wings, and the tails are all quite different from each other.
The sketches were done freehand with Pilot Hi-Tec-C pens on
tracing paper.

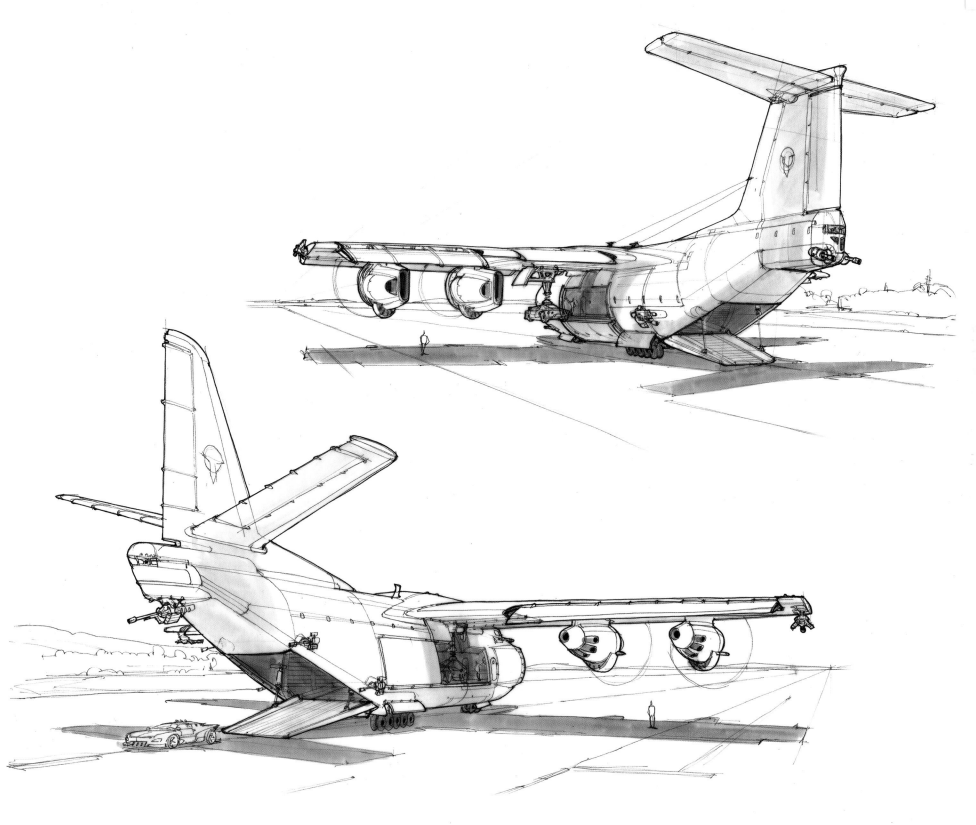

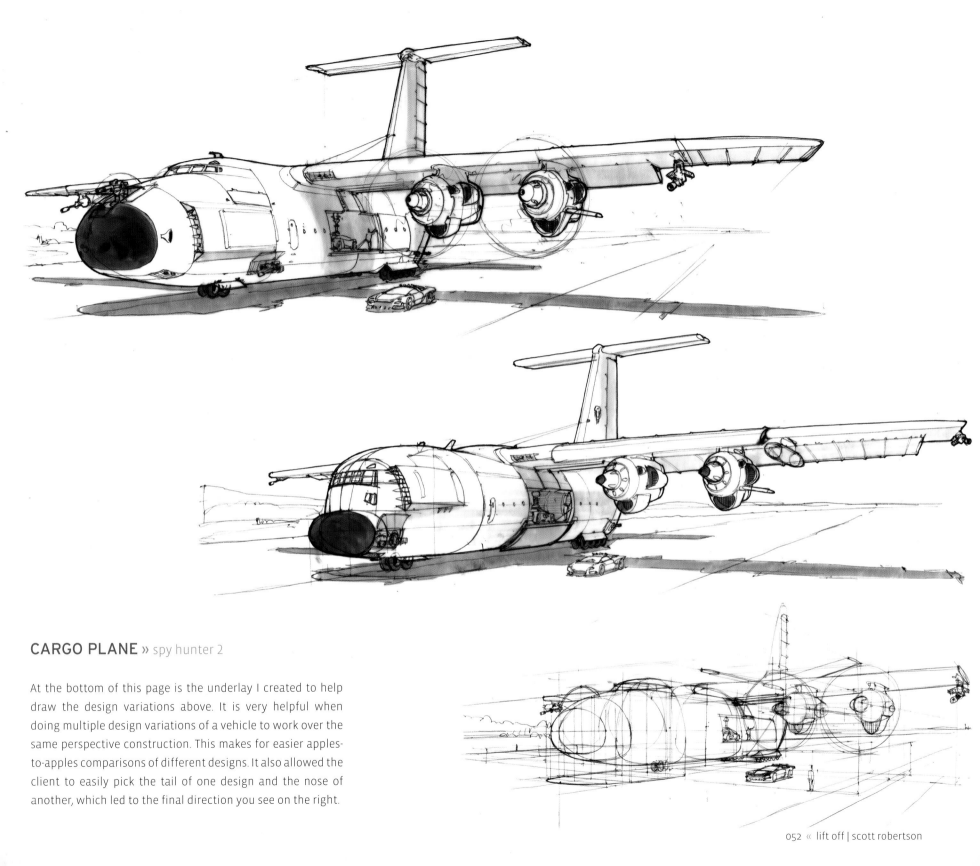

CARGO PLANE » spy hunter 2

At the bottom of this page is the underlay I created to help draw the design variations above. It is very helpful when doing multiple design variations of a vehicle to work over the same perspective construction. This makes for easier apples-to-apples comparisons of different designs. It also allowed the client to easily pick the tail of one design and the nose of another, which led to the final direction you see on the right.

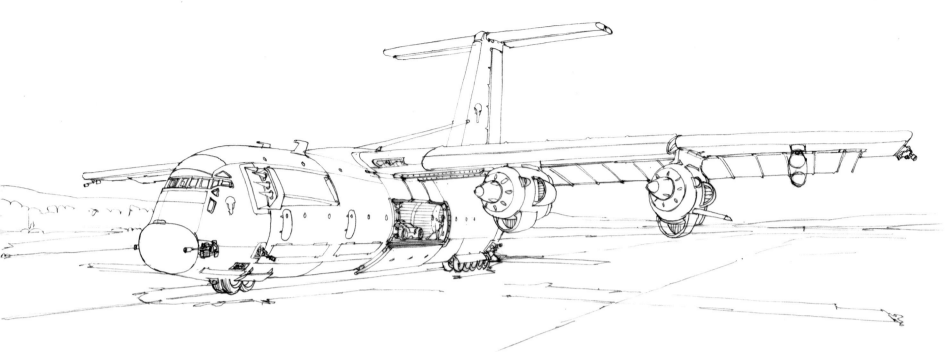

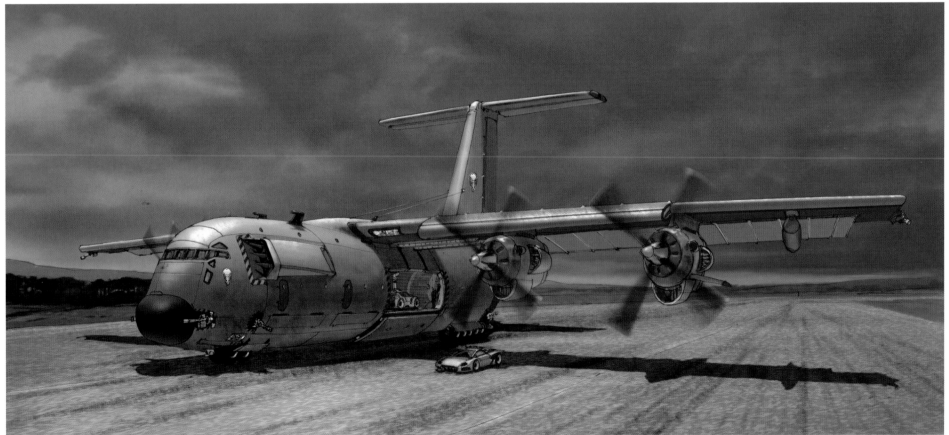

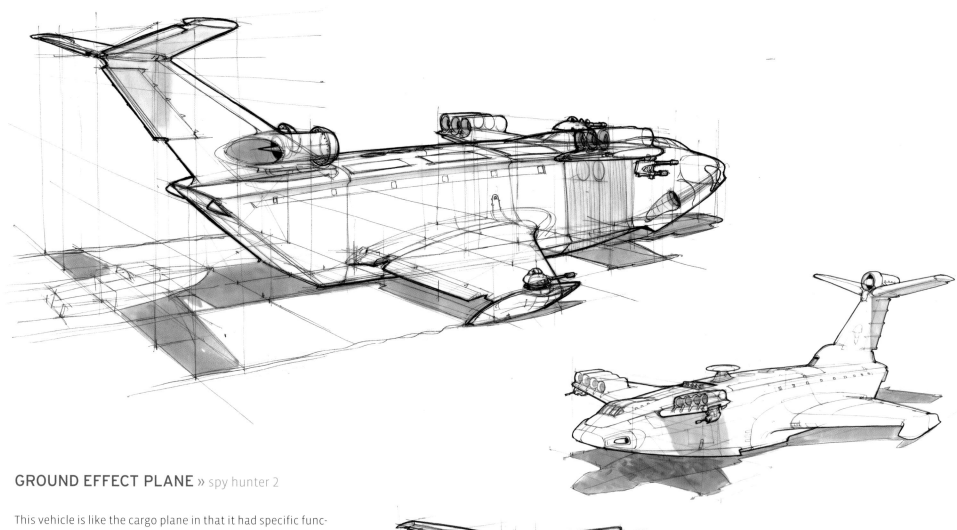

GROUND EFFECT PLANE » spy hunter 2

This vehicle is like the cargo plane in that it had specific functions it had to retain in each design direction. The goal here was to design a huge, seagoing cargo plane that incorporates ground effect wings. The design directions are reminiscent of the old Russian ground effect planes. Additional requirements were to make it feel a bit old and allow for the wave cutter to be brought into the rear of it for service. It was to have several machine guns for protection that were placed under the front wings and on the nose. The manned gun turrets at the ends of the main wings are my favorites. That could be a wild ride out there in rough waters! On the bottom of the right page you can see the final design drawing for the plane. This was drawn very lightly with a ballpoint pen since it would be rendered later in Photoshop, as you will see on the next spread.

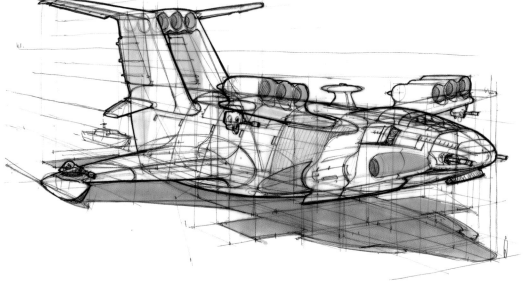

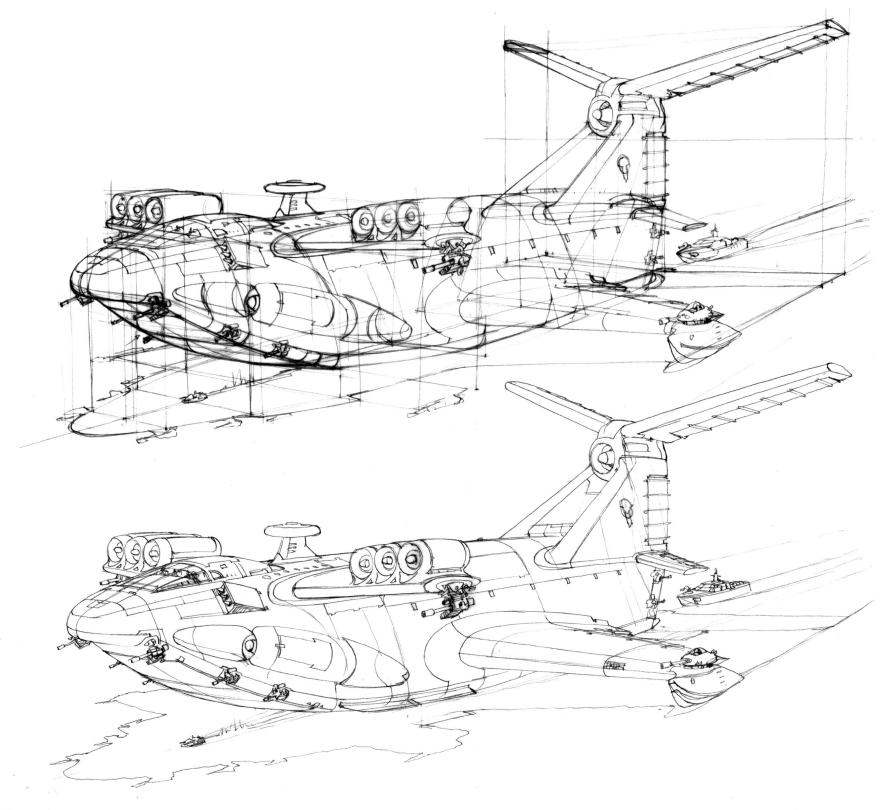

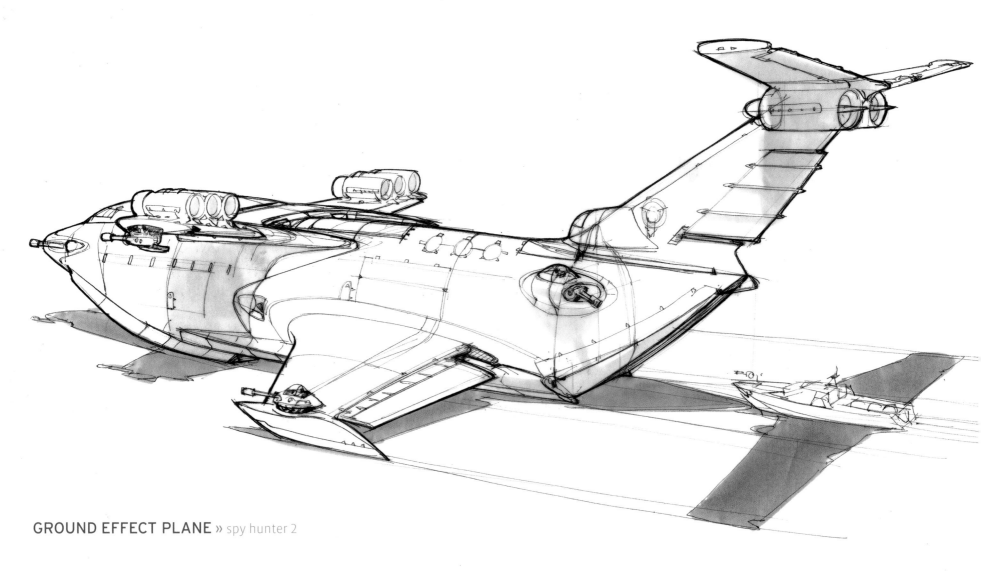

GROUND EFFECT PLANE » spy hunter 2

Above is one of my favorite sketches from this project. It has all of the things I like: an attractive design, a strong perspective, efficiency of line and varying line weights. As the perspective angle chosen here might make the tail and front wing a little hard to understand, the addition of the shadow using a marker is to help explain which parts of the plane overlap each other. I often add the shadow of the vehicle straight down as if the sun were directly above it to aid the viewer in understanding the top view. When doing industrial design or concept design jobs for the entertainment industry, it is very important to remember that the purpose of these drawings is to evaluate a design direction and, ultimately, to aid in the construction of the object. This

is why the sketches that have more cross-sections as a result of drawing through the form are often the more desired ones as a means to communicate to the model builders. This is the fundamental difference between drawing for illustration, where the drawing is the finished product and things like style, technique and composition are much more important, and drawing for industrial design where the sole function of the drawing is to communicate the forms of the object to a modeler. In a color rendering like the one to the right, the goal is to show the finished object as it will look when painted and lit directly by the sun.

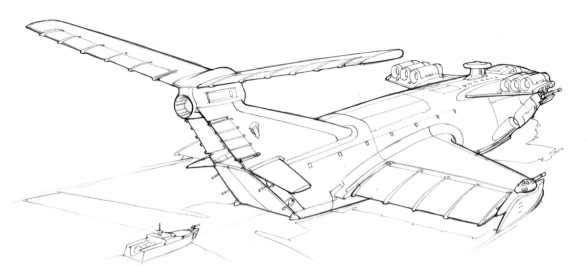

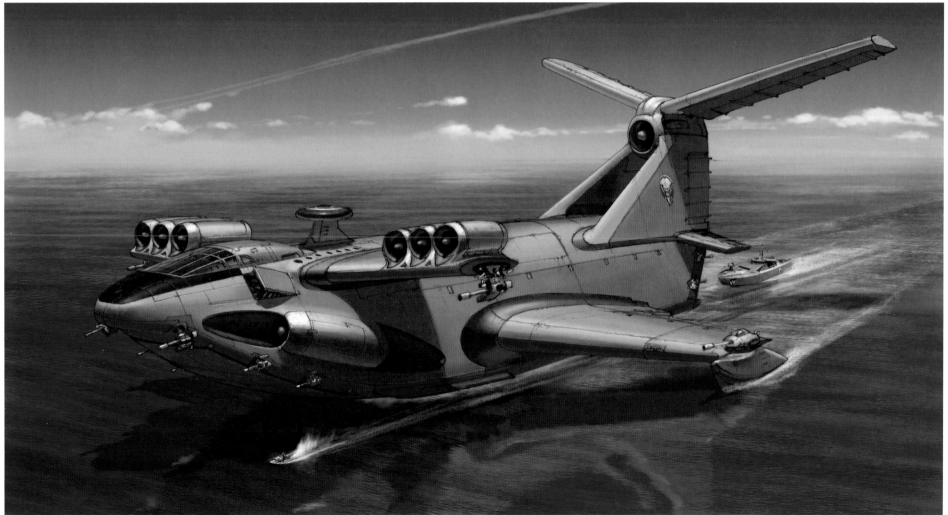

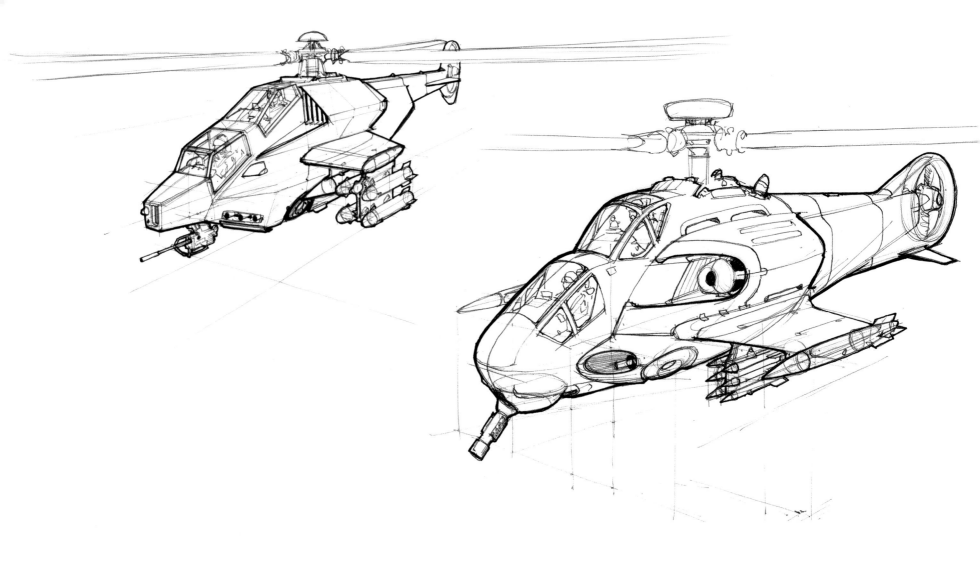

TWO-MAN GUNSHIP » spy hunter 2

Steven requested that I design a two-man helicopter gunship. Other than that, the styling goal remained the same for all of the bad-guy vehicles, which was to be slightly older looking and less high-tech than those of the good-guy *Spy Hunter* organization. I tried tandem seating on this page and side-by-side seating on the right page, which is where I hit on the double rotor design. We both thought this added a bit more power and menacing character to the design.

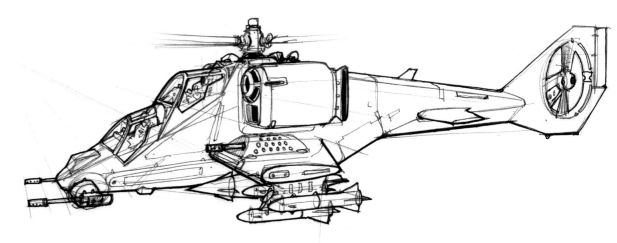

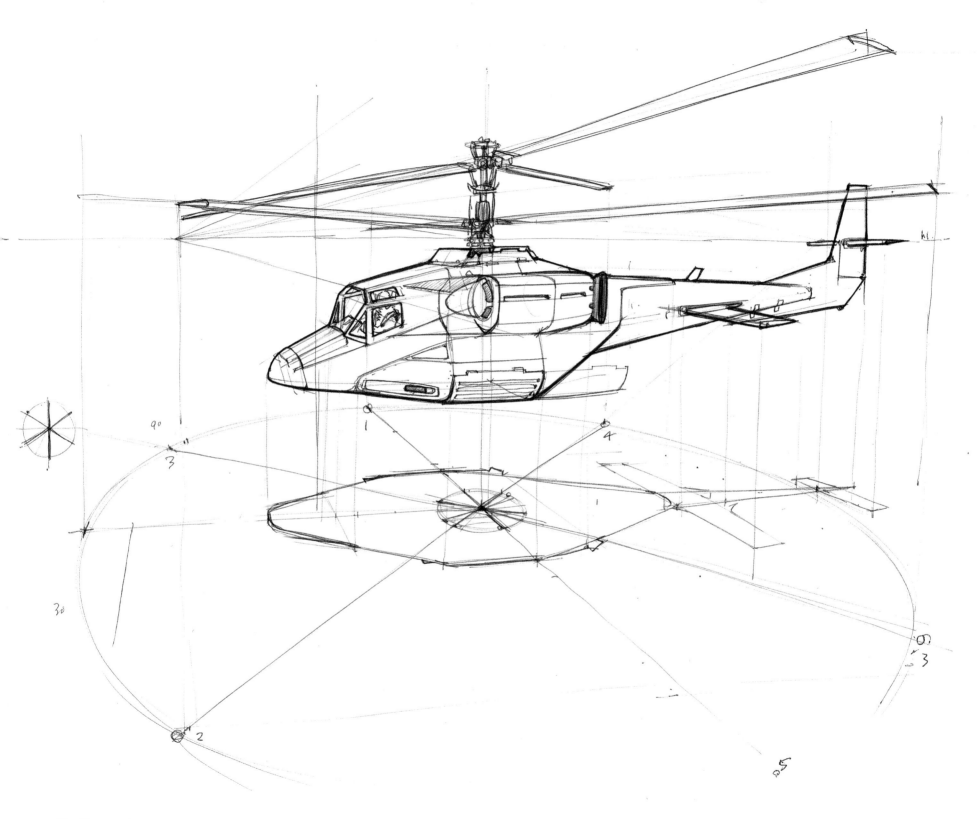

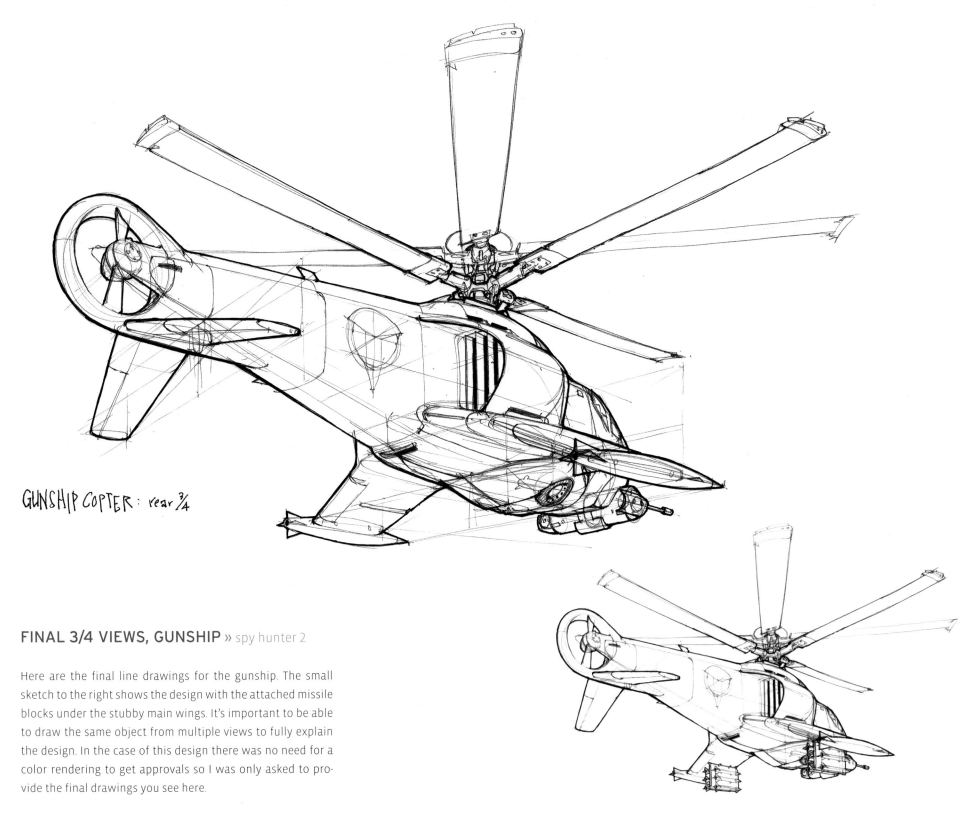

GUNSHIP COPTER: rear ¾

FINAL 3/4 VIEWS, GUNSHIP » spy hunter 2

Here are the final line drawings for the gunship. The small sketch to the right shows the design with the attached missile blocks under the stubby main wings. It's important to be able to draw the same object from multiple views to fully explain the design. In the case of this design there was no need for a color rendering to get approvals so I was only asked to provide the final drawings you see here.

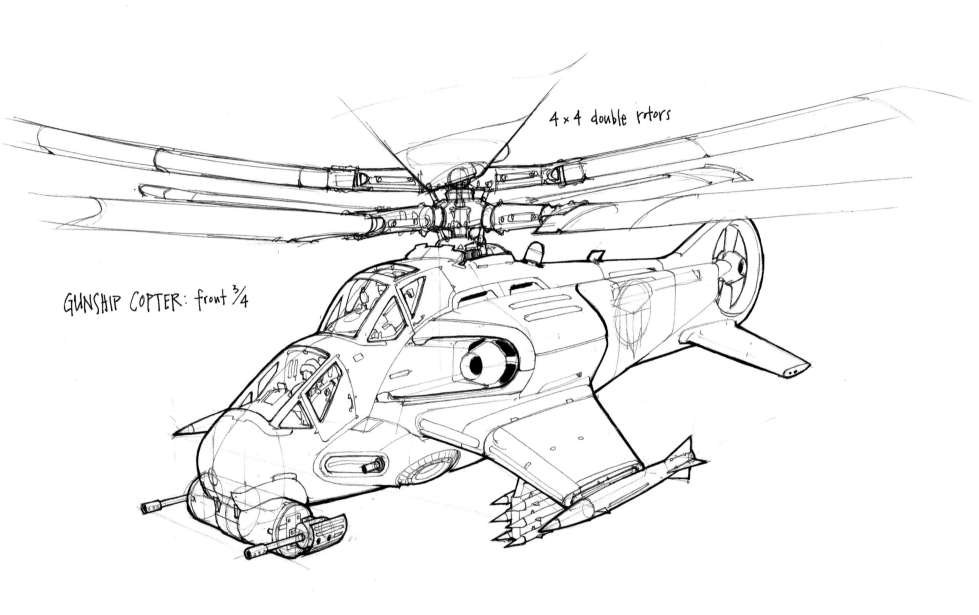

4 x 4 double rotors

GUNSHIP COPTER: front ¾

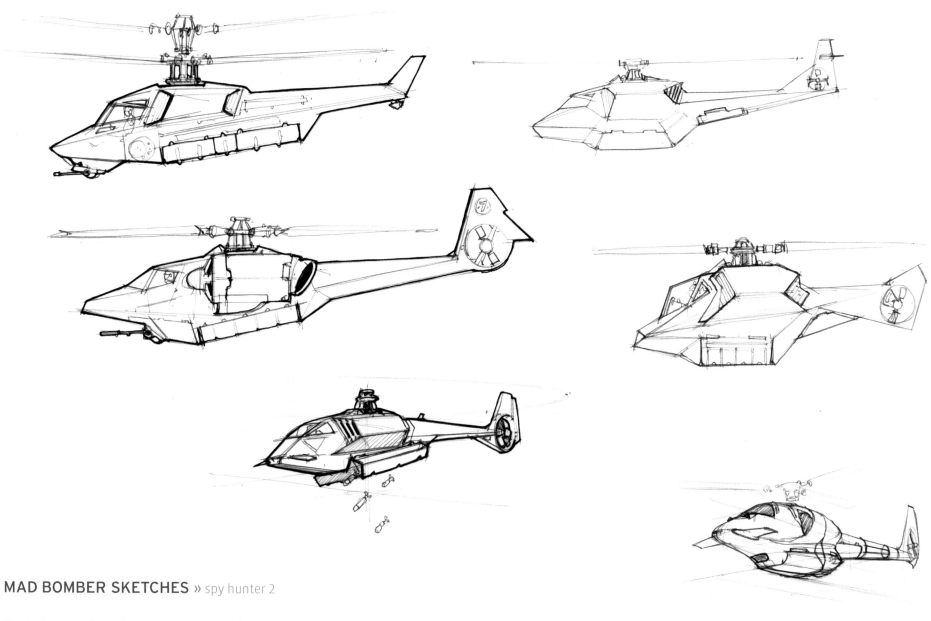

MAD BOMBER SKETCHES » spy hunter 2

The helicopter shown here is a one-seater. The goal was to make the silhouette look different than the two-man gunship. The primary function it performs in the game is to drop a bunch of small bombs, hence the name "the mad bomber." Whenever designing any object for a video game it is especially important to draw the object as it will be seen in the game. If you do not do this, you run the risk of wasting a lot of time designing something that may never be seen during the playing of the game.

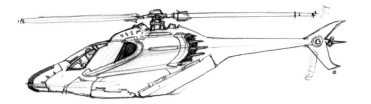

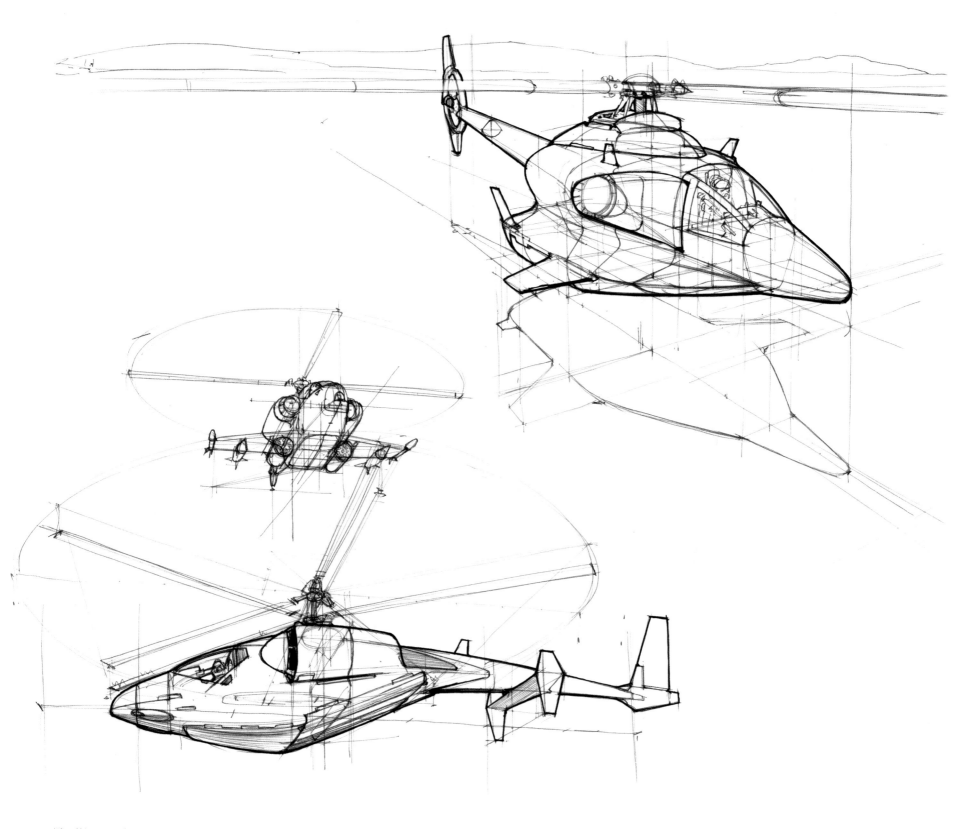

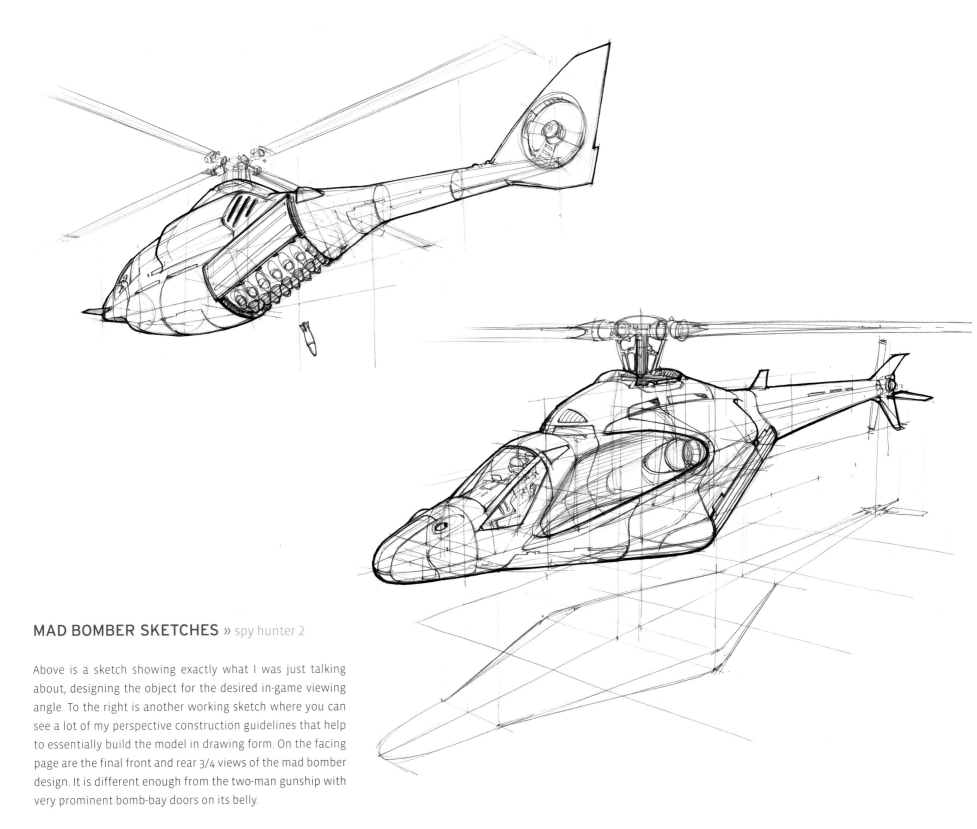

MAD BOMBER SKETCHES » spy hunter 2

Above is a sketch showing exactly what I was just talking about, designing the object for the desired in-game viewing angle. To the right is another working sketch where you can see a lot of my perspective construction guidelines that help to essentially build the model in drawing form. On the facing page are the final front and rear 3/4 views of the mad bomber design. It is different enough from the two-man gunship with very prominent bomb-bay doors on its belly.

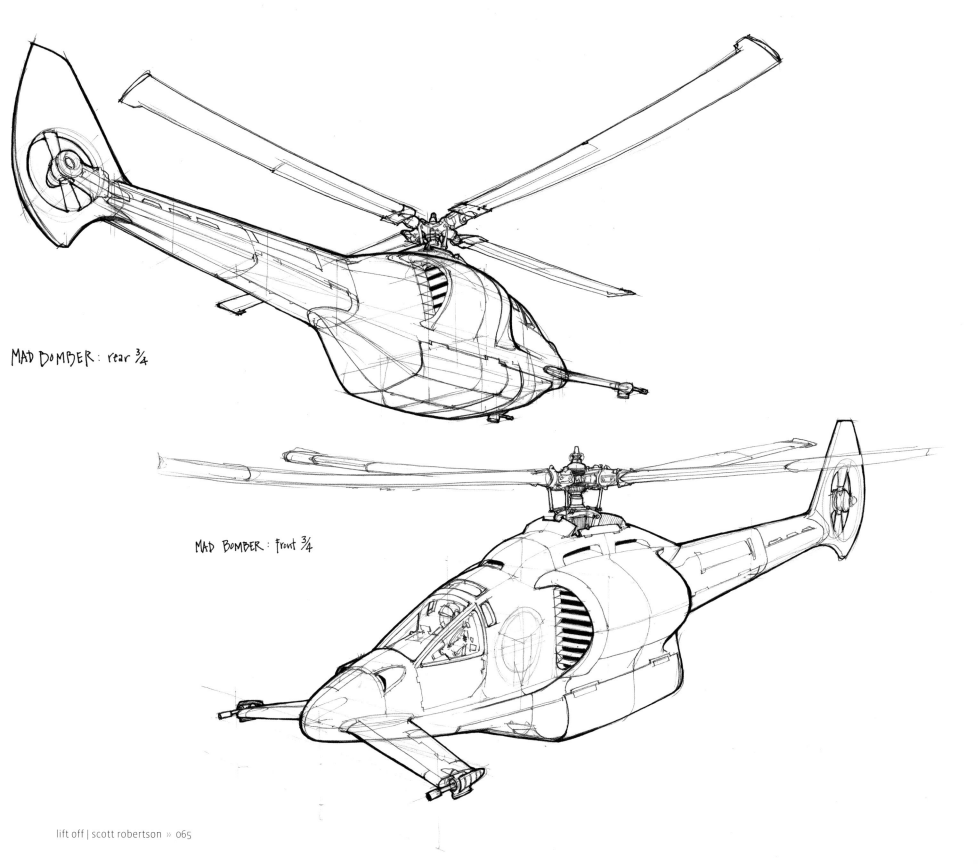

MAD BOMBER: rear ¾

MAD BOMBER: front ¾

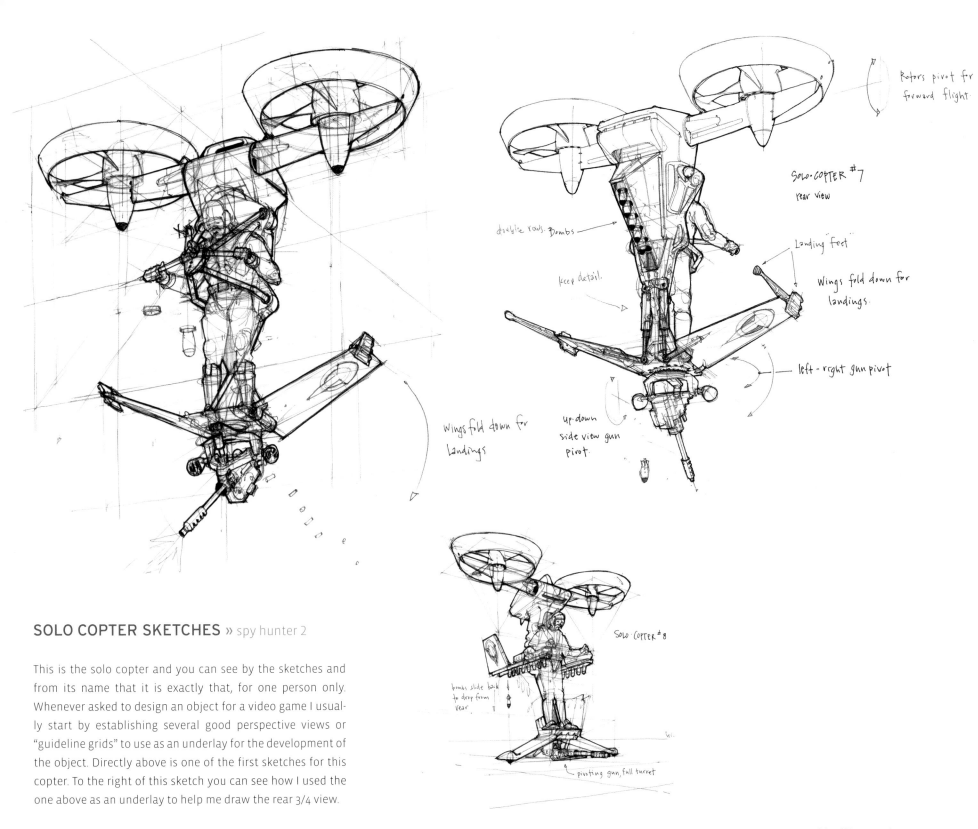

Rotors pivot for forward flight.

SOLO·COPTER #7
rear view

double rows. Bombs

Keep detail.

Landing feet

Wings fold down for landings.

left - right gun pivot

Wings fold down for landings

Up·down side view gun pivot.

SOLO·COPTER #8

bombs slide back to drop from rear

pivoting gun, full turret

SOLO COPTER SKETCHES » spy hunter 2

This is the solo copter and you can see by the sketches and from its name that it is exactly that, for one person only. Whenever asked to design an object for a video game I usually start by establishing several good perspective views or "guideline grids" to use as an underlay for the development of the object. Directly above is one of the first sketches for this copter. To the right of this sketch you can see how I used the one above as an underlay to help me draw the rear 3/4 view.

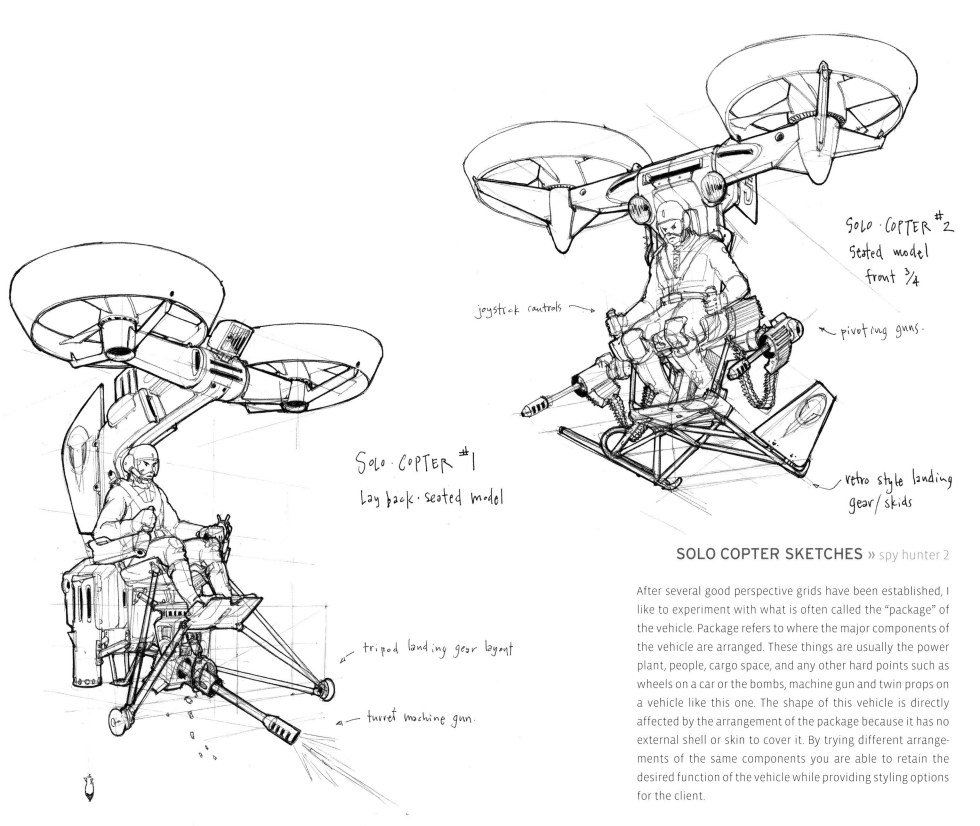

SOLO·COPTER #1
Lay back·seated model

joystick controls

SOLO·COPTER #2
Seated model
front ¾

← pivoting guns.

← tripod landing gear layout

← turret machine gun.

retro style landing
gear/skids

SOLO COPTER SKETCHES » spy hunter 2

After several good perspective grids have been established, I like to experiment with what is often called the "package" of the vehicle. Package refers to where the major components of the vehicle are arranged. These things are usually the power plant, people, cargo space, and any other hard points such as wheels on a car or the bombs, machine gun and twin props on a vehicle like this one. The shape of this vehicle is directly affected by the arrangement of the package because it has no external shell or skin to cover it. By trying different arrangements of the same components you are able to retain the desired function of the vehicle while providing styling options for the client.

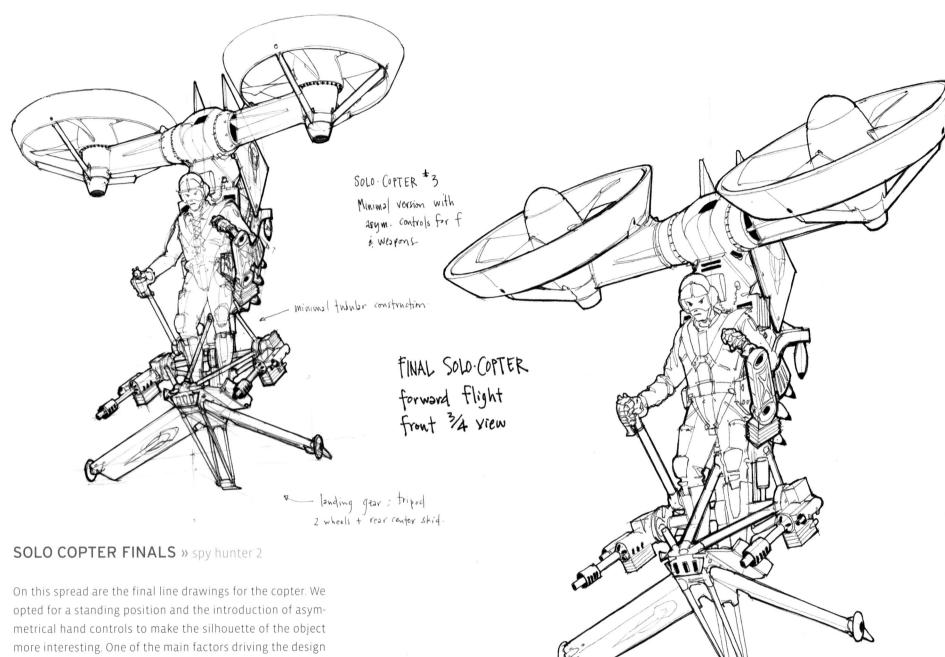

SOLO·COPTER #3
Minimal version with
asym. controls for f
& weapons

minimal tubular construction

FINAL SOLO·COPTER
forward flight
front 3/4 view

landing gear : tripod
2 wheels + rear center skid.

SOLO COPTER FINALS » spy hunter 2

On this spread are the final line drawings for the copter. We
opted for a standing position and the introduction of asym-
metrical hand controls to make the silhouette of the object
more interesting. One of the main factors driving the design
of the little tracks on the back that carry the bombs up to the
drop position was that Steven wanted to have these little
bombs visible from many different angles; this direction was
chosen because it accomplished this goal. In the color sketch
to the right the design really becomes more about the sil-
houette than anything else when painted dark against a
bright sky.

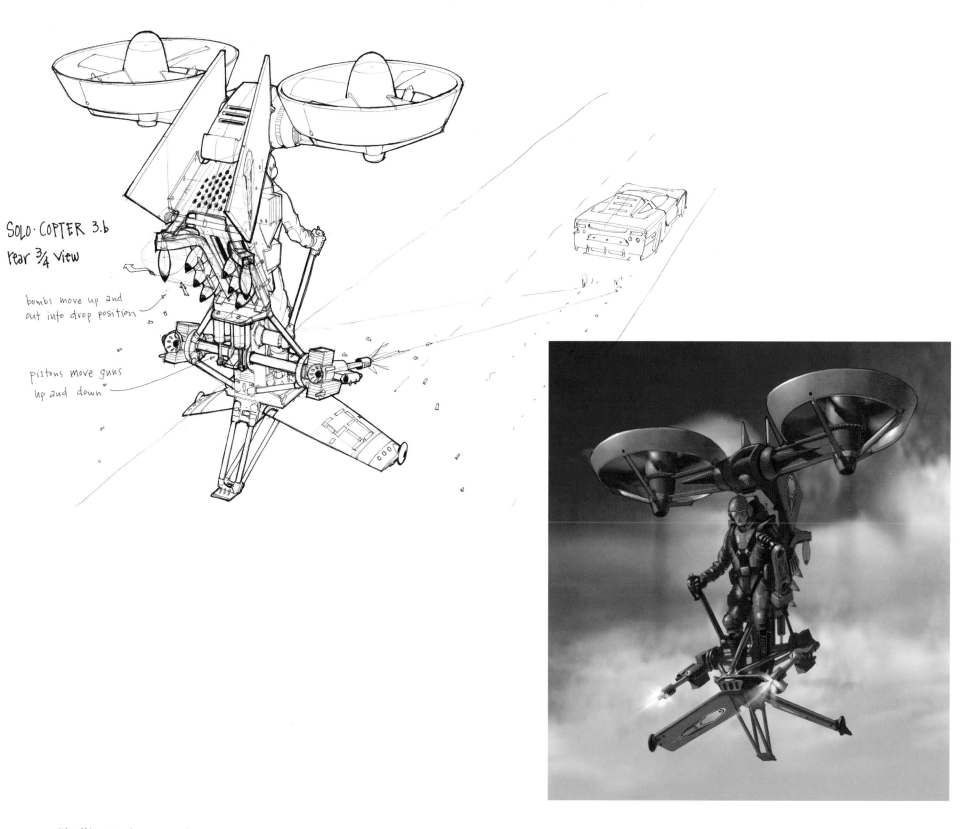

SOLO·COPTER 3.b
rear ¾ view

bombs move up and
out into drop position

pistons move guns
up and down

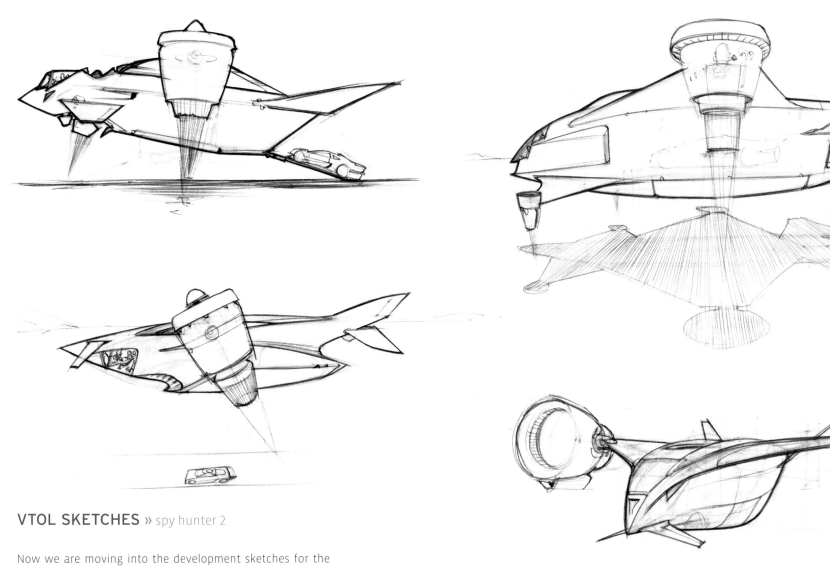

VTOL SKETCHES » spy hunter 2

Now we are moving into the development sketches for the VTOL, which stands for "vertical take-off and landing." This vehicle was developed early on in the project and was the second vehicle I designed after the weapons van shown in *Start Your Engines*. This VTOL is for the service and re-supply of the hero car. It's a good-guy vehicle and so the desired aesthetic was to be more high-tech than that of the bad-guy vehicles. The blue you see on the sketches is non-photo blue pencil which is an old comic book technique in which making a black and white copy of the sketch will cause the blue to disappear, leaving you with a nicer looking sketch. This allows for exploration and roughing out the sketch before you commit to darkening it with the black pen.

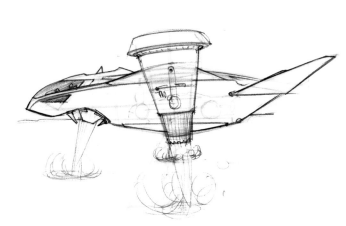

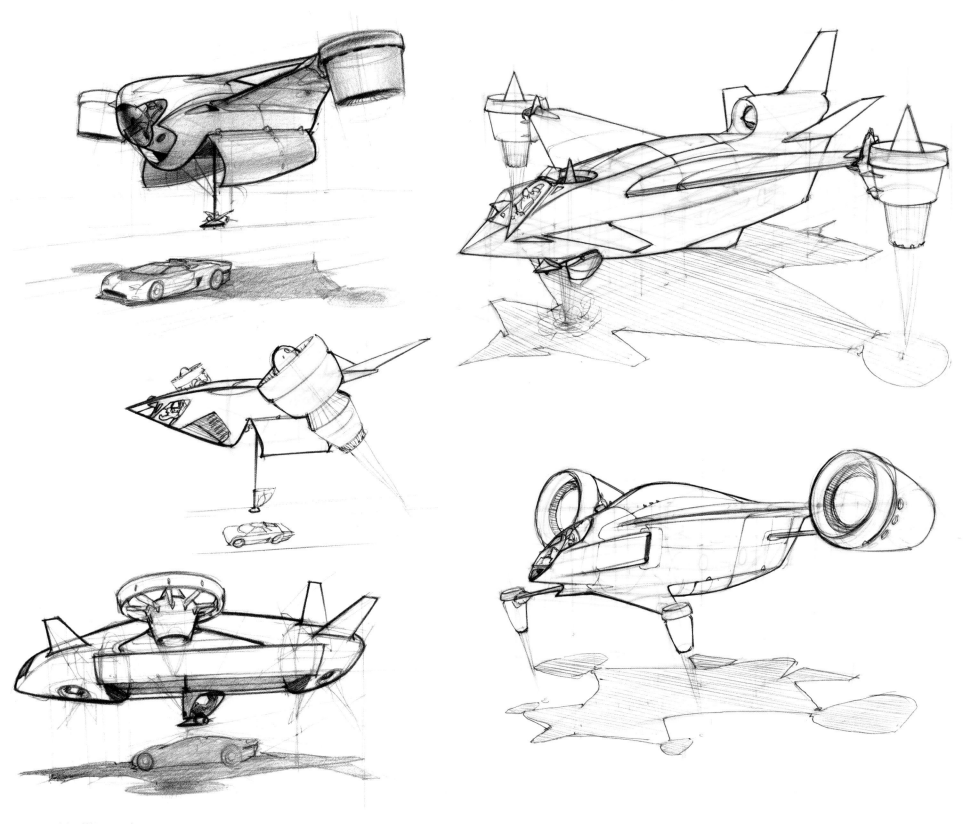

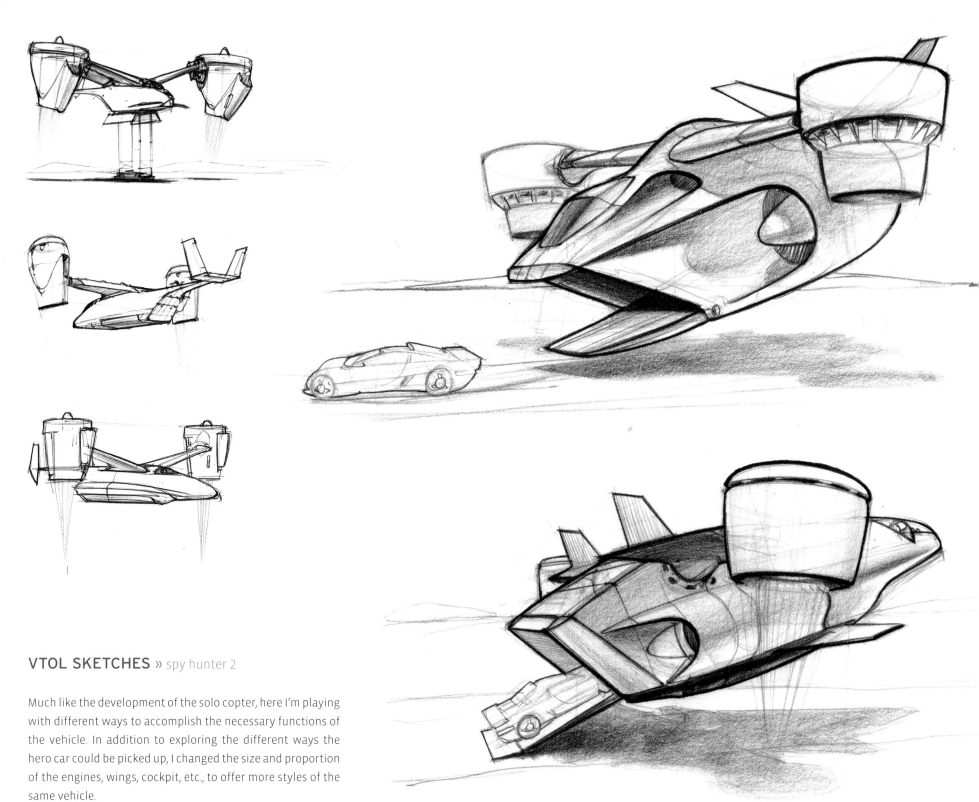

VTOL SKETCHES » spy hunter 2

Much like the development of the solo copter, here I'm playing with different ways to accomplish the necessary functions of the vehicle. In addition to exploring the different ways the hero car could be picked up, I changed the size and proportion of the engines, wings, cockpit, etc., to offer more styles of the same vehicle.

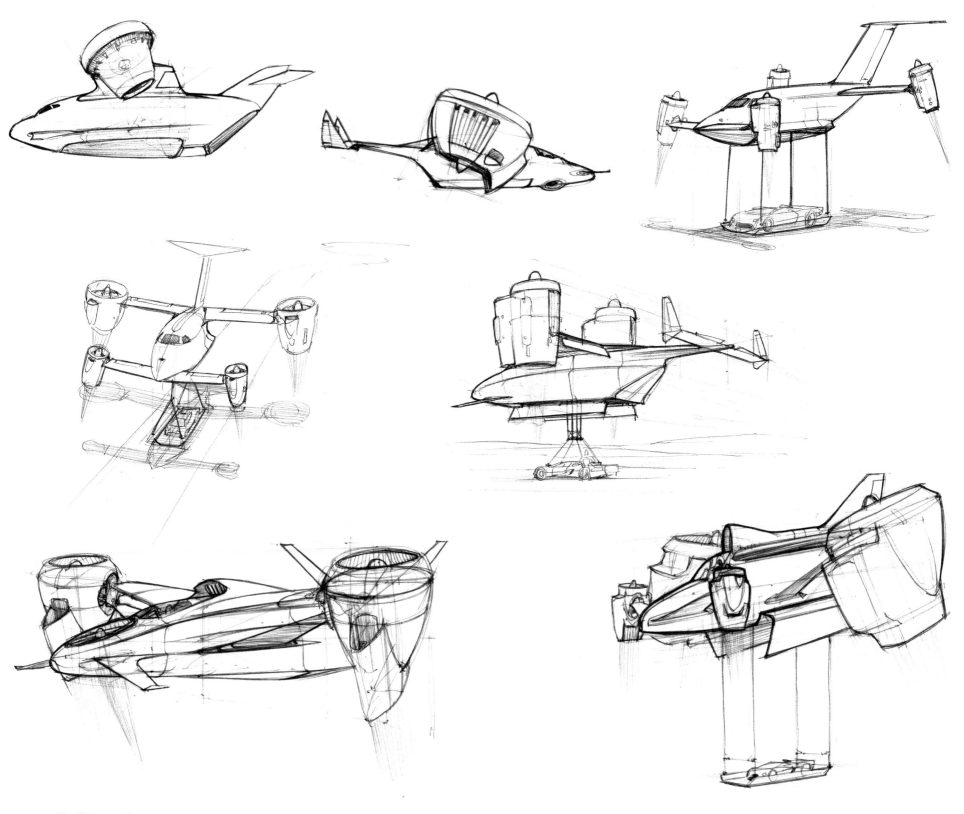

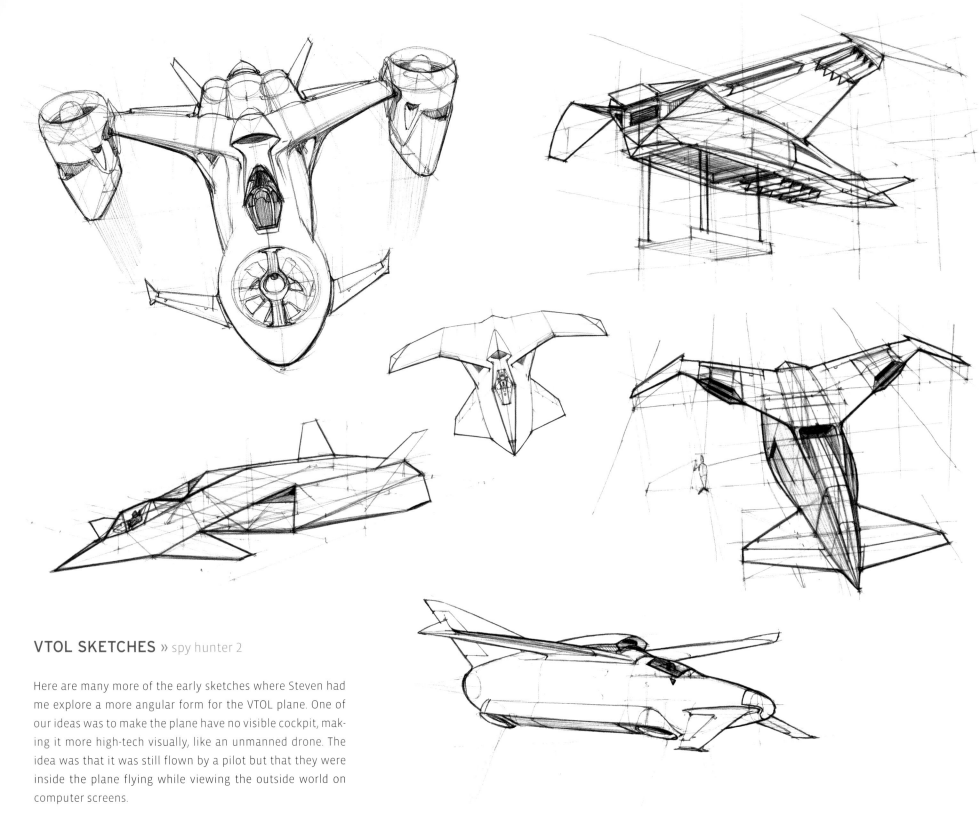

VTOL SKETCHES » spy hunter 2

Here are many more of the early sketches where Steven had me explore a more angular form for the VTOL plane. One of our ideas was to make the plane have no visible cockpit, making it more high-tech visually, like an unmanned drone. The idea was that it was still flown by a pilot but that they were inside the plane flying while viewing the outside world on computer screens.

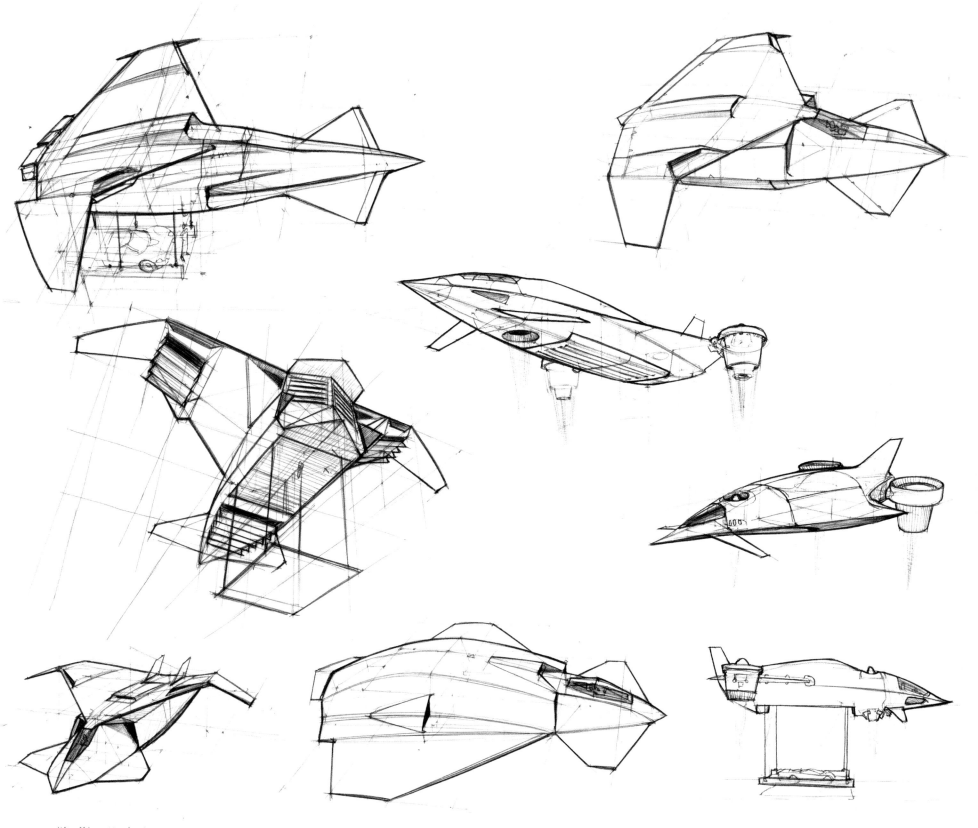

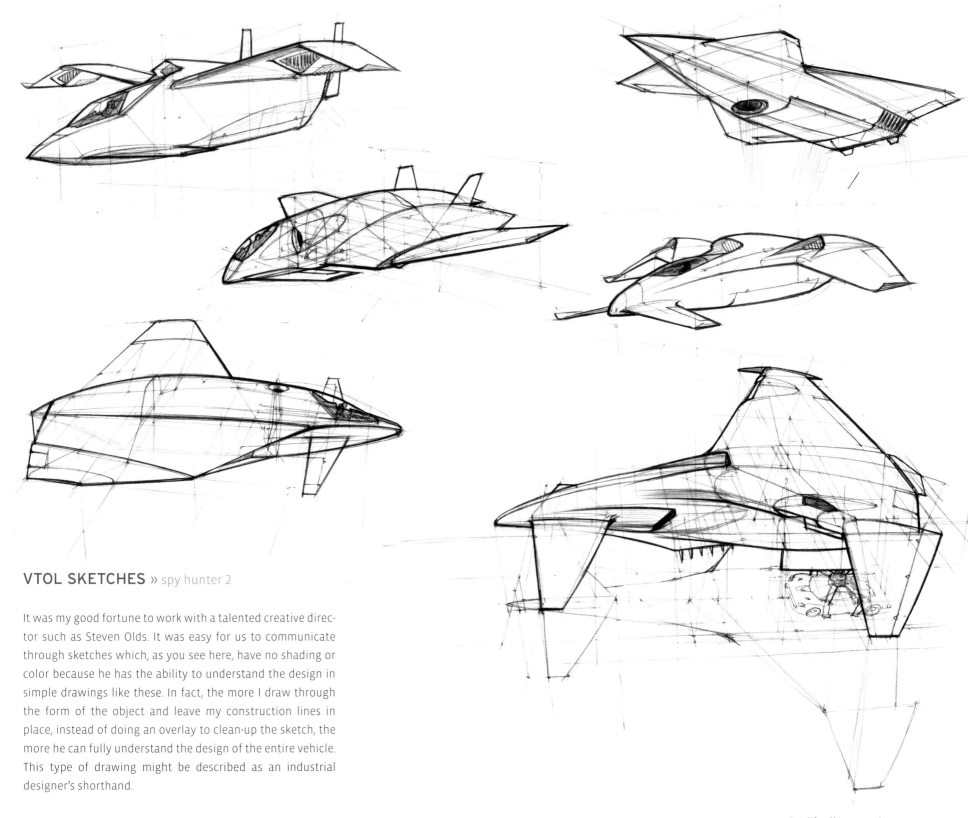

VTOL SKETCHES » spy hunter 2

It was my good fortune to work with a talented creative director such as Steven Olds. It was easy for us to communicate through sketches which, as you see here, have no shading or color because he has the ability to understand the design in simple drawings like these. In fact, the more I draw through the form of the object and leave my construction lines in place, instead of doing an overlay to clean-up the sketch, the more he can fully understand the design of the entire vehicle. This type of drawing might be described as an industrial designer's shorthand.

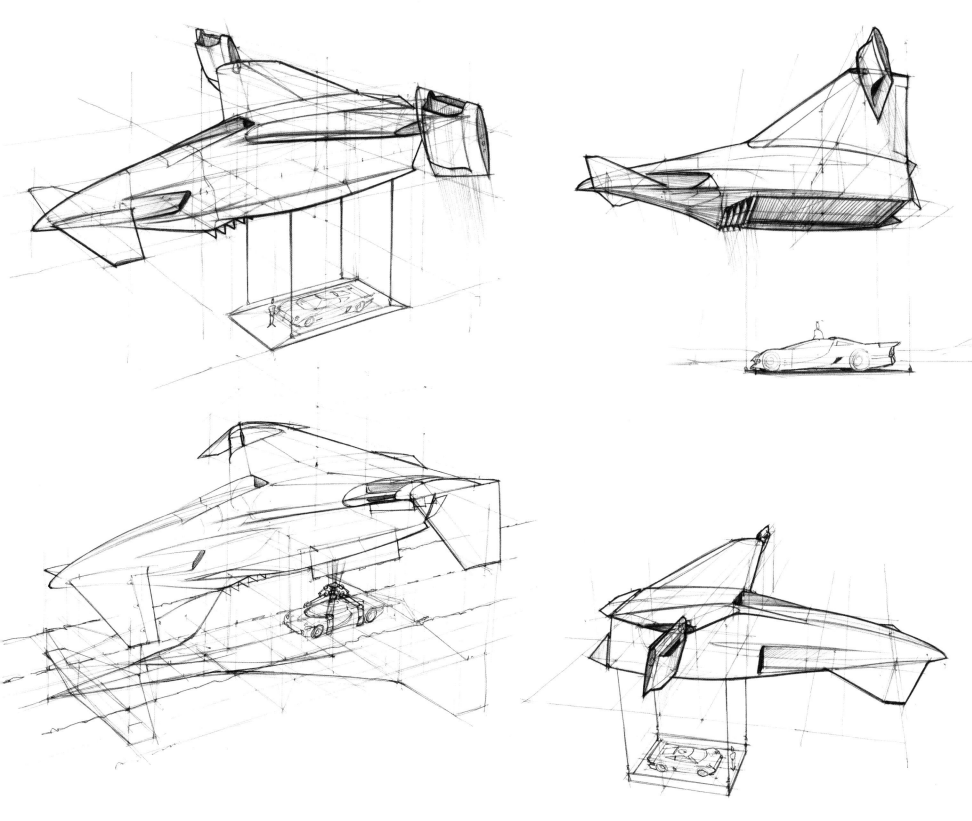

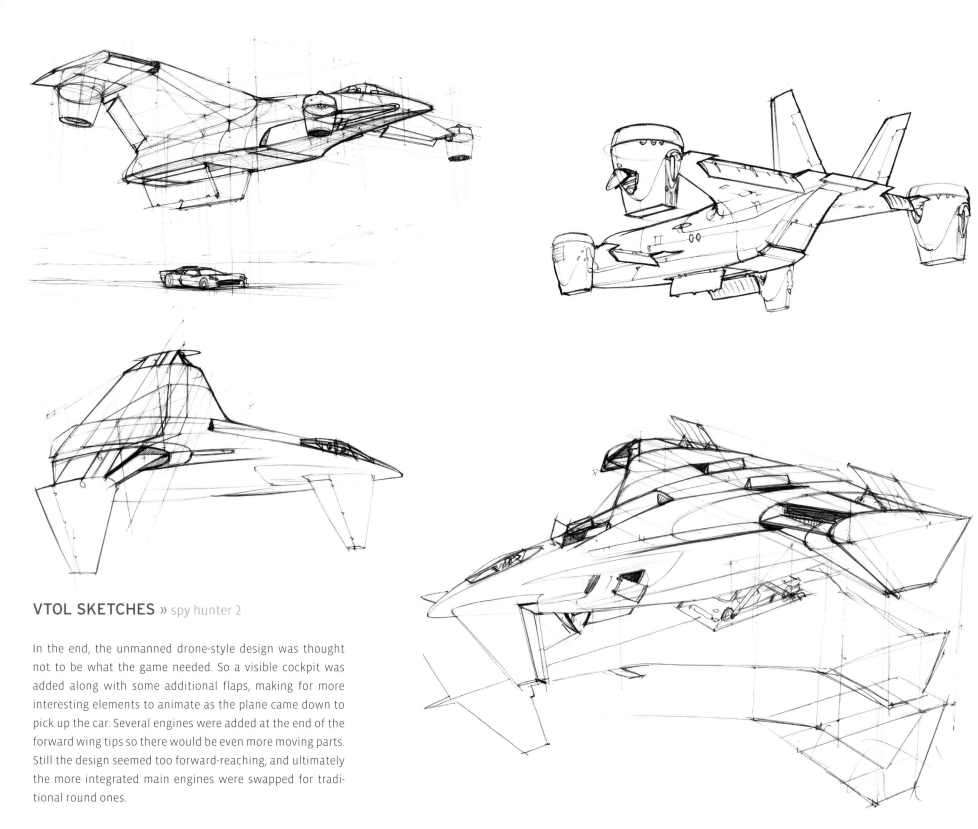

VTOL SKETCHES » spy hunter 2

In the end, the unmanned drone-style design was thought not to be what the game needed. So a visible cockpit was added along with some additional flaps, making for more interesting elements to animate as the plane came down to pick up the car. Several engines were added at the end of the forward wing tips so there would be even more moving parts. Still the design seemed too forward-reaching, and ultimately the more integrated main engines were swapped for traditional round ones.

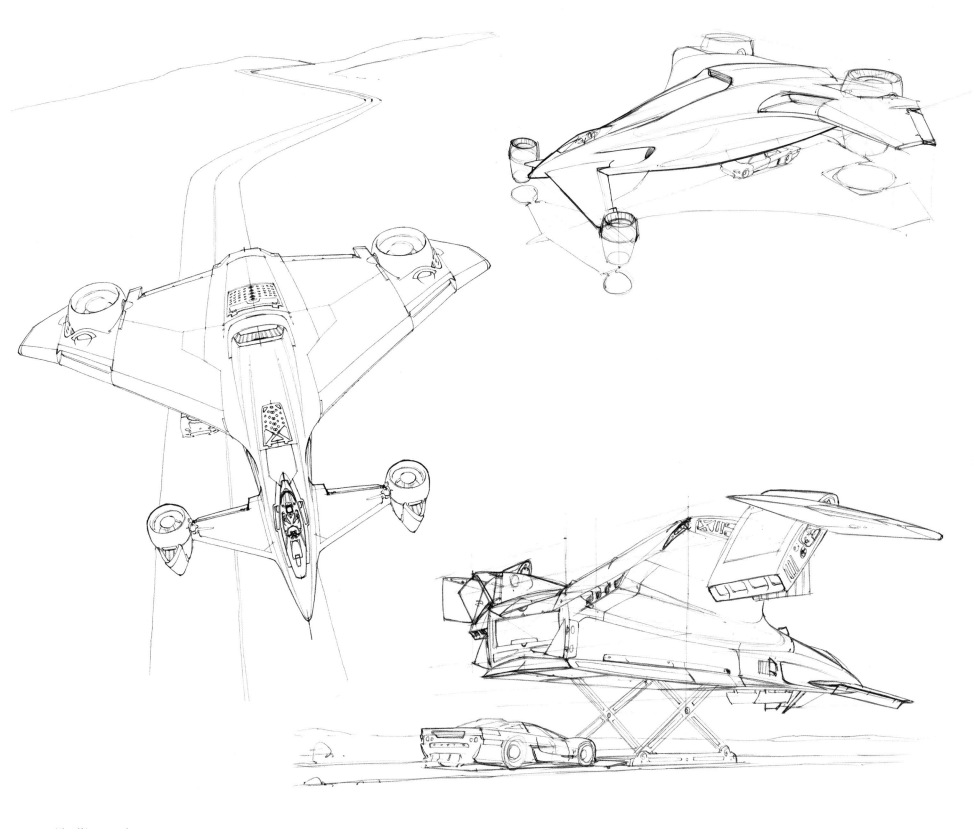

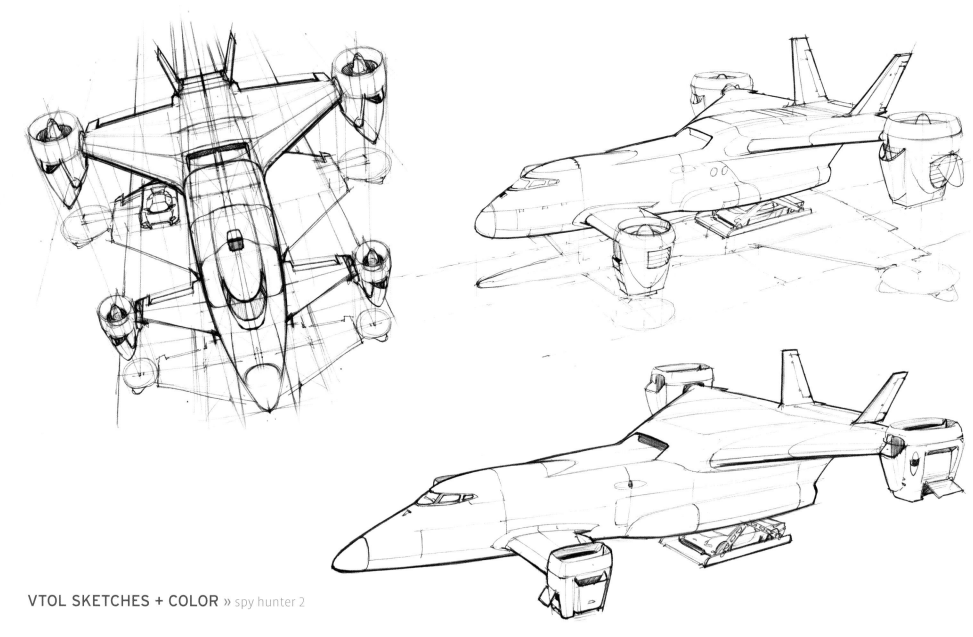

VTOL SKETCHES + COLOR » spy hunter 2

On the right page is the final VTOL design for the game. Along the way we took a little side departure into exploring a much more traditional-looking sort of cargo-style VTOL plane (shown above). Eventually, a balance was struck between the two directions. The color of the plane was the same as that of the weapons van, a matte-metallic grey finish. It was not required that I add a background to any of the color sketches done for this project but I could not resist. A couple of beneficial things happen when you add a background to the color sketch of a vehicle. It can add a narrative to the sketch, providing more infor-

mation about the function of the object, such as in the piece to the right where the VTOL plane is swooping down to pick the car off the dam. It also makes it much easier to render shiny surfaces. This is because when you render an object that has bright reflective highlights against a background with value, it will always look shinier than when it is rendered against a white background. When the eye can see what is reflected from the background into the surface of the vehicle, the reflections are much easier to understand.

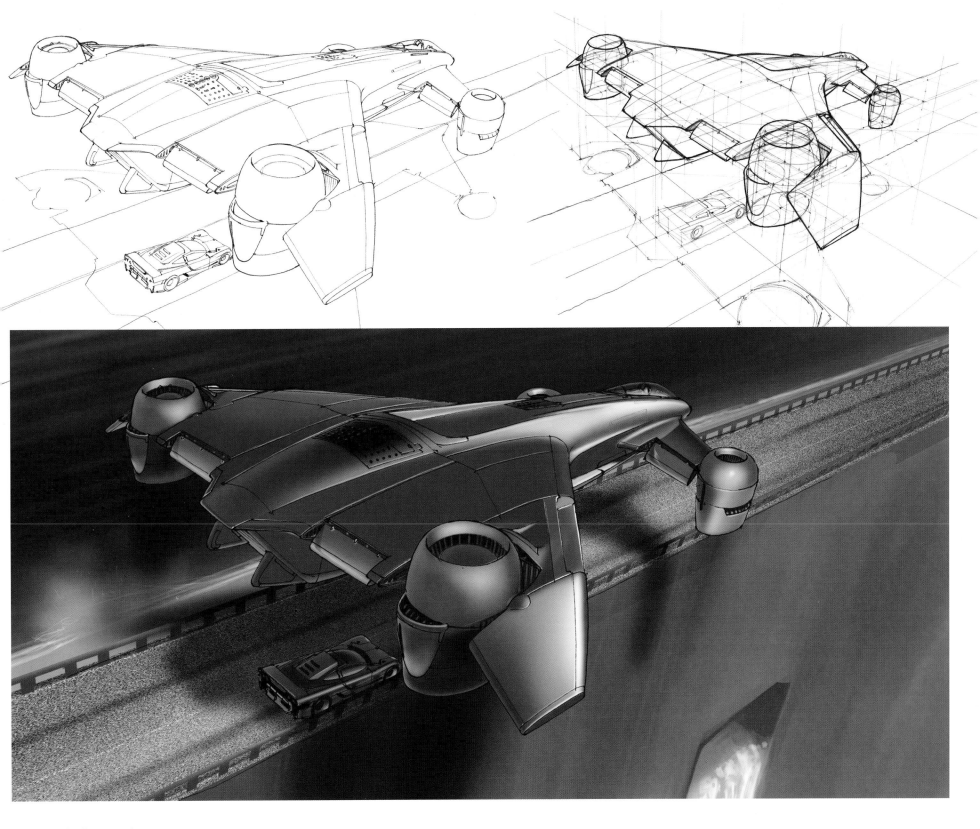

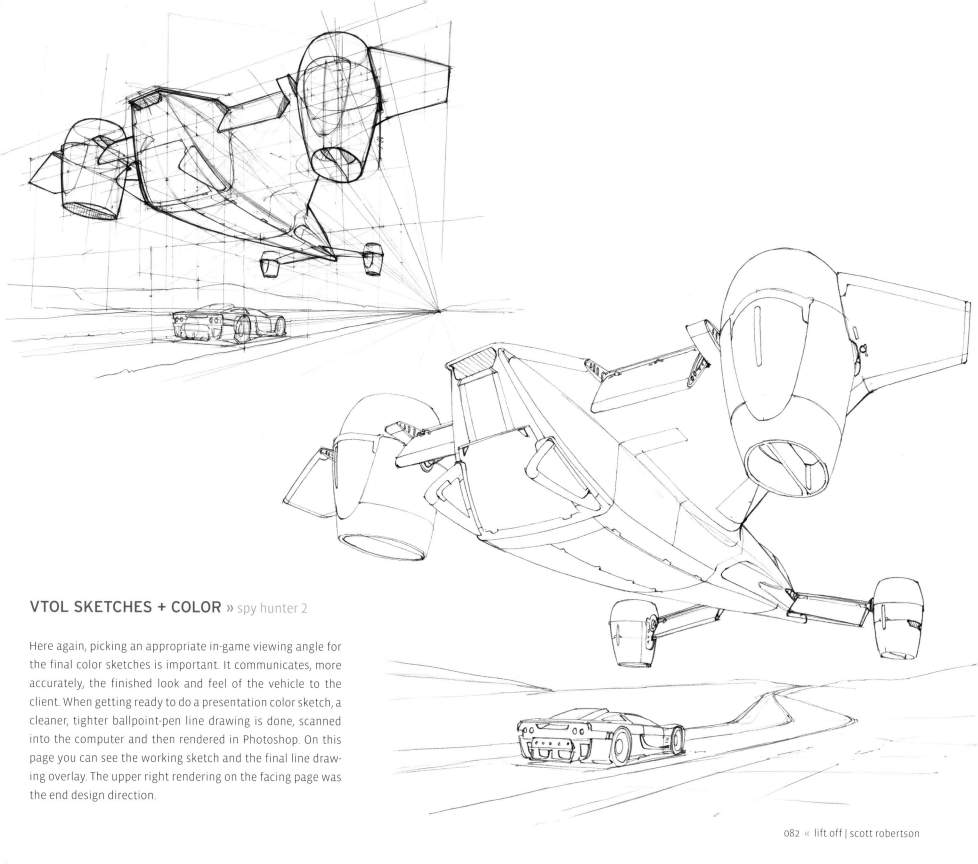

VTOL SKETCHES + COLOR » spy hunter 2

Here again, picking an appropriate in-game viewing angle for
the final color sketches is important. It communicates, more
accurately, the finished look and feel of the vehicle to the
client. When getting ready to do a presentation color sketch, a
cleaner, tighter ballpoint-pen line drawing is done, scanned
into the computer and then rendered in Photoshop. On this
page you can see the working sketch and the final line draw-
ing overlay. The upper right rendering on the facing page was
the end design direction.

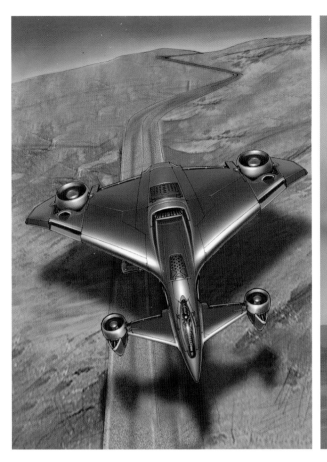

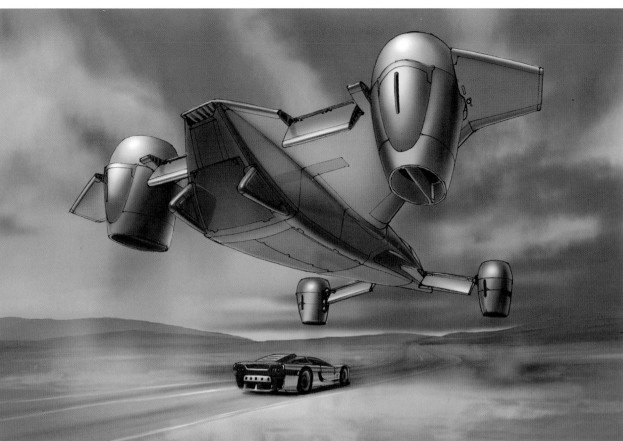

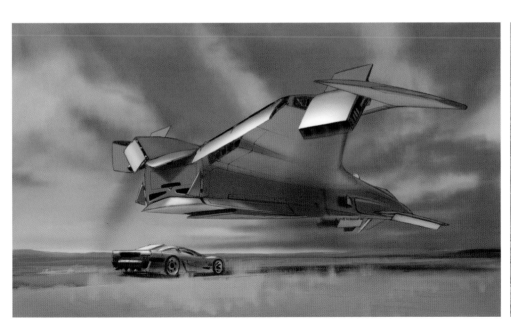

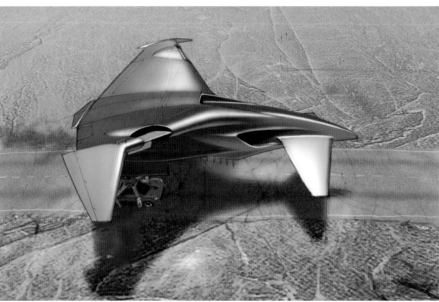

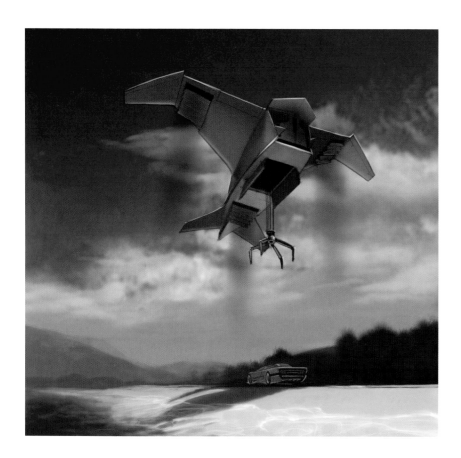

VTOL SKETCH-RENDERINGS » spy hunter 2

Here are the rest of the color sketches that were done over the course of the VTOL plane's development. All of these renderings are what I call sketch-renderings. By this I mean that they all have the original line drawing still visible in the final rendering, helping to hold the vehicle together. The plane in the green one is the only exception to this. Again, adding the backgrounds, even though not required, helps to give the plane context. Also when rendering the shinier highlights, having the background value and color greatly aid in giving the viewer the sense that the object is metallic. My favorites of these are the green one on this page and the lower right one on the facing page. On the green one I like the idea of this big claw coming down through the trees to grab the hero car and hoist it up into the belly of the plane. On the other favorite I like thinking about the plane animated with all of the moving flaps.

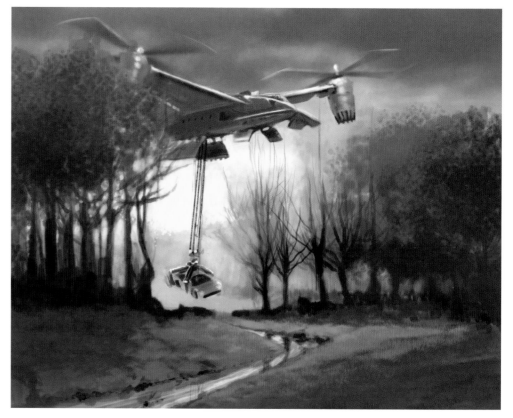

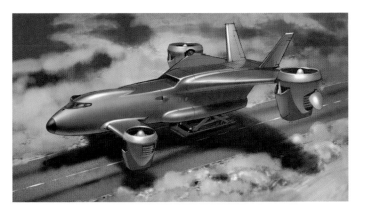

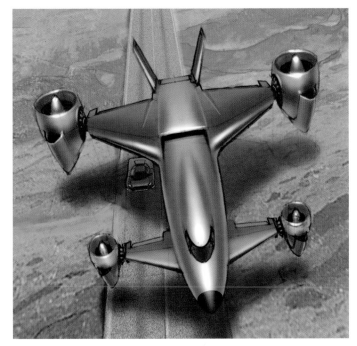

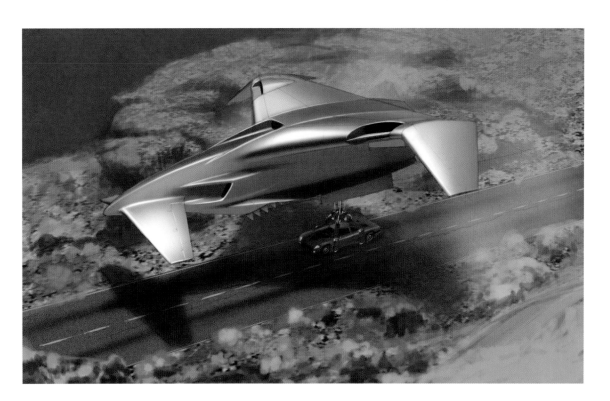

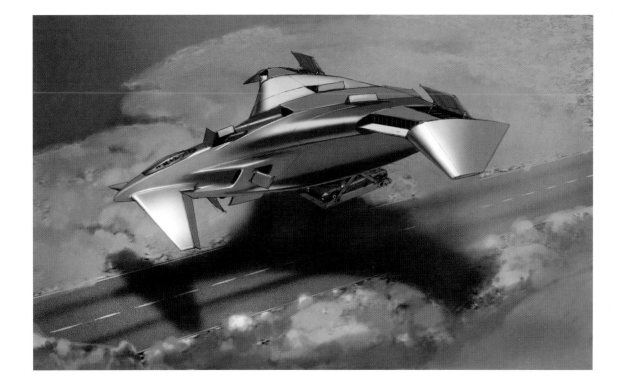

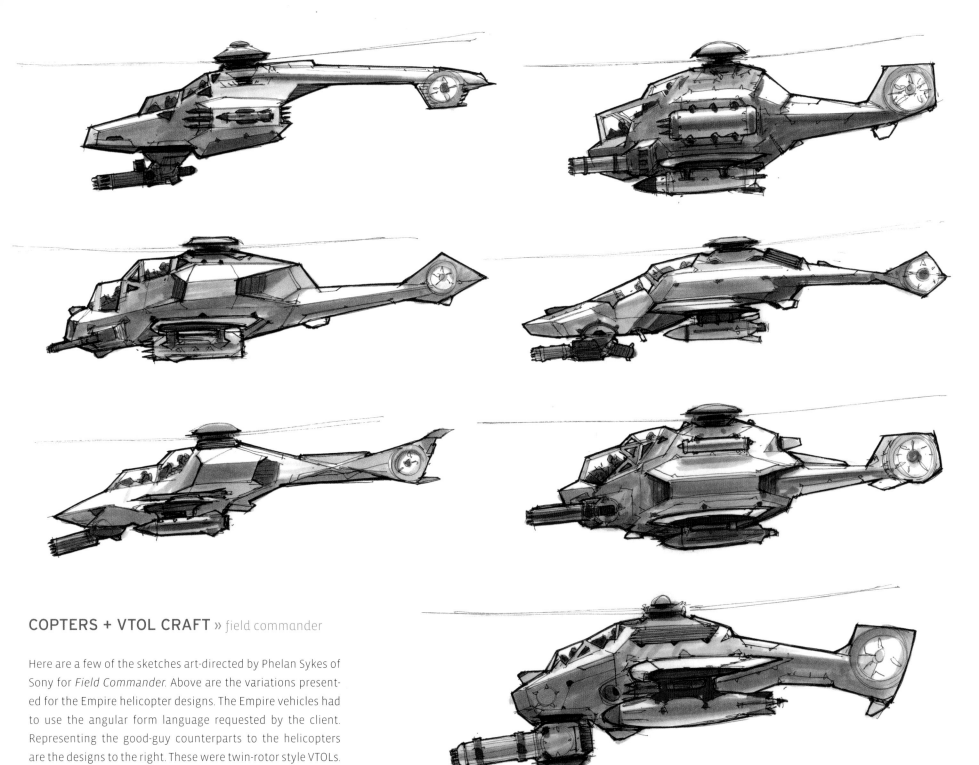

COPTERS + VTOL CRAFT » field commander

Here are a few of the sketches art-directed by Phelan Sykes of Sony for *Field Commander*. Above are the variations presented for the Empire helicopter designs. The Empire vehicles had to use the angular form language requested by the client. Representing the good-guy counterparts to the helicopters are the designs to the right. These were twin-rotor style VTOLs. All of the sketches seen on this spread were drawn with Copic markers and Pilot, Hi-Tec-C pens.

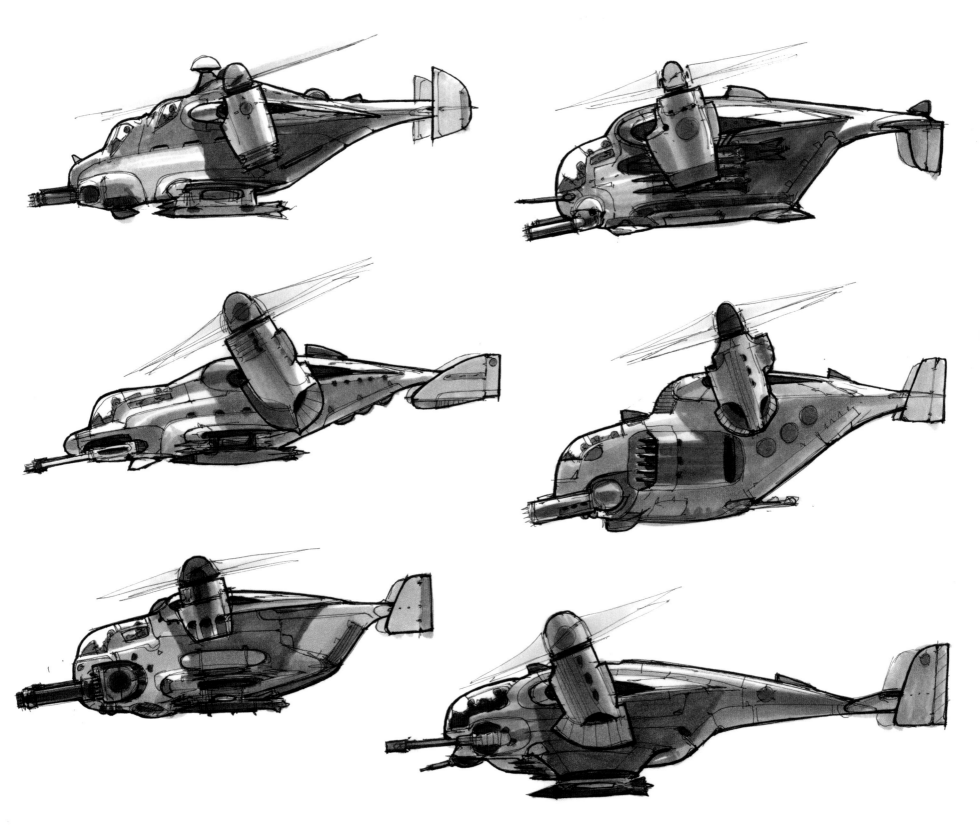

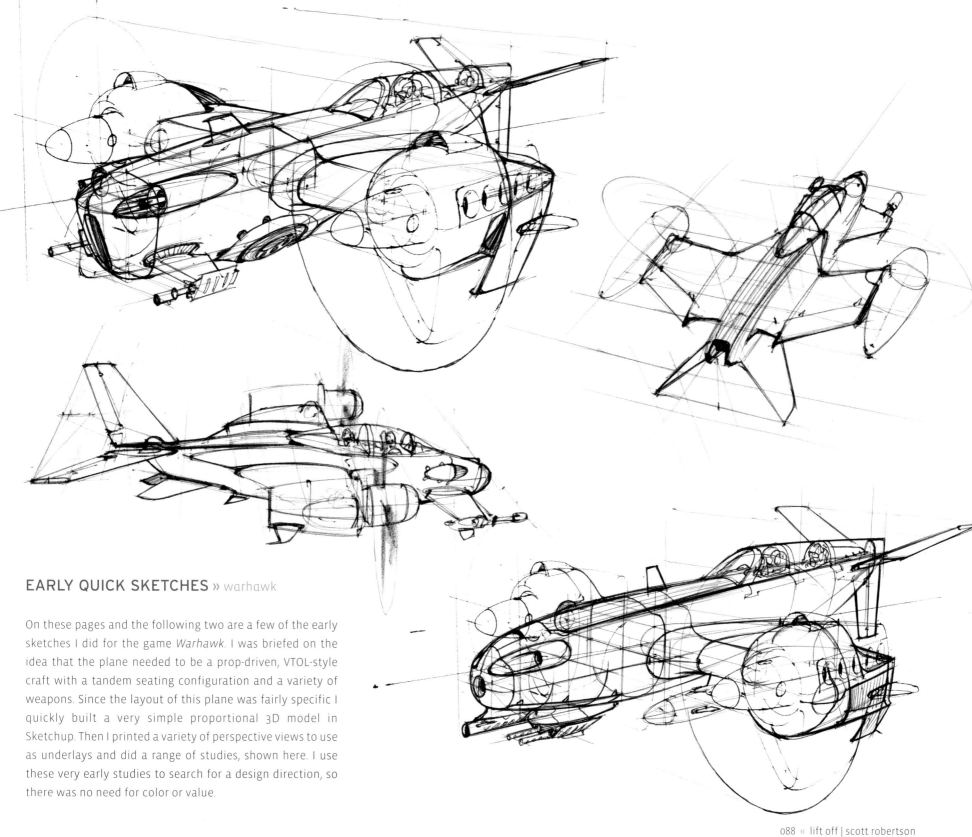

EARLY QUICK SKETCHES » warhawk

On these pages and the following two are a few of the early sketches I did for the game *Warhawk*. I was briefed on the idea that the plane needed to be a prop-driven, VTOL-style craft with a tandem seating configuration and a variety of weapons. Since the layout of this plane was fairly specific I quickly built a very simple proportional 3D model in Sketchup. Then I printed a variety of perspective views to use as underlays and did a range of studies, shown here. I use these very early studies to search for a design direction, so there was no need for color or value.

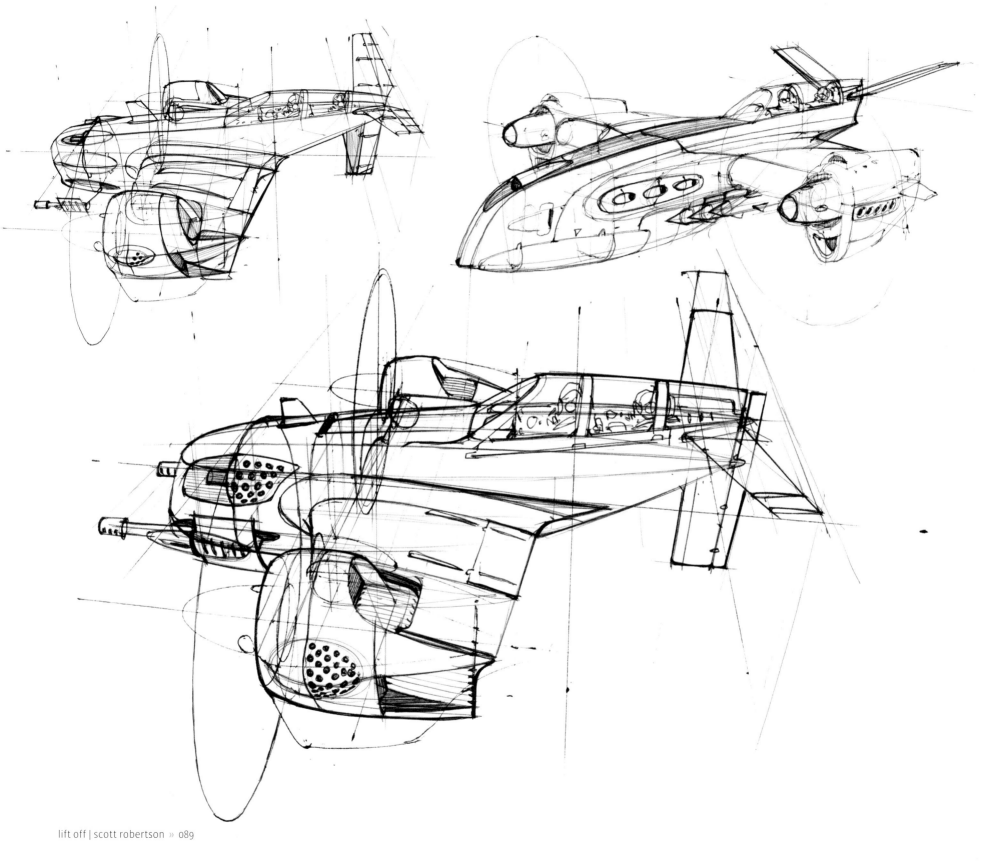

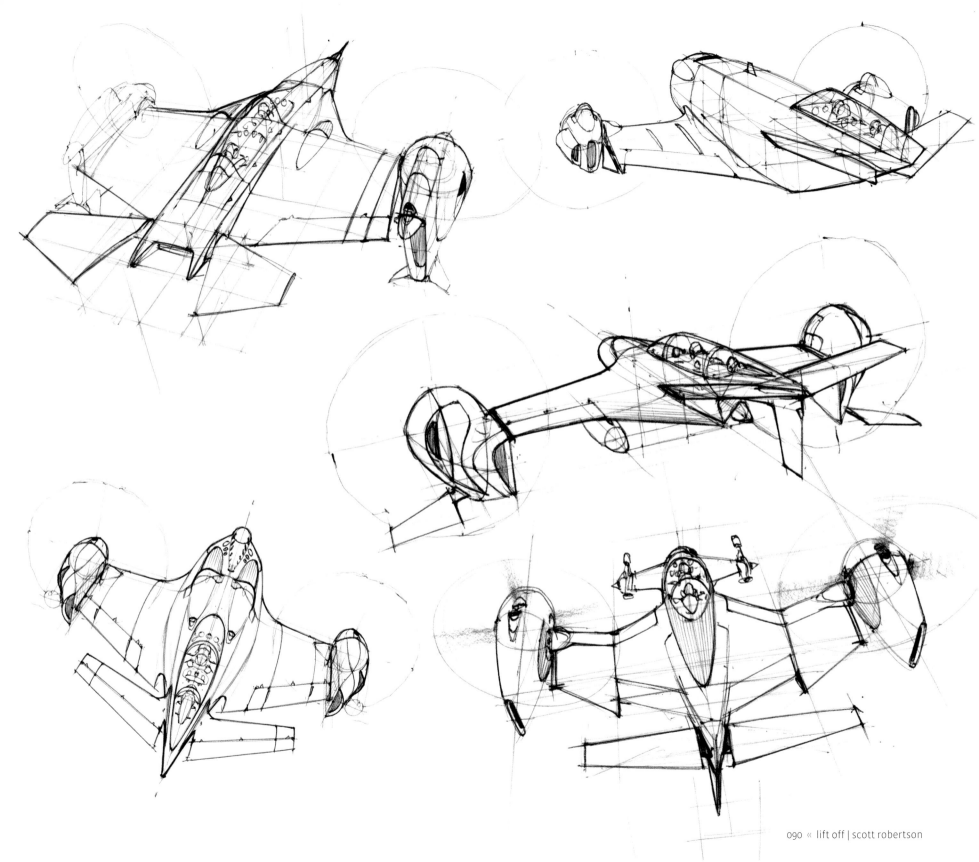

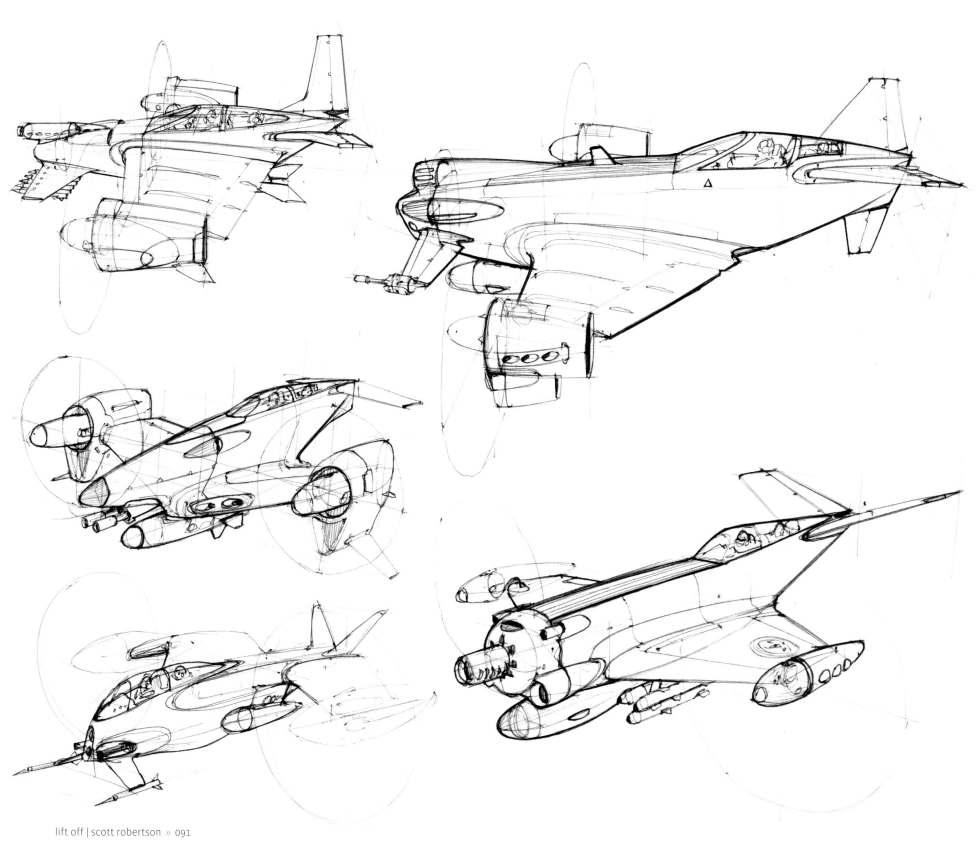

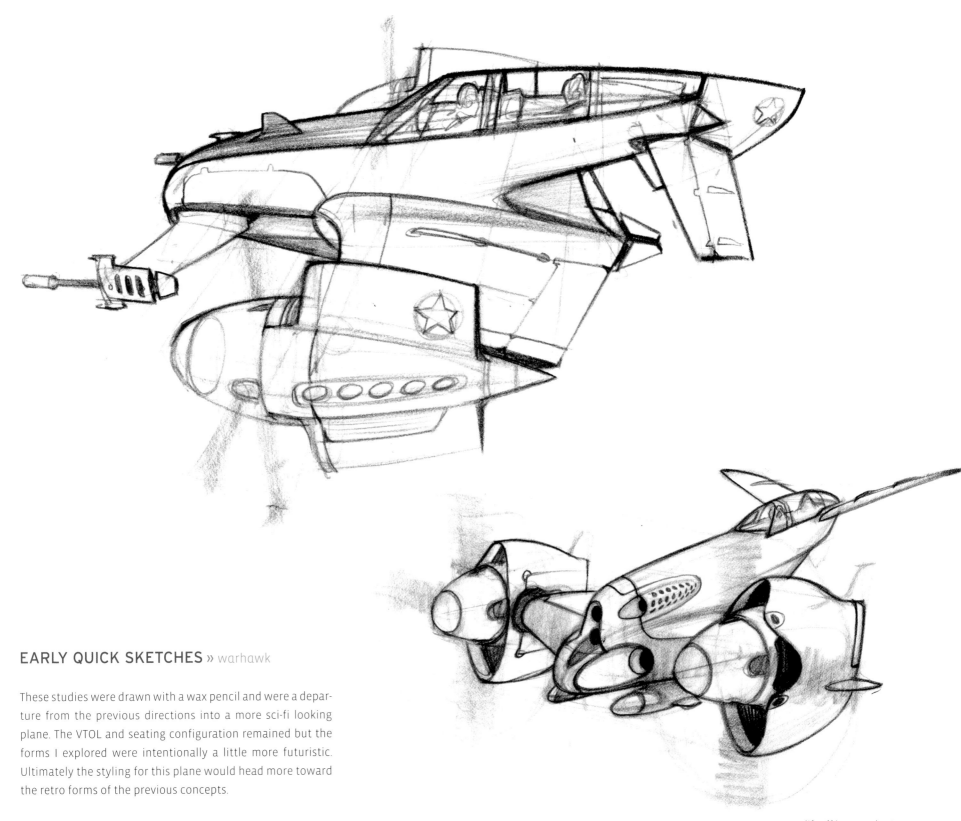

EARLY QUICK SKETCHES » warhawk

These studies were drawn with a wax pencil and were a departure from the previous directions into a more sci-fi looking plane. The VTOL and seating configuration remained but the forms I explored were intentionally a little more futuristic. Ultimately the styling for this plane would head more toward the retro forms of the previous concepts.

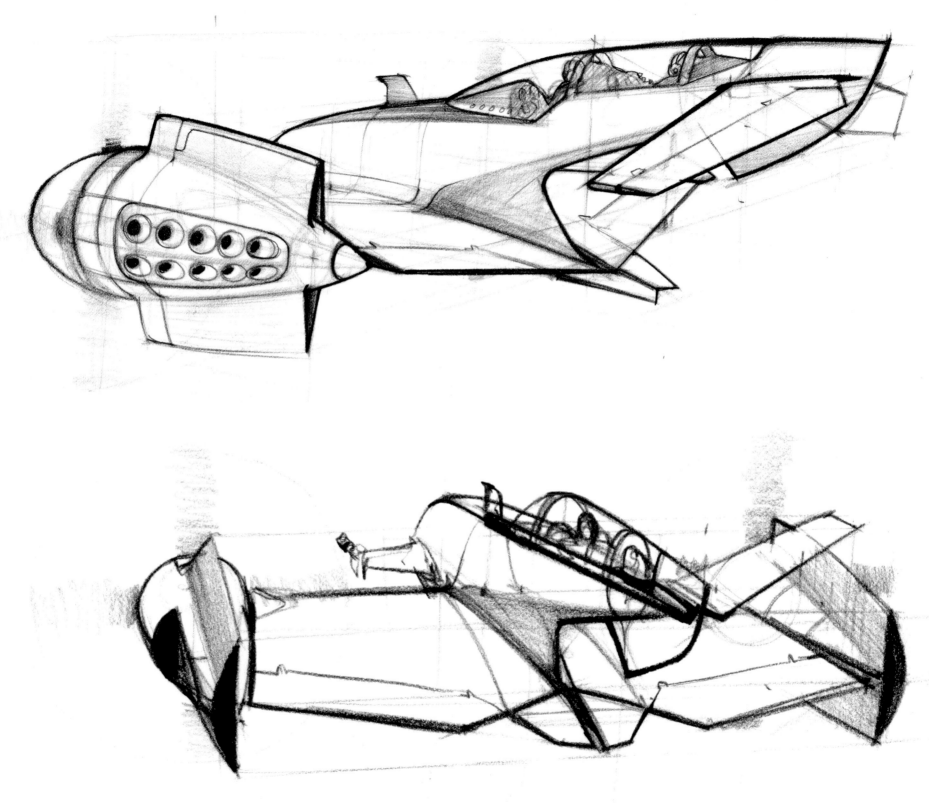

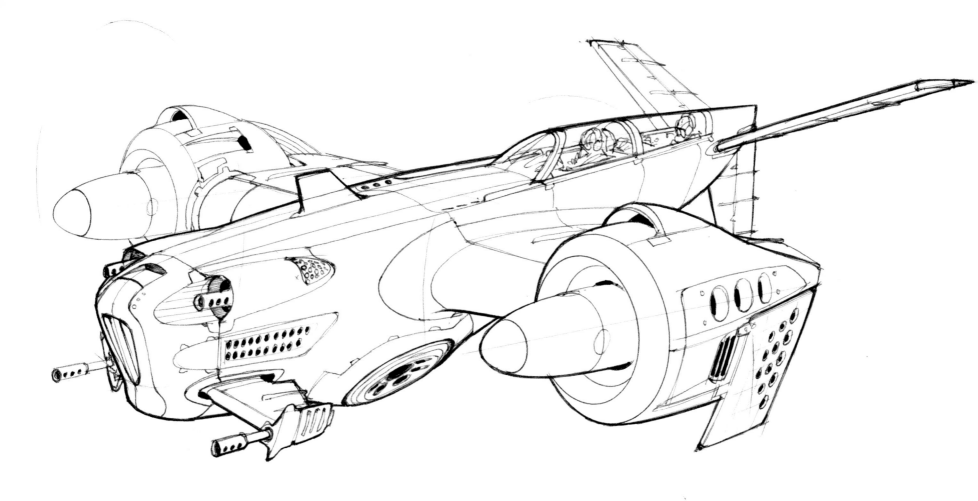

FINAL SKETCHES » warhawk

I had only a brief window of availability to help out on this project and the design shown here is the final direction I proposed. It is a common practice in the industry to provide the modelers with matching front and rear three-quarter views of the proposed design direction. I added a little graphic value break-up to the sketch at the right to help define some of the holes and potential material changes.

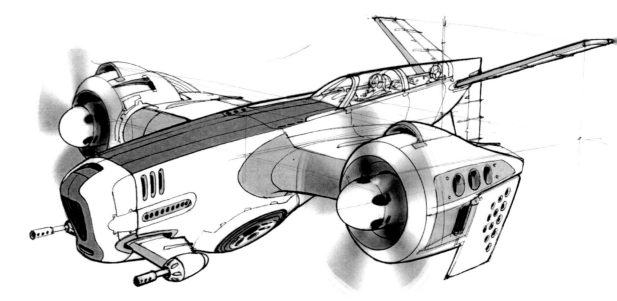

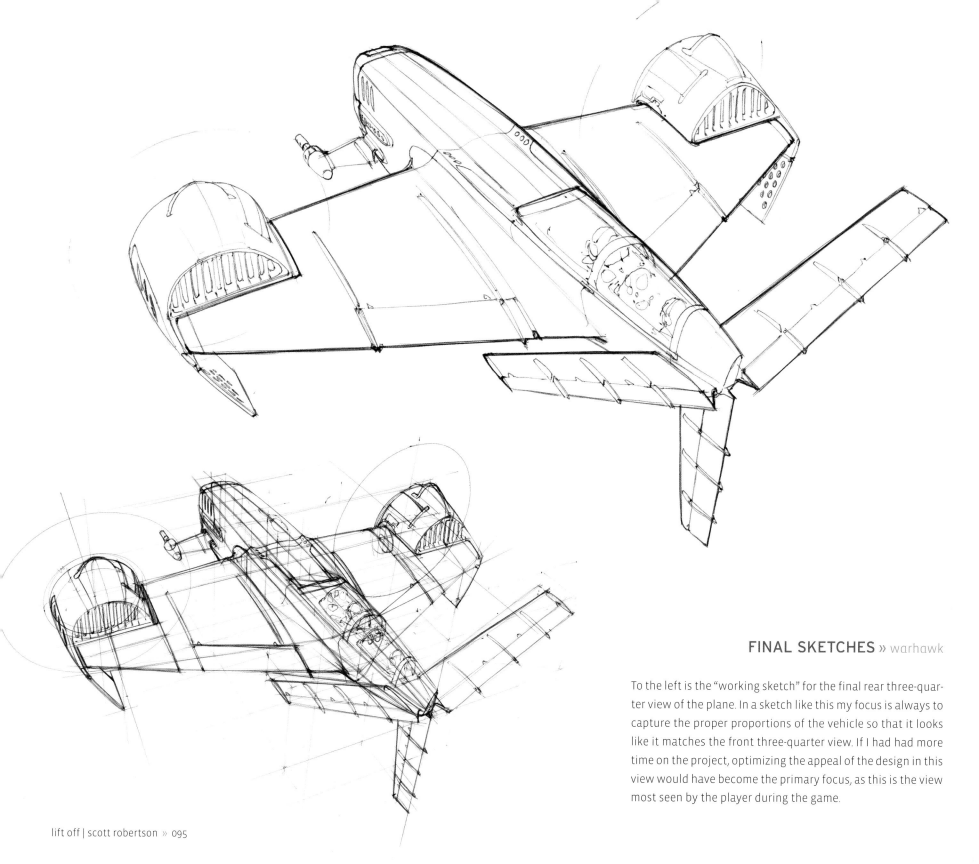

FINAL SKETCHES » warhawk

To the left is the "working sketch" for the final rear three-quarter view of the plane. In a sketch like this my focus is always to capture the proper proportions of the vehicle so that it looks like it matches the front three-quarter view. If I had had more time on the project, optimizing the appeal of the design in this view would have become the primary focus, as this is the view most seen by the player during the game.

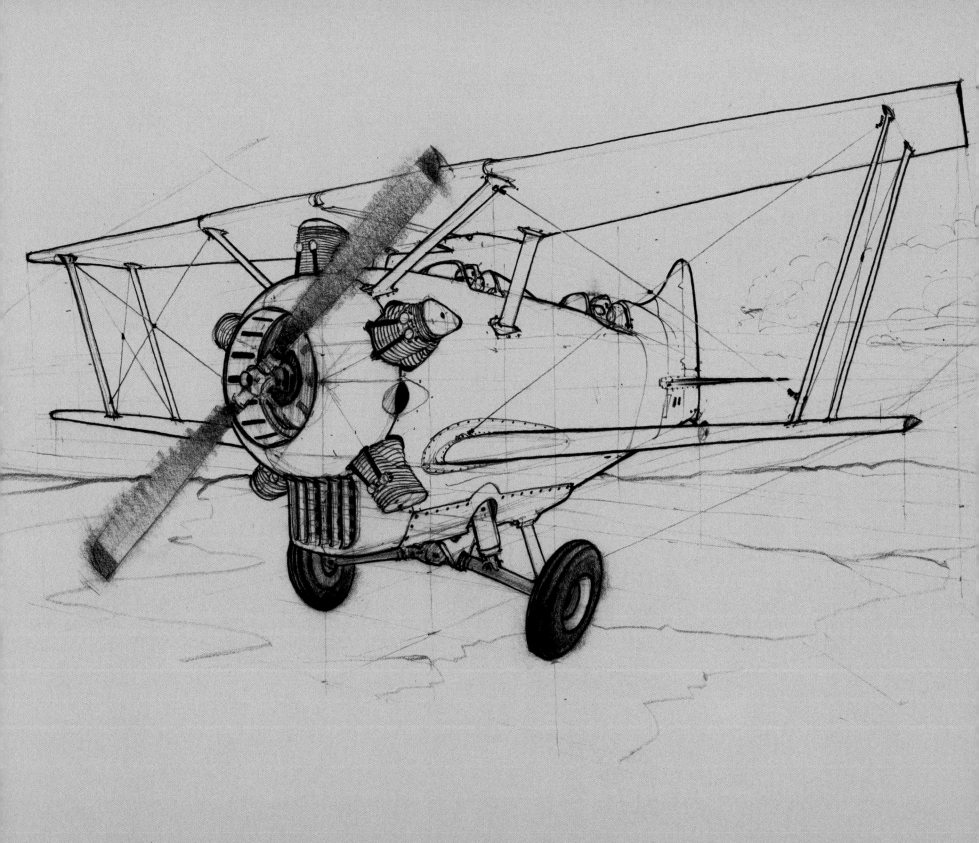

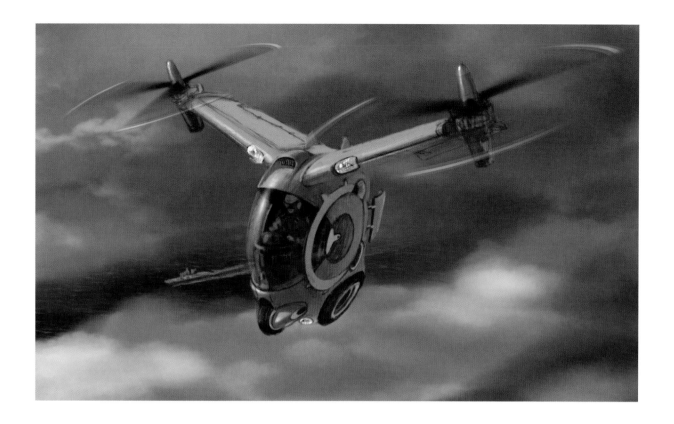

aircraft

For me, aircraft are much like cars in that it is usually very easy for people to have a good "feel" for what looks right and what looks wrong. Most people understand the basics of flight and therefore have certain built-in expectations as to what an aircraft needs to look like in order to fly. These built-in expectations work both for and against the designer. On the plus side, when you design a really stunning example of the vehicle, most everyone can appreciate it because they have a long-established familiarity with the object from years of observation. On the flip side, it is exactly this preconceived idea of "what an object should look like" that can skew their acceptance away from any new style that challenges this view. So, although viewers have a good point of reference to evaluate a new design, it is this same point of reference that holds back their acceptance of new forms in such well-established vehicle genres as aircraft and cars. With all of that said, my favorite book on the subject of aircraft is *The World's Worst Aircraft*. I love the failed experiments of the aeronautical engineers for the fresh vehicle forms they created. Since none of my designs really have to fly, I can have all the fun I want in this chapter without the stress of the test flight.

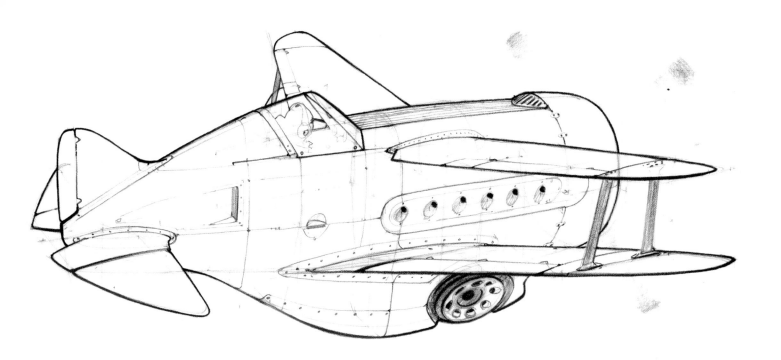

PENCIL SKETCHES »

On this page are a couple of basic prop-powered airplanes I did for my students to show what I expected of their drawings. All of the sketches on both of these pages were drawn with black Prismacolor and Verithin pencils. All of the lines were drawn freehand which I think helps to give the lines a little more life than if they had been cleaned up with my sweeps and ellipse guides.

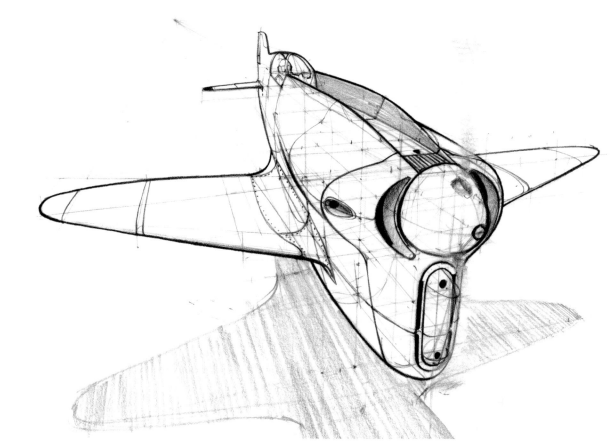

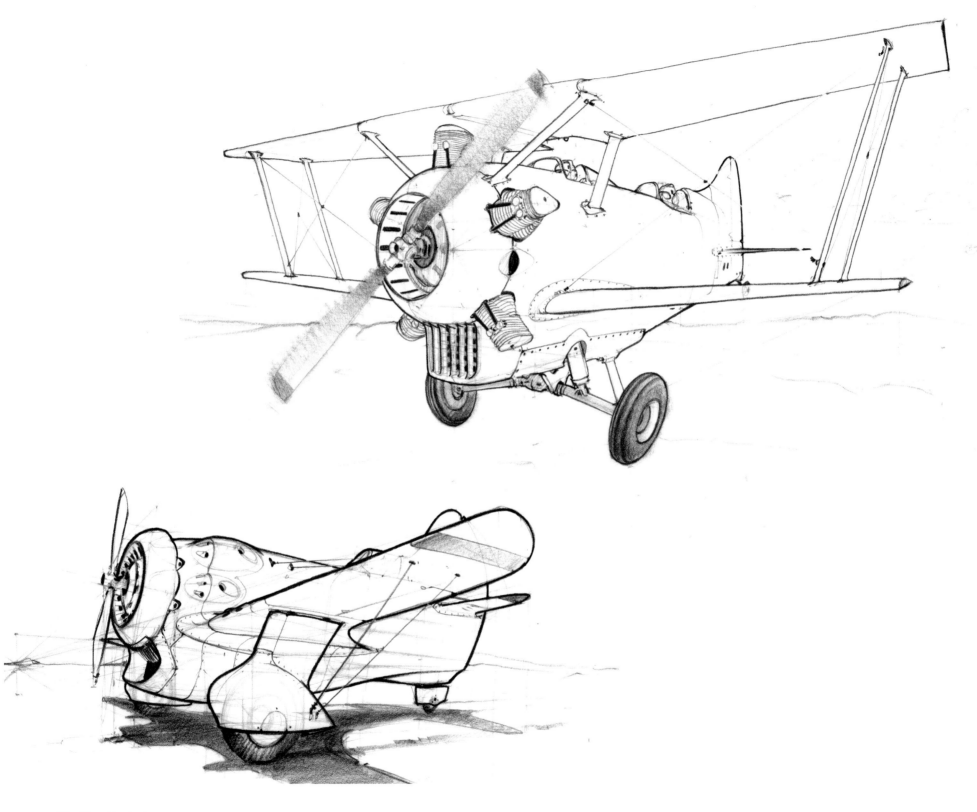

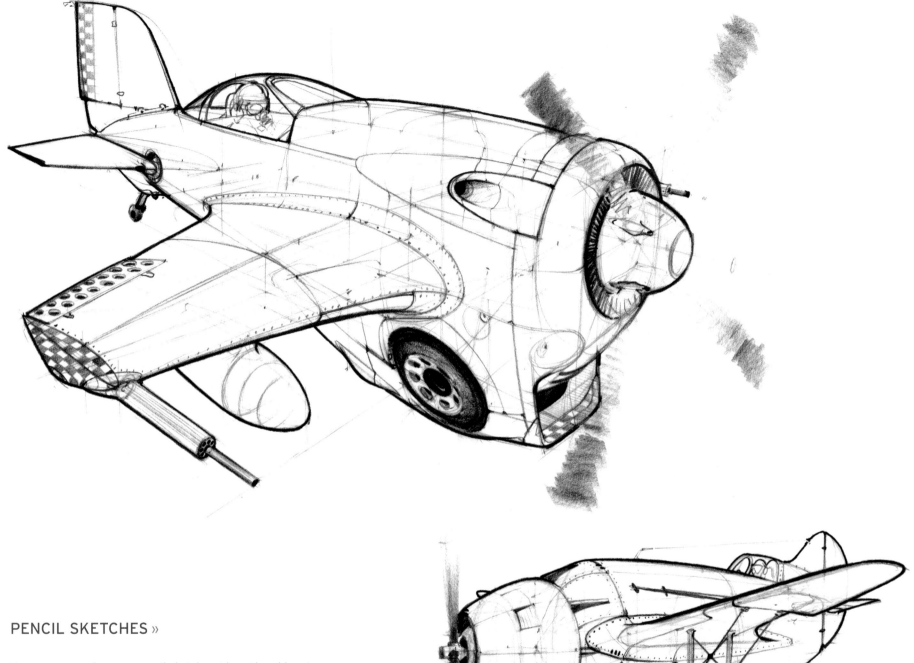

PENCIL SKETCHES »

Here are a couple more pencil sketches. I love the old racing planes that had extremely large engines in relation to the size of their cockpits. These were both imagined to be toy-like planes of a similar proportion to the planes of that era. Again, you see the telltale perspective construction lines I almost always use to draw vehicles of any type.

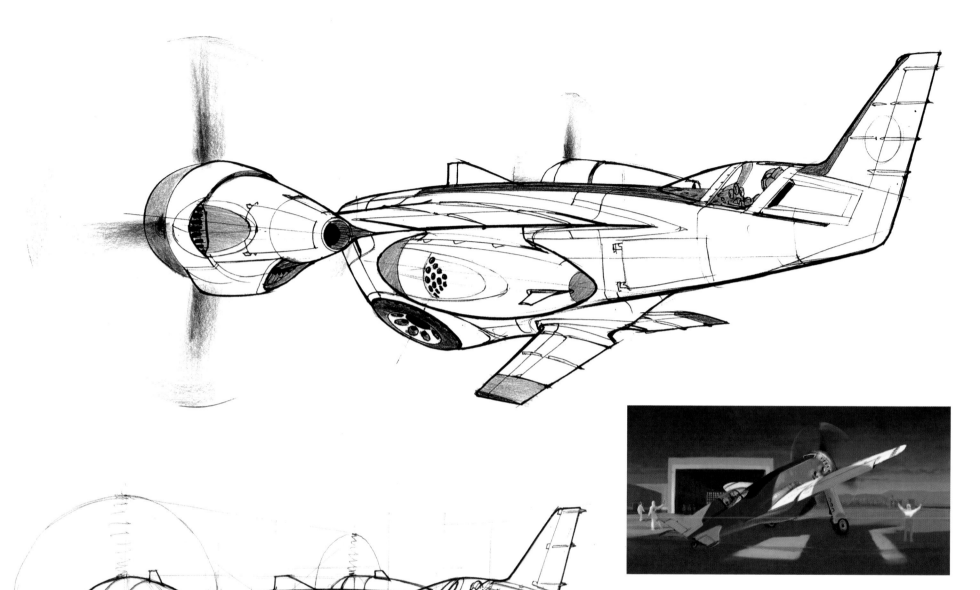

DVD DEMOS + COLOR SKETCH »

The sketches on this page were done for my *How To Draw Aircraft* instructional DVD. It is a wacky little airplane design with immensely large engines and an extremely rearward cockpit position. By playing with proportion it is entertaining to invent strange and new looking aircraft, even if they could only truly exist as toys. The top line drawing is an overlay of the lower sketch. Directly above is a quick color sketch where I stole the background from one of my renderings in the airship chapter.

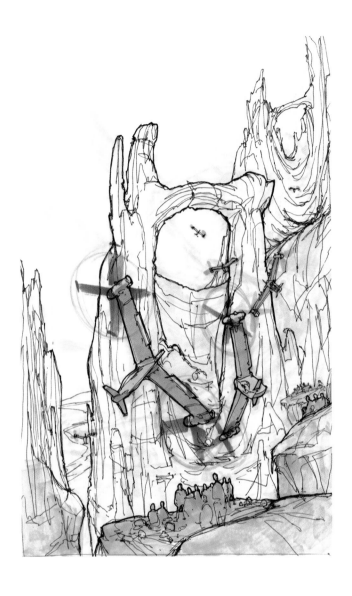

CANYON RACE »

In these canyons there is a crazy race through the treacherous high mountains, where lots of people turn out to watch the daredevil pilots duel overhead. The original sketch above was scanned and then initially rendered to the level that you see to the right, where it stayed for quite awhile. In gathering up work for this book I revisited the piece, changed the composition and converted the crowd into a cameraman.

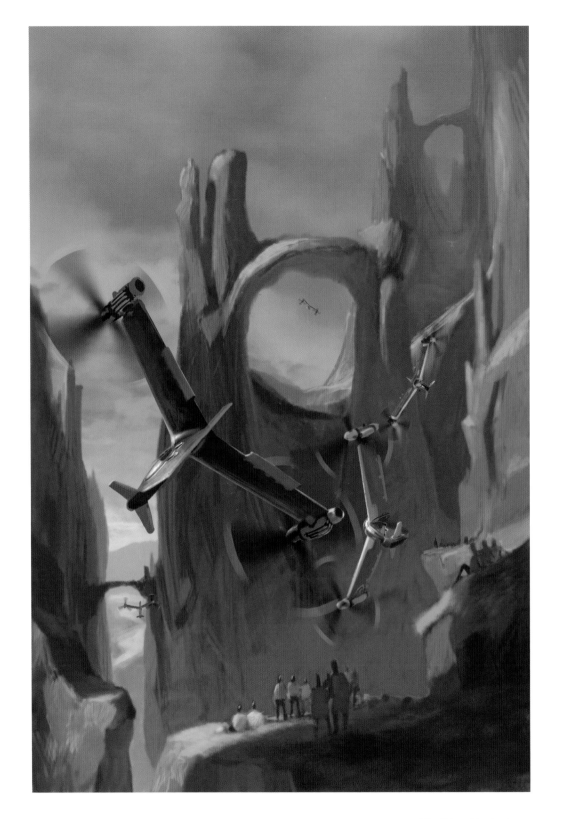

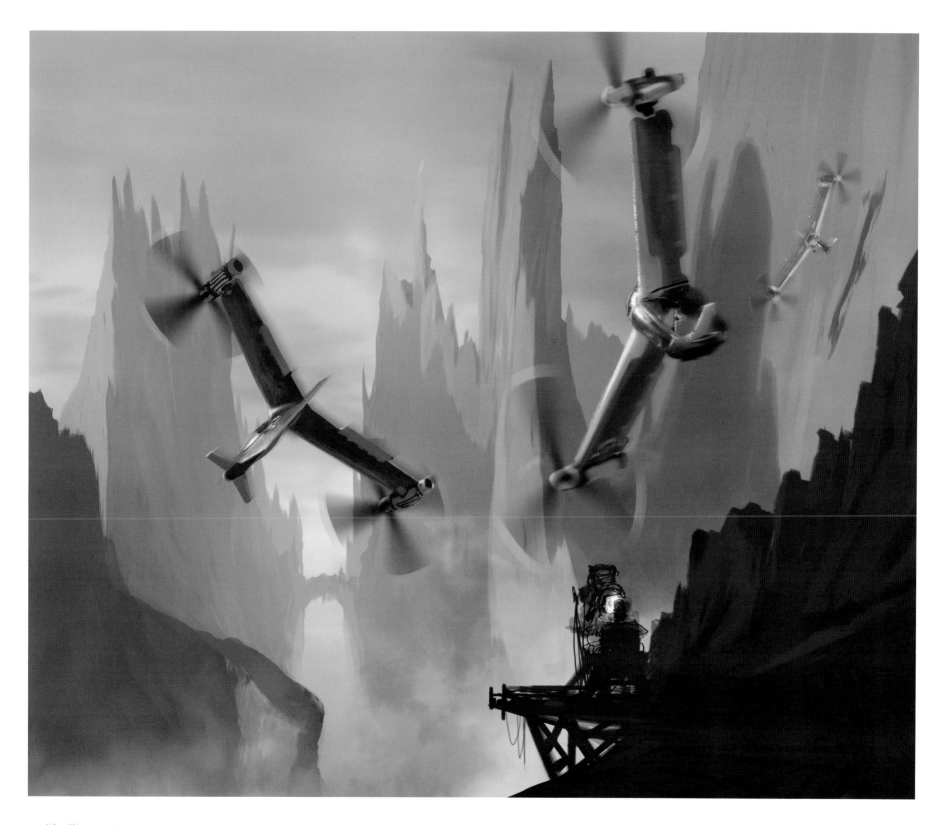

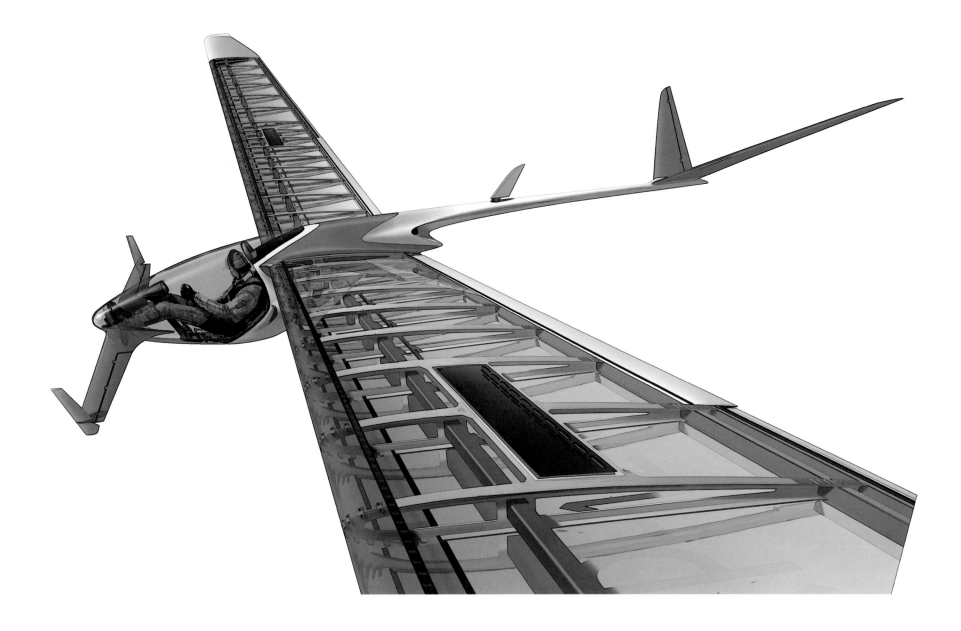

BOYHOOD DREAMS REVISITED »

Since this book has a horizontal format, I had the opportunity to expand this piece that was done originally for *Concept Design 1*. What I like about the wider format is the chance to show the entire design of the plane. The sketch above was created by selecting everything that was on the rendering layer of the plane and then applying a "find edges" filter to create the line drawing effect. Afterward, the entire image was saved as a grayscale image.

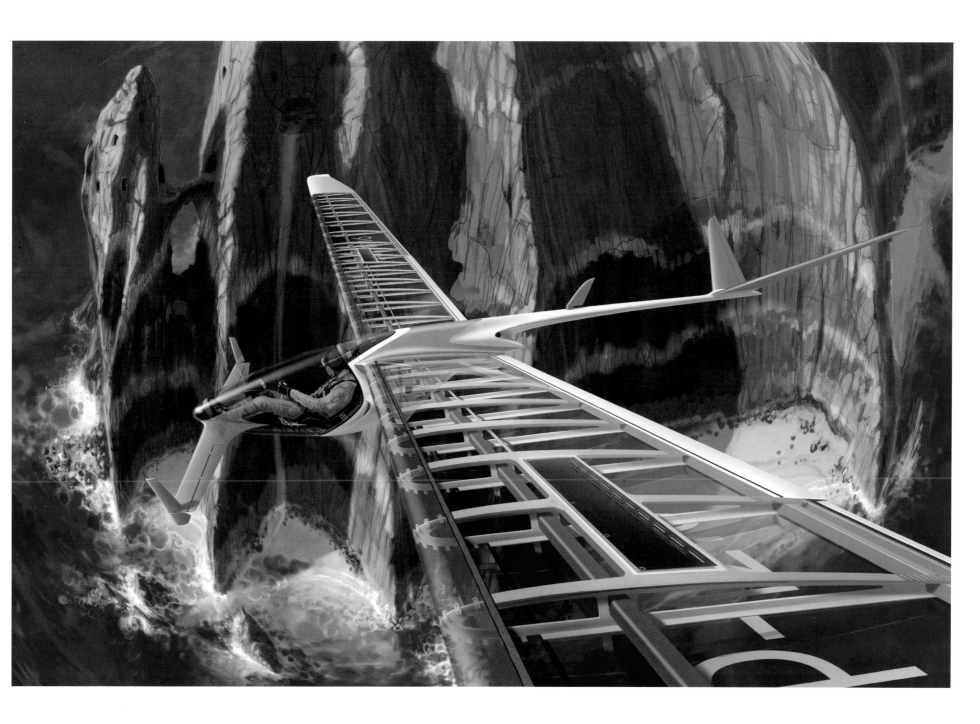

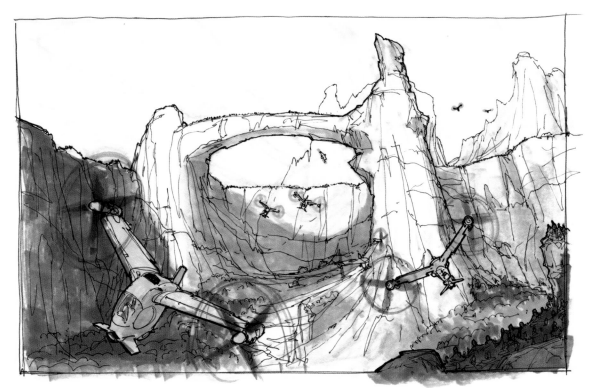

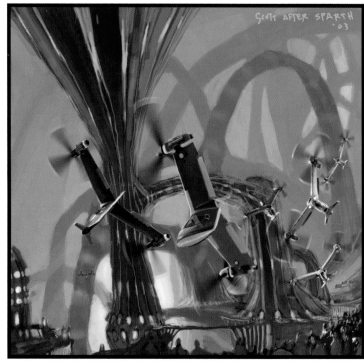

MORE AIR RACES »

Above is another marker-and-pen sketch exploring the canyon race idea. Often when thinking about a rendering for a book, I'll do many quick, little sketches just for fun to find interesting compositions and to develop my vehicle designs. To the right is a quick color rough of what the rendering might look like. This is usually the first step after scanning in the sketch. Sometimes I will work up the entire piece in grayscale mode before going into color.

On the upper right of this page is a rendering that says, "Scott after Sparth." Sparth is another concept-artist friend of mine with whom I traded some illustrations back and forth in a thread on one of the online concept art forums. This was my attempt to paint in his style for the environment, with my own twin-prop planes racing through it.

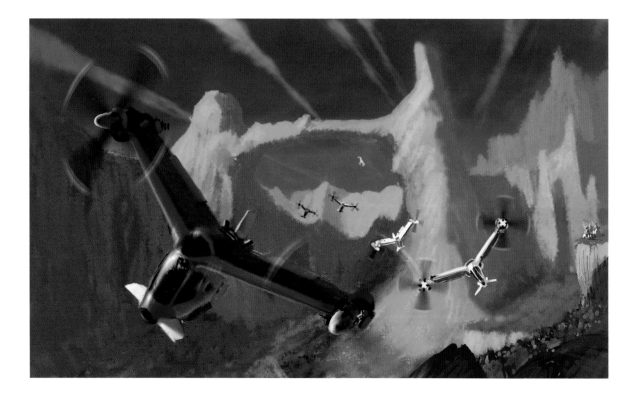

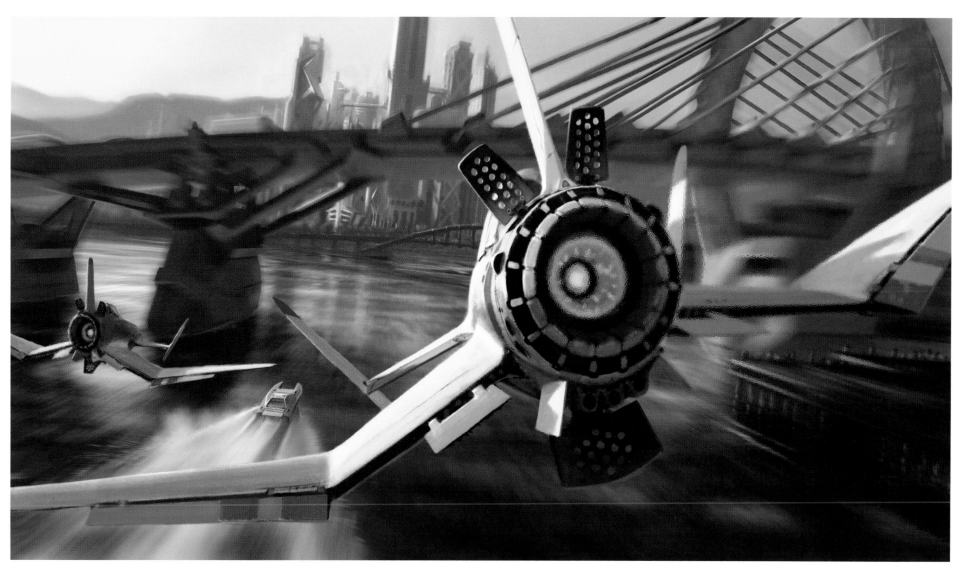

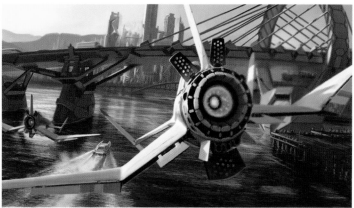

UNDERPASS REVISITED »

To the left is a piece seen originally in *Concept Design 1*. For inclusion in this book I reworked it a little to create a stronger sense of motion and speed; with the help of some image-distortion filters in Photoshop. Above is the result. The idea is that you are the camera and are flying along at the same speed as the jets and the boat, so they stay in focus while the background whizzes by..

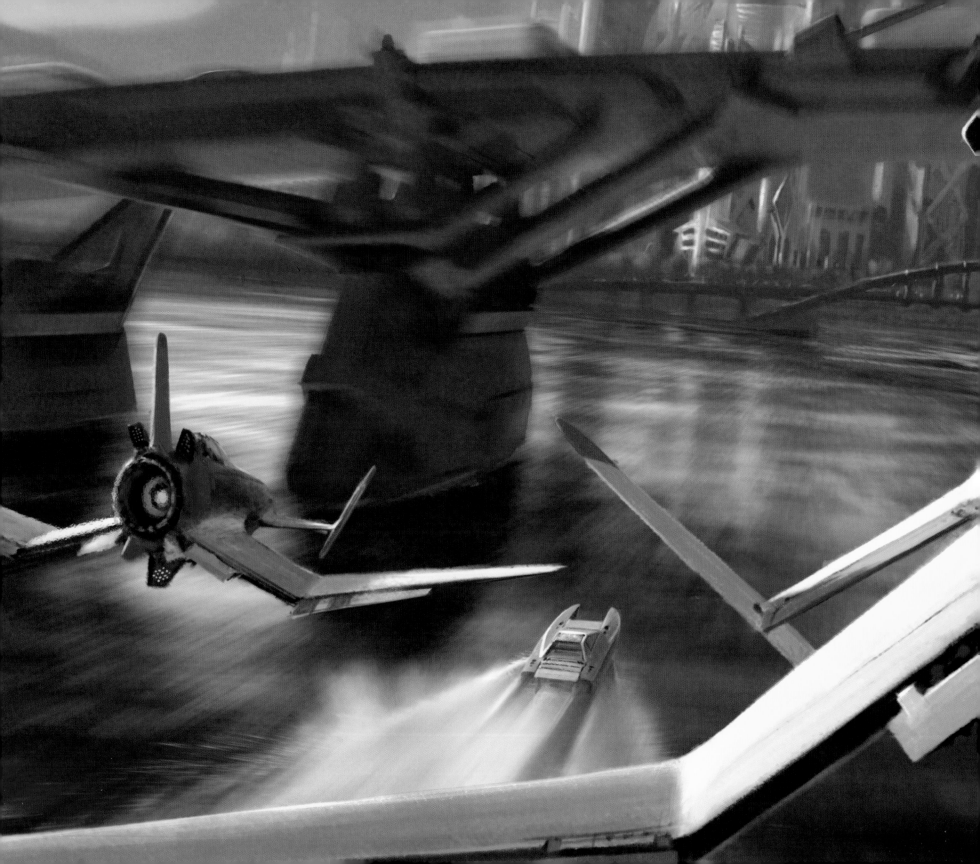

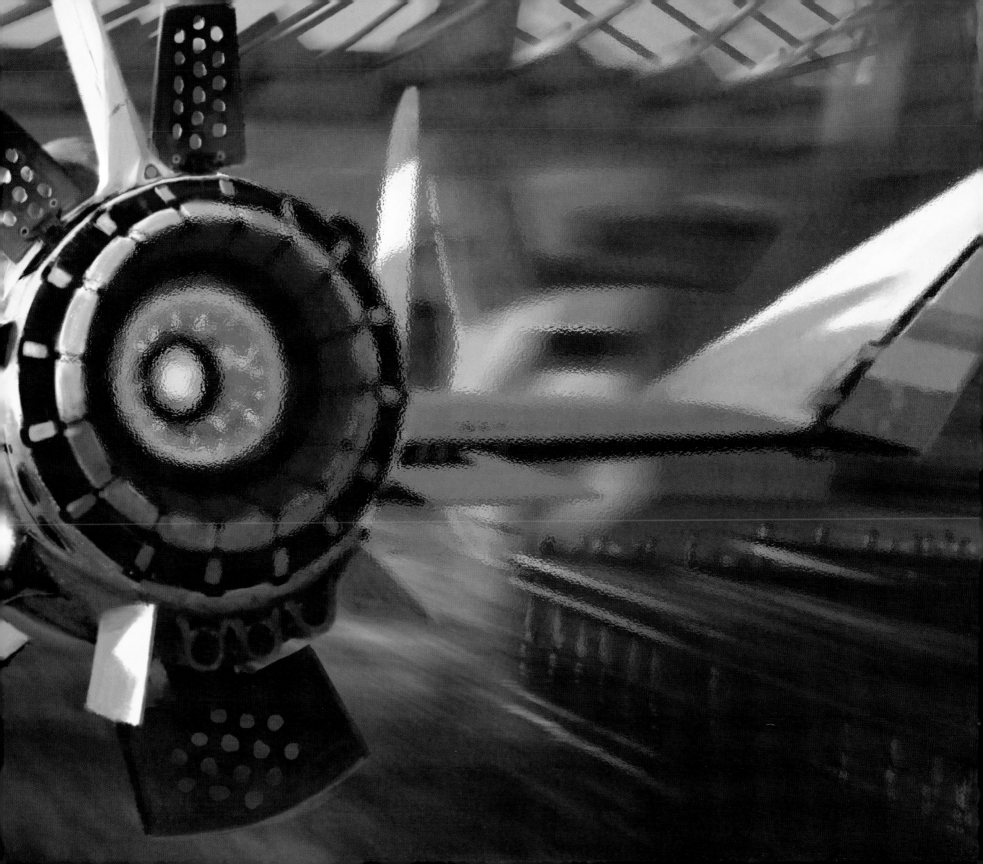

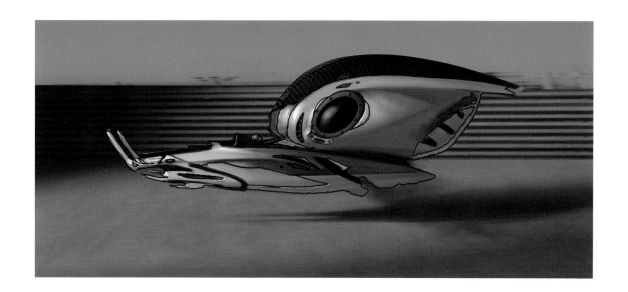

lefties

I'm a serious right-hander. If I lost the use of my right hand I might starve to death! My left hand is so uncoordinated that when fellow concept artist Nick Pugh said I should do some drawings with it I thought, "Oh, this ought to be interesting." Well it was, and I have to say that after years of sketching with my right hand, I have built up some muscle-memory and I often find myself sketching the same curves over and over again. By using my left hand a couple of interesting things occurred. I found I had no expectation that the quality of the finished drawing would be anything worth keeping. In turn, this actually allowed my mind to free up and think more about the shapes I was drawing versus whether they were "in perspective" or if the lines were straight or smooth. Also, in having no muscle-memory in my left hand, I think I created some interesting vehicle forms that I would not have created otherwise. As compared to the other sketches in this book and those in *Start Your Engines,* I hope you find something interesting in the sketches in this chapter. So let the left-handed wobbly lines commence!

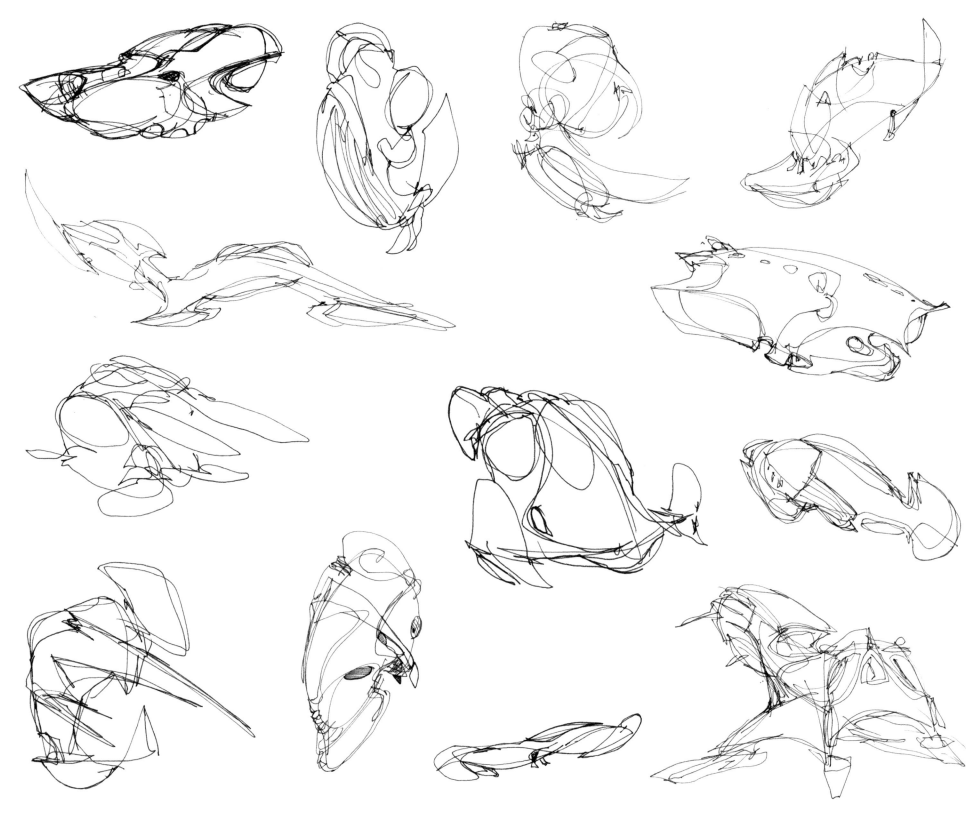

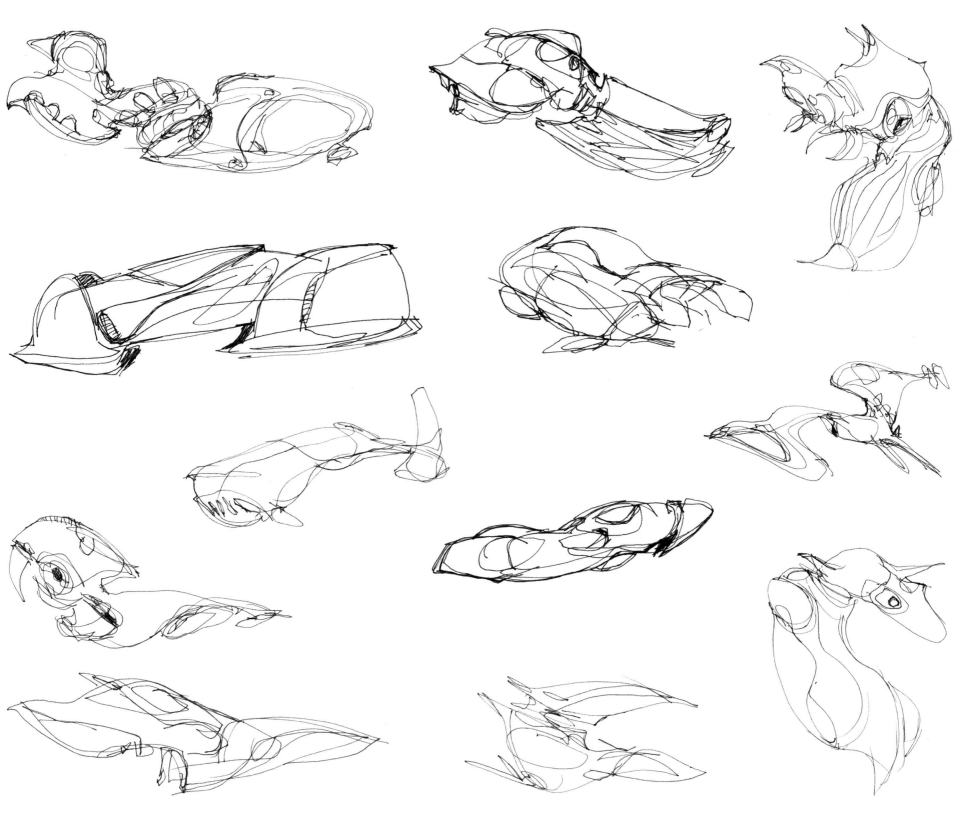

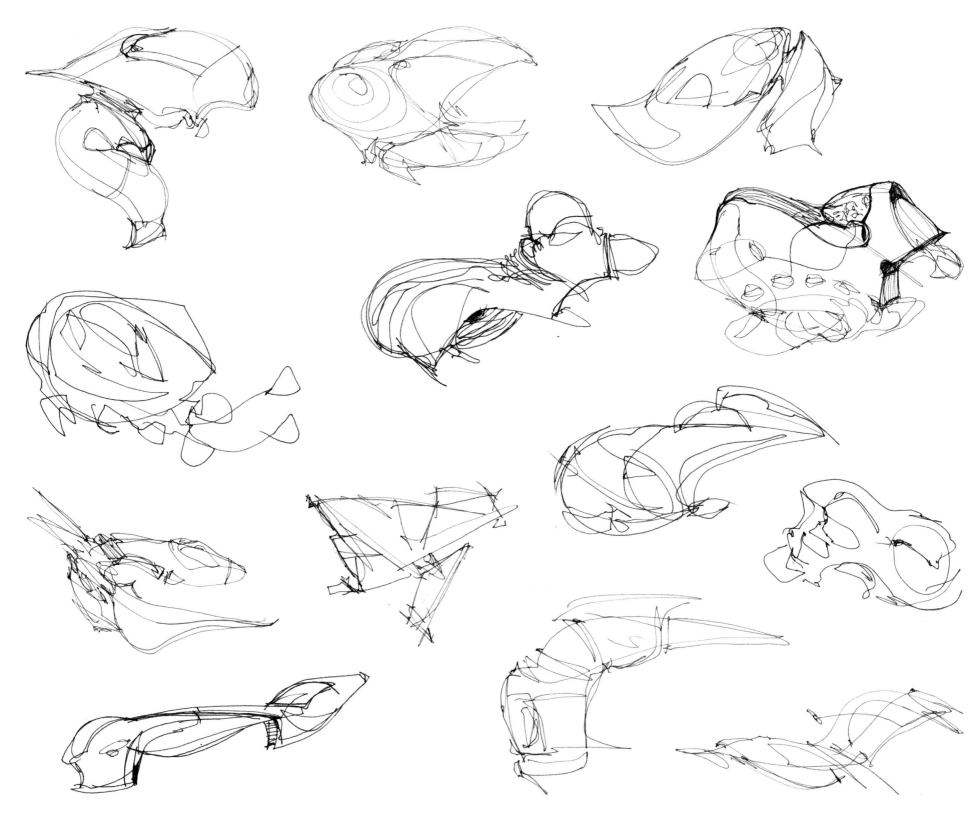

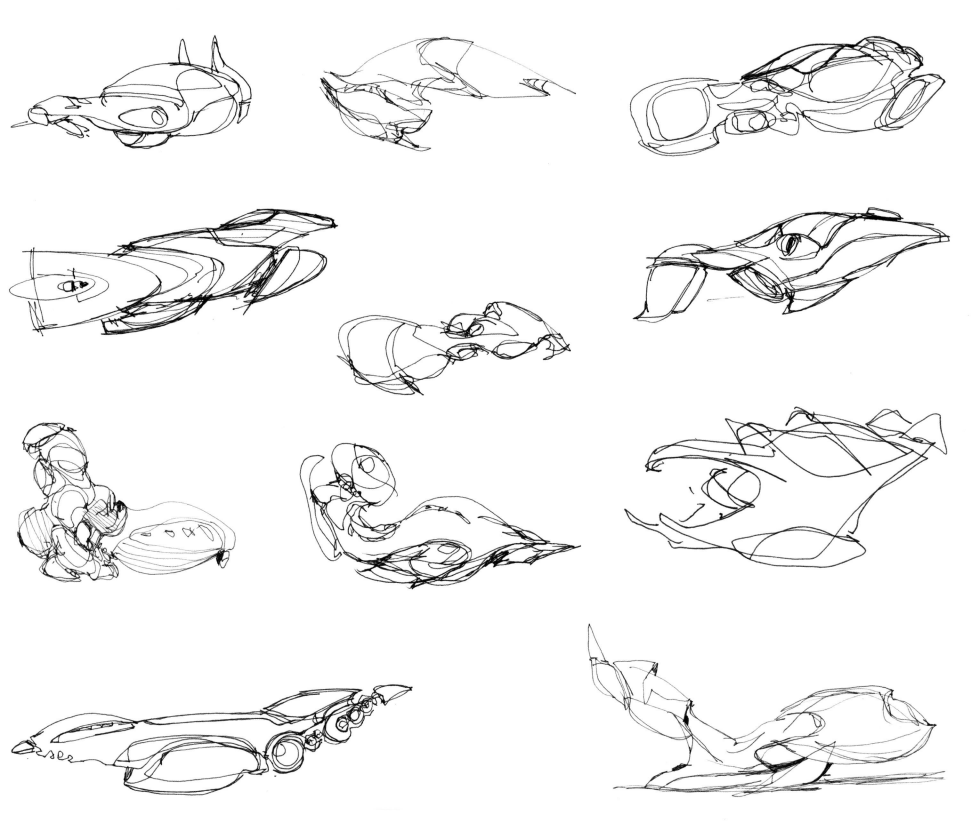

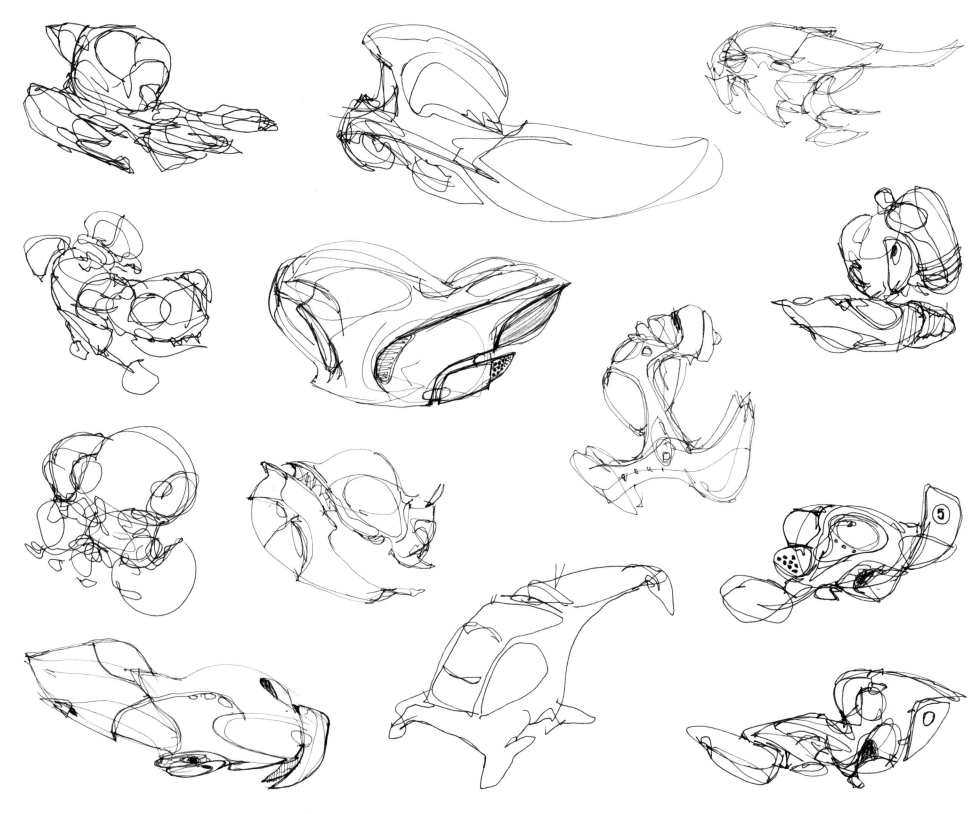

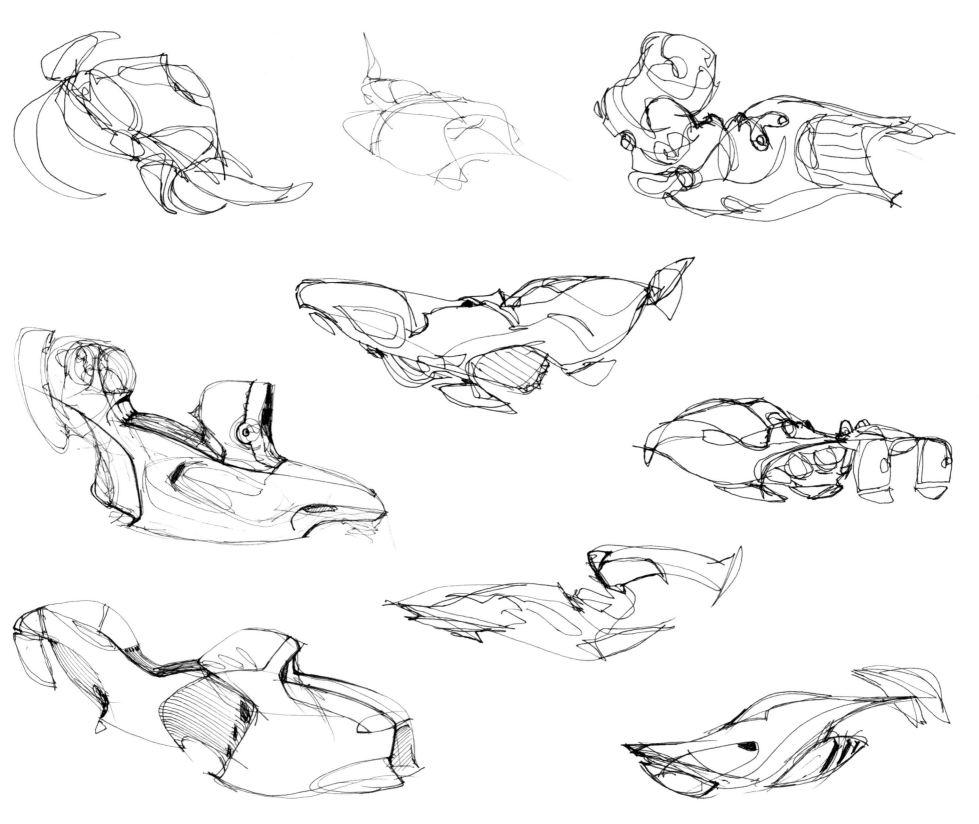

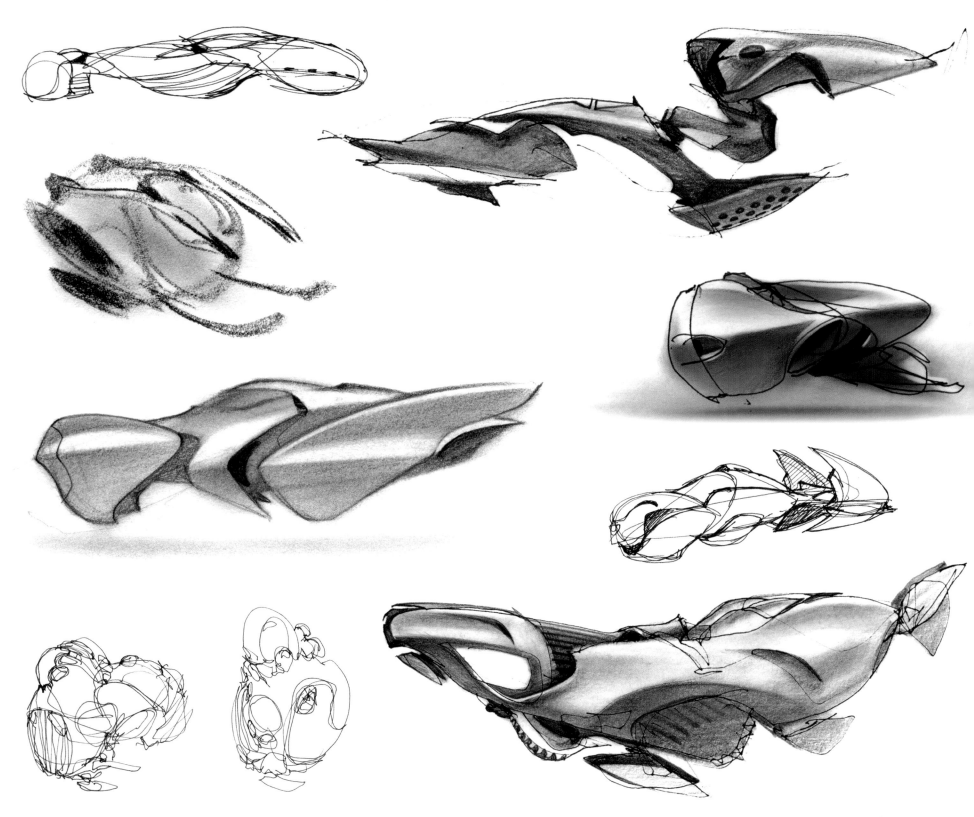

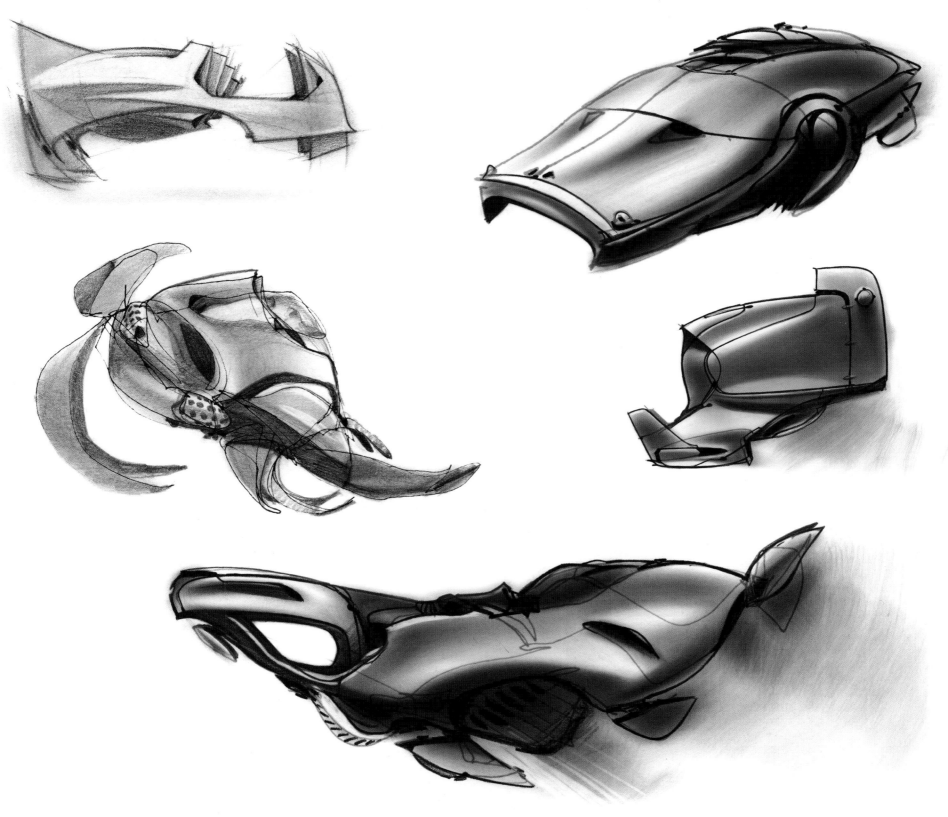

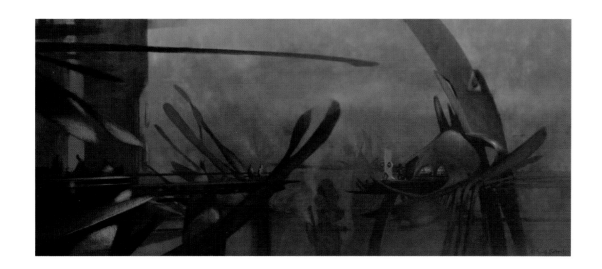

CHAPTER »06

airships

This type of vehicle is one that most of us have seen floating lazily in the early morning sky; perhaps it was a hot air balloon or, more on topic for this chapter, an airship circling over a sporting event. I'm always fascinated by the huge visual size of these craft as compared to their apparent weightlessness. Airships are quickly becoming another of my favorites to daydream about. Not very much has been done with regard to the styling of these craft. As you will see in this chapter, most of my airships look like tropical fish. This is no mistake

and I have had a lot of fun experimenting with the "fishy influence" in the design of my airships. The chapter starts with more of my left-handed sketches, which find their way into the last rendering of the chapter. I would love someday to build a couple of small-scale desktop models of a few of these designs. As is common with most Industrial Design graduates from Art Center, I still have a fond affection for a beautifully detailed scale model.

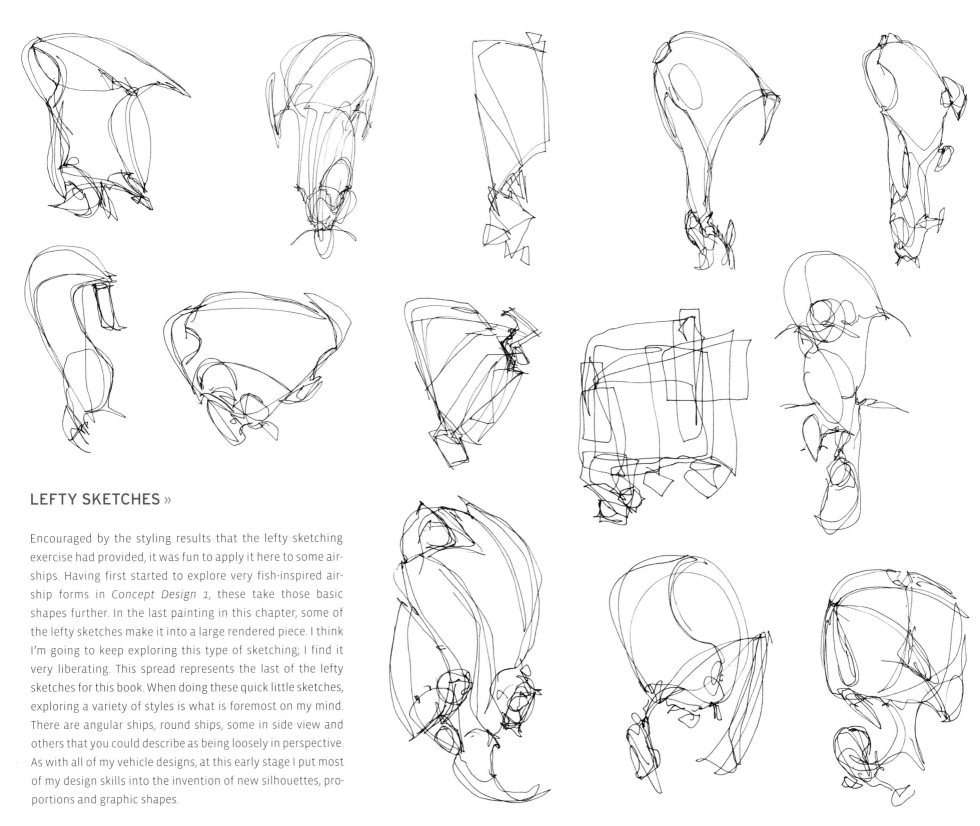

LEFTY SKETCHES »

Encouraged by the styling results that the lefty sketching exercise had provided, it was fun to apply it here to some airships. Having first started to explore very fish-inspired airship forms in *Concept Design 1*, these take those basic shapes further. In the last painting in this chapter, some of the lefty sketches make it into a large rendered piece. I think I'm going to keep exploring this type of sketching; I find it very liberating. This spread represents the last of the lefty sketches for this book. When doing these quick little sketches, exploring a variety of styles is what is foremost on my mind. There are angular ships, round ships, some in side view and others that you could describe as being loosely in perspective. As with all of my vehicle designs, at this early stage I put most of my design skills into the invention of new silhouettes, proportions and graphic shapes.

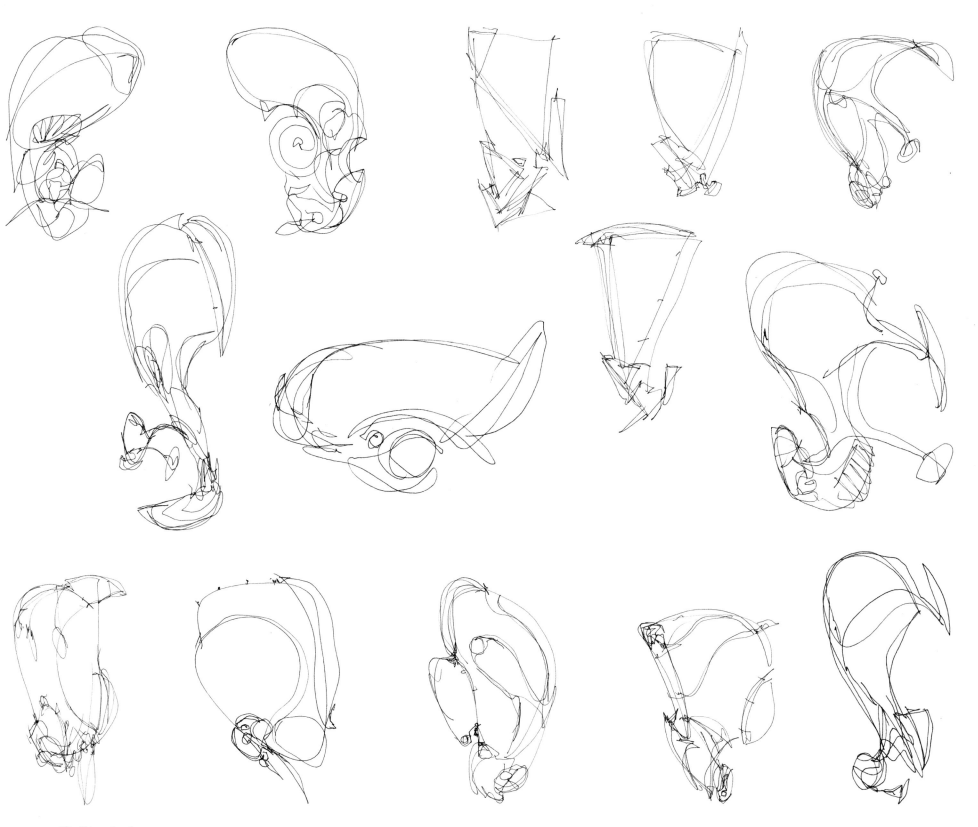

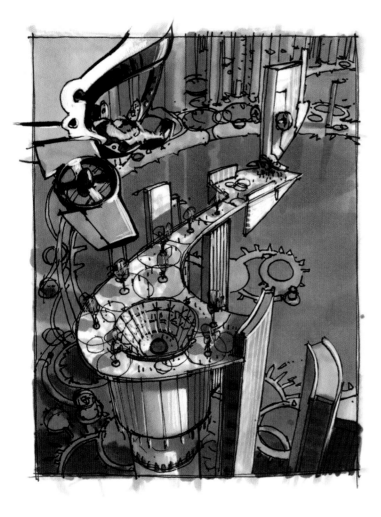

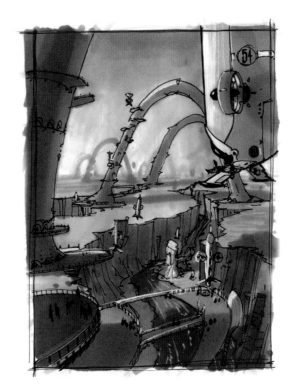

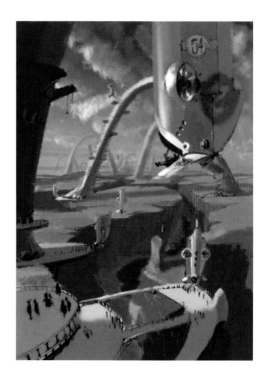

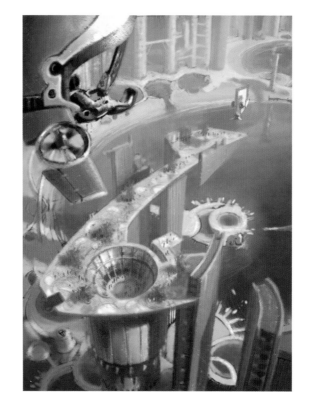

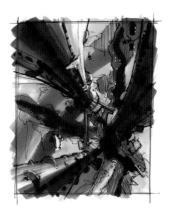

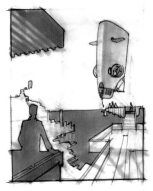

MARKER + COLOR COMPS »

Presented here are several marker-and-pen sketches for potential paintings of scenes featuring more odd airships. The two larger marker sketches were scanned and then quickly colored to explore the possibilities of becoming more finished pieces. Neither has been taken beyond this first step as of yet. The larger marker sketch at the lower left of the facing page is the sketch that was developed into the painting in the next spread.

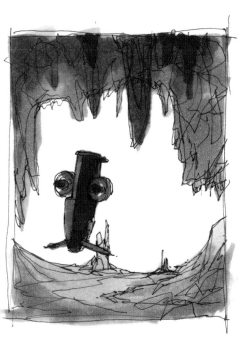

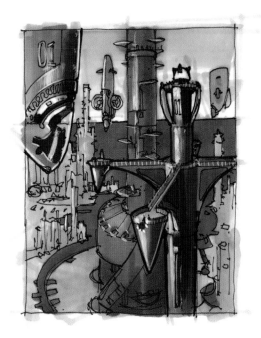

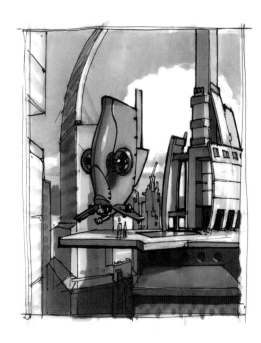

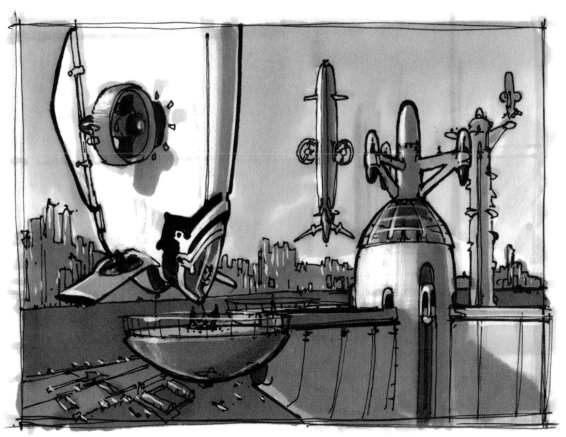

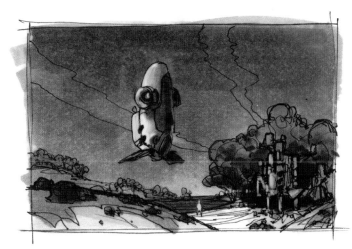

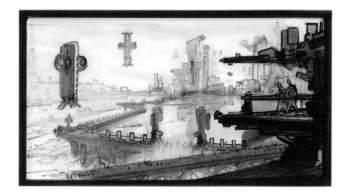

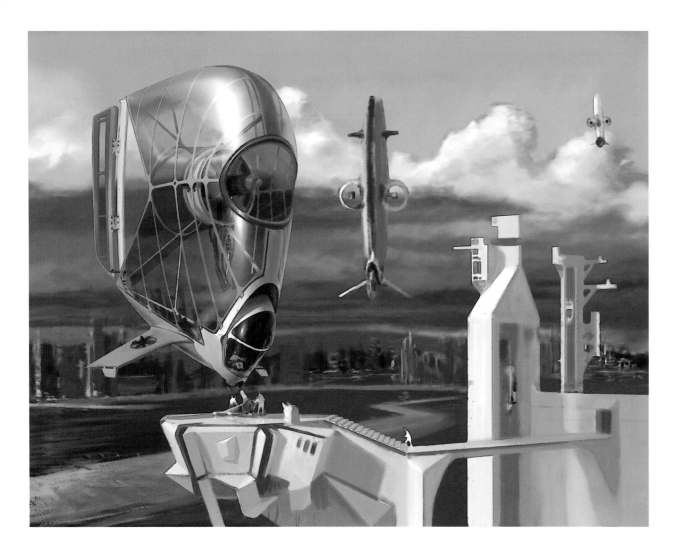

PIT STOP REVISITED »

Above is a work-in-progress image that was saved during the painting of the piece on the facing page. At this point the building is not very defined, and there remains a third airship at the center of the image. Later this ship would disappear. The red lines visible in the above image are created by using a "find edges" filter in Photoshop to create a "fake" line-drawing effect. These lines are then colorized to red, switched to "multiply" and placed back on top of the original layer. To the right is a rendering done for the spine of this book. It is a rework of a portion of the rendering in the next spread.

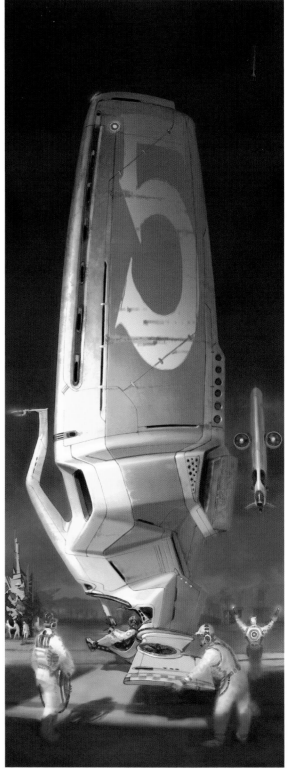

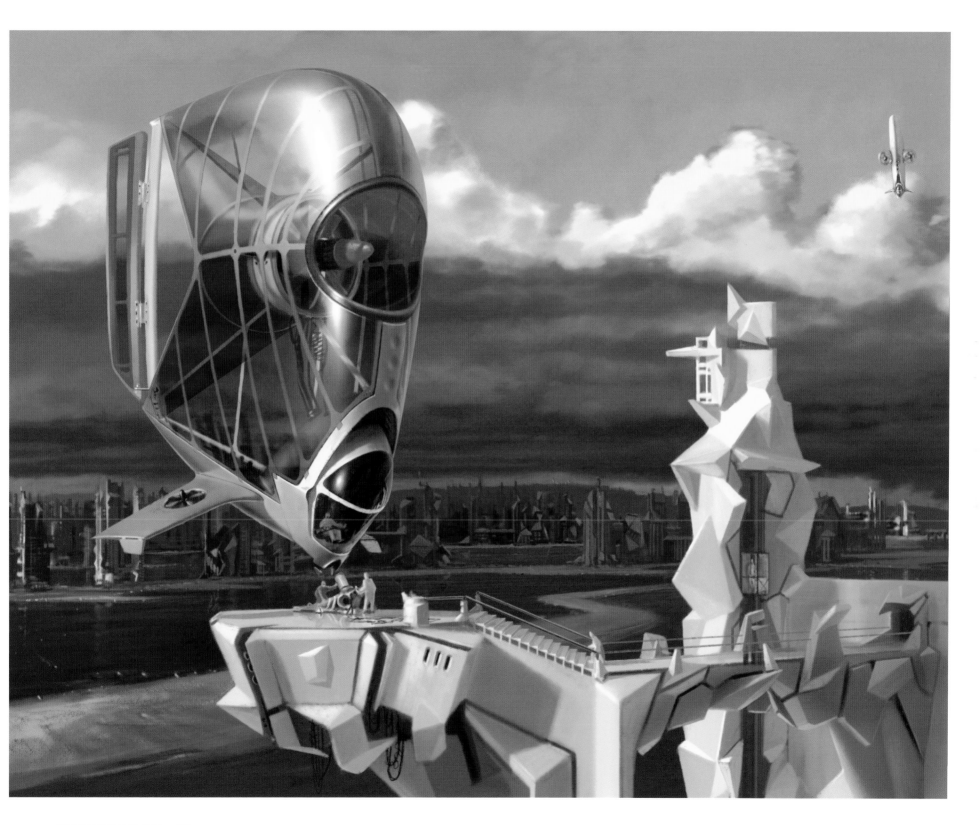

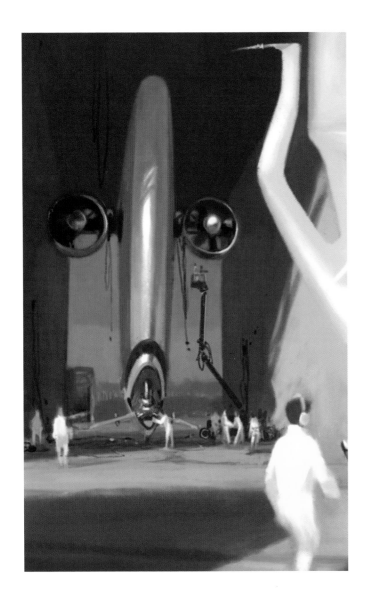

OUTSIDE THE HANGARS »

Both of these were the last pieces done for *Concept Design 1*, and since they were some of the first renderings to feature my fishy airships I wanted to include them in this book. The approach to both of these paintings was to draw and then render the scenes as if viewed through a wide-angle lens. Ideally this would allow us, the viewers, to be near to the airship and the ground workers while at the same time able to see the entire height of the ship.

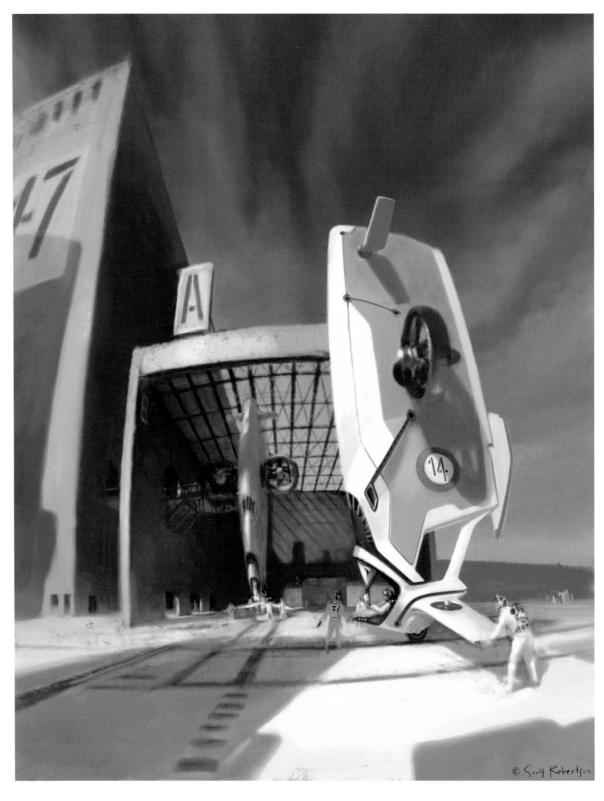

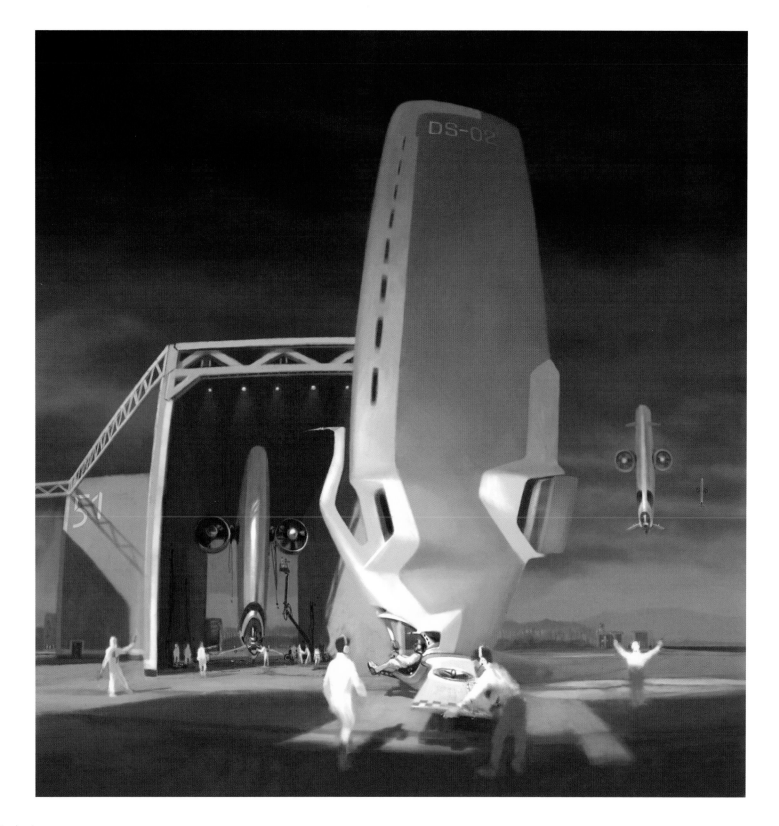

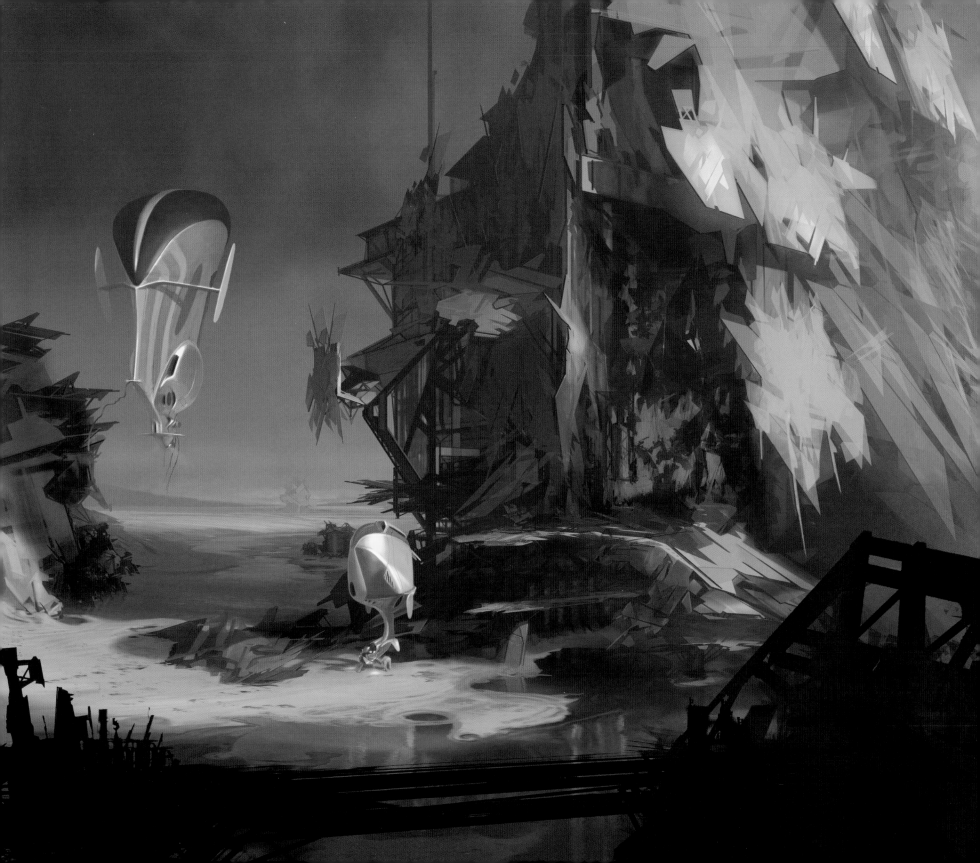

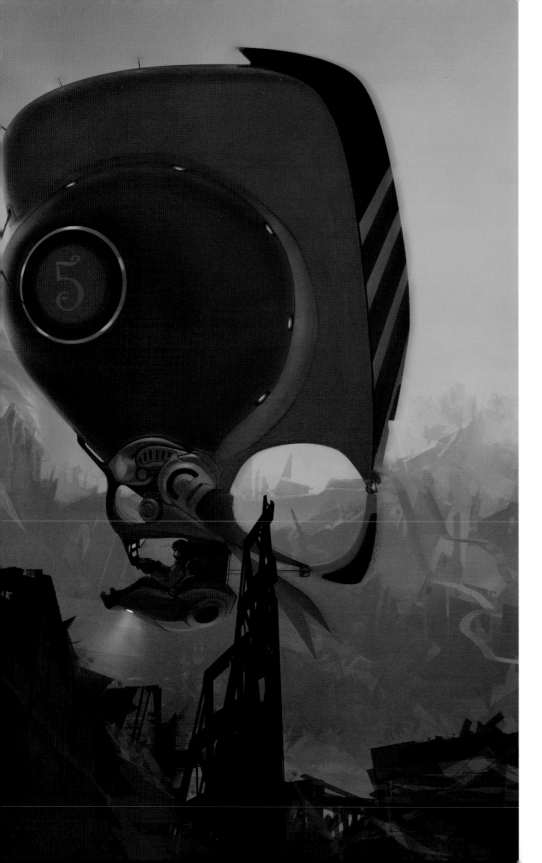

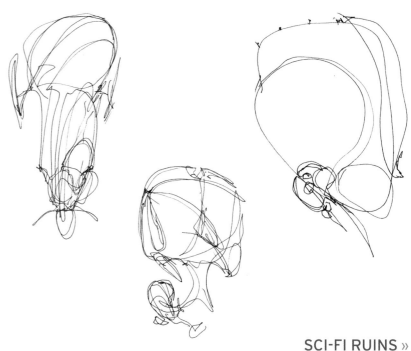

SCI-FI RUINS »

The backstory on this piece might be something like this: three explorers are out for an afternoon in their airships. They might be on another planet with all the former inhabitants now long gone. Our lead explorer has already landed and his companions are on approach to the deserted, strange-looking buildings of the past. At first glance, the buildings look as if they had once been magnificent, shining, contemporary examples of the design of their time. Though in ruins, we can still see the strange, translucent material of their construction: not quite glass, not quite steel. Pure "unobtainium" as we used to call unrealistic materials when I was in school. Due to the bright colors and flowing ribbons in this piece, one of my students pointed out that maybe these three people have taken the day off from the local air show or circus for a little adventure? Whatever story the piece suggests to you, I hope you enjoy it.

Regarding the airship designs themselves, these ships came directly from my quick, left-handed sketches. I just grabbed a few that I liked and dropped them into this Photoshop rendering where I added color, and refined the perspective and the designs.

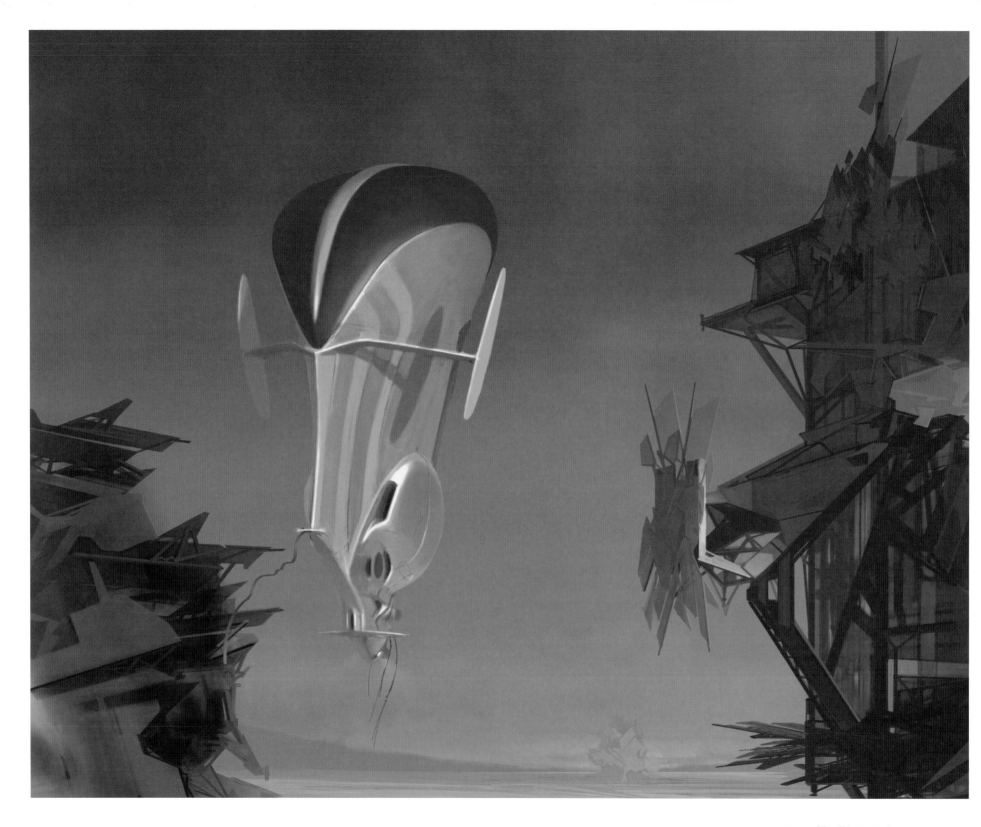

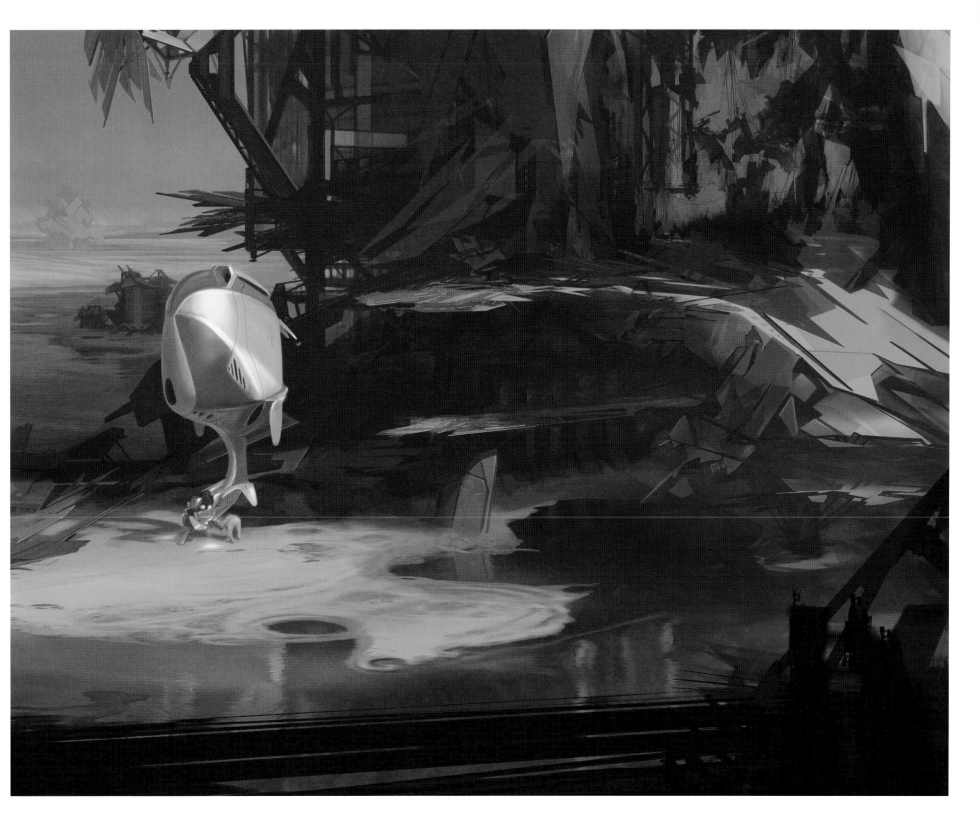

001

2.10.06 © Scott Robertson.

002

2.9.06 © Scott Robertson.

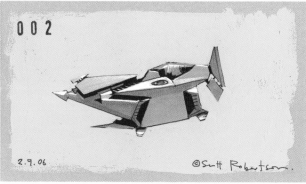

003

2.10.06 © Scott Robertson.

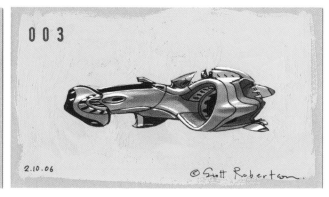

004

2.15.06 © Scott Robertson.

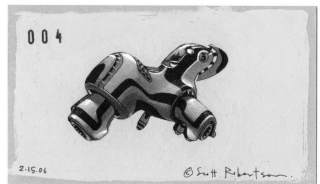

005

2.17.06 © Scott Robertson.

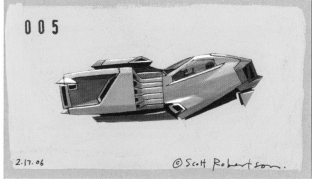

006

2.17.06 © Scott Robertson.

007

3.1.06 © Scott Robertson.

008

2.11.06 © Scott Robertson.

009

2.15.06 © Scott Robertson.

010

2.15.06 © Scott Robertson.

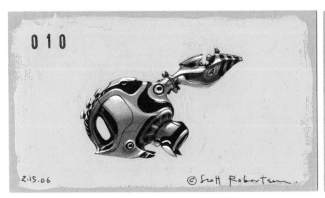

011

2.26.06 © Scott Robertson.

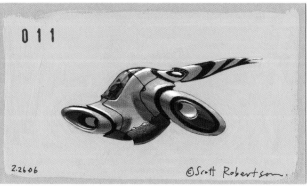

012

2.16.06 © Scott Robertson.

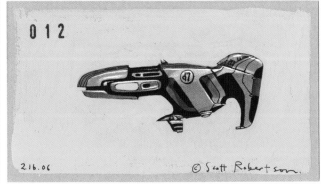

CHAPTER »07

card collection

While hanging out at our booth during Comic-Con 2005 in San Diego, California, I started doing little ship sketches on the back of my business cards and giving them away. The 108 ship cards shown here were done specifically for this book. Each design was sketched directly on the back of a card designed by Fancygraphics and printed just for this collection. I began each illustration using Pilot Hi-Tec-C ink pens. After the design and line drawing were done, I rendered it with markers, a little white pencil and white gouache. The last touches were to add the gouache background, tint the glass area, and of course sign it and add the number. There were some casualties along the way—I seem to recall about a half-dozen so ugly they actually flew...off my desk and into the trash! All in all,

these were a lot of fun to create. The most enjoyable part of the process was that these were done with traditional media and each one is an original. This is not the case with the digital art that I so often do now. If you are one of the 108 people who purchased one of the original cards within the limited edition of my books, thank you. For those of you without an original, I hope you enjoy the reproductions within this chapter. Who knows...maybe there will be another card collection in my future...

013 2.9.06 ©Scott Robertson.
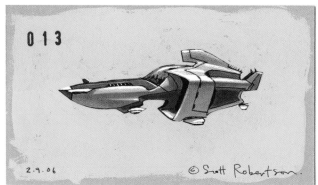

014 2.9.06 ©Scott Robertson.
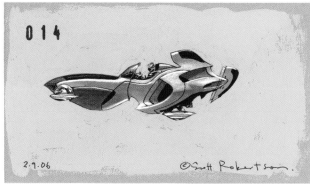

015 2.24.06 ©Scott Robertson.
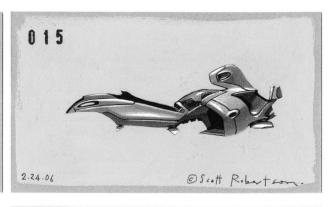

016 2.24.06 ©Scott Robertson.
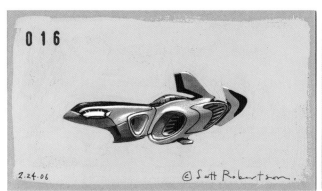

017 2.10.06 ©Scott Robertson.
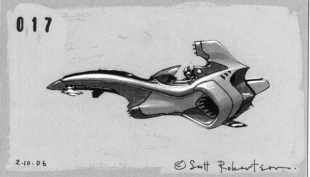

018 2.10.06 ©Scott Robertson.
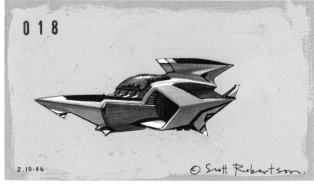

019 2.10.06 ©Scott Robertson.
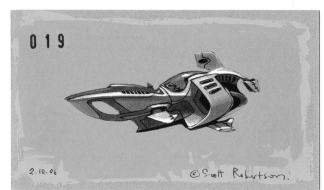

020 2.24.06 ©Scott Robertson.
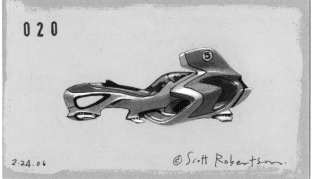

021 2.24.06 ©Scott Robertson.
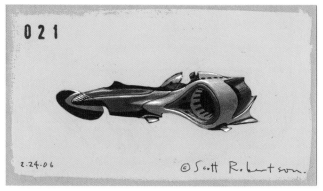

022 2.9.06 ©Scott Robertson.
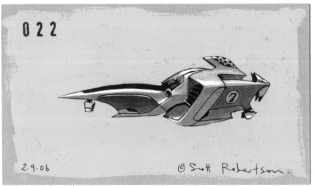

023 2.10.06 ©Scott Robertson.
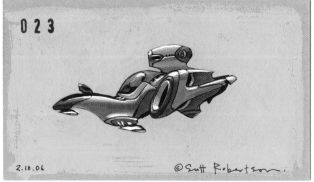

024 2.10.06 ©Scott Robertson.
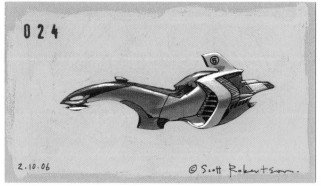

025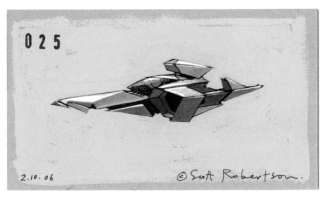
2.10.06 © Scott Robertson.

026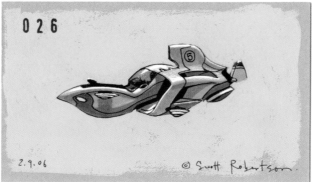
2.9.06 © Scott Robertson.

027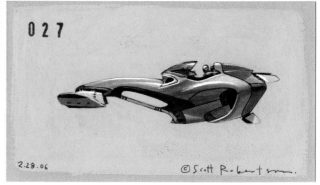
2.28.06 © Scott Robertson.

028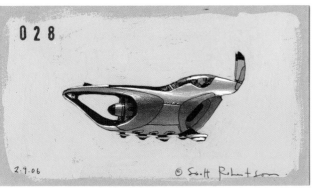
2.9.06 © Scott Robertson.

029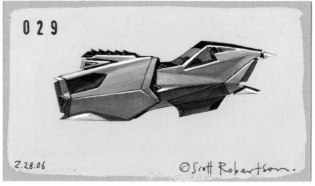
2.28.06 © Scott Robertson.

030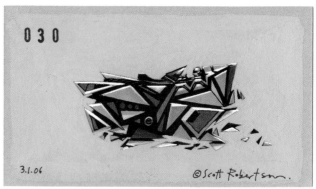
3.1.06 © Scott Robertson.

031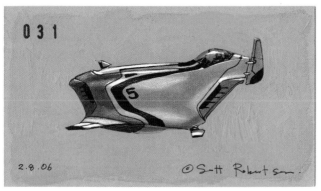
2.8.06 © Scott Robertson.

032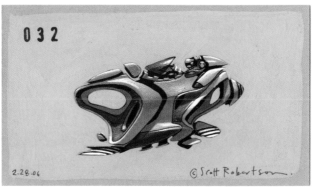
2.28.06 © Scott Robertson.

033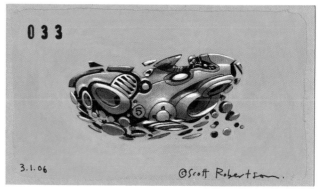
3.1.06 © Scott Robertson.

034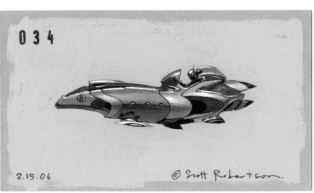
2.15.06 © Scott Robertson.

035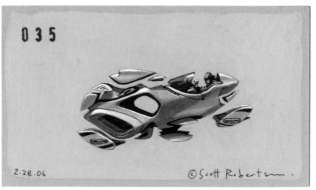
2.28.06 © Scott Robertson.

036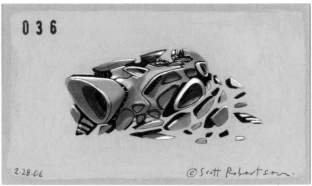
2.28.06 © Scott Robertson.

037
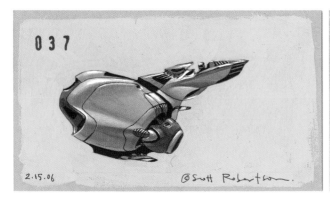
2.15.06 © Scott Robertson.

038
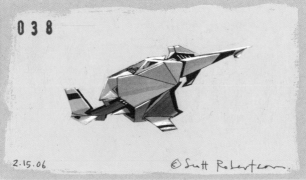
2.15.06 © Scott Robertson.

039
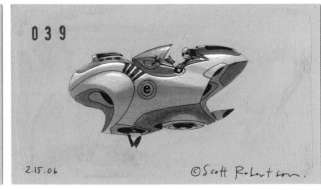
2.15.06 © Scott Robertson.

040
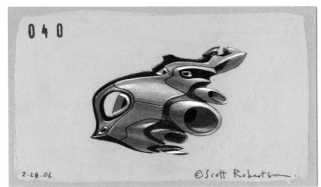
2.28.06 © Scott Robertson.

041
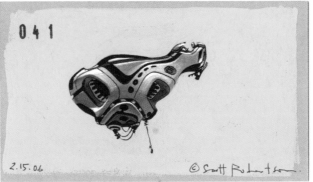
2.15.06 © Scott Robertson.

042
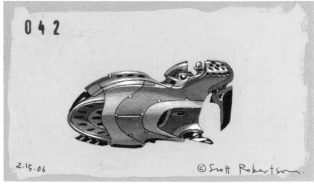
2.15.06 © Scott Robertson.

043
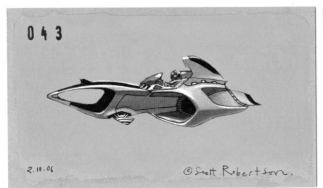
2.10.06 © Scott Robertson.

044
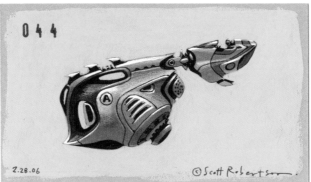
2.28.06 © Scott Robertson.

045
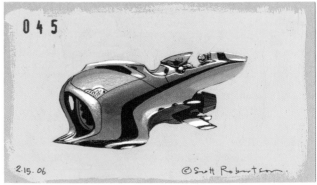
2.15.06 © Scott Robertson.

046
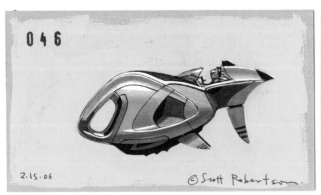
2.15.06 © Scott Robertson.

047
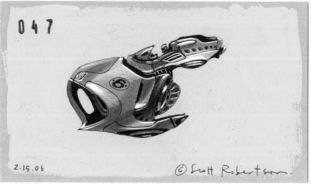
2.15.06 © Scott Robertson.

048
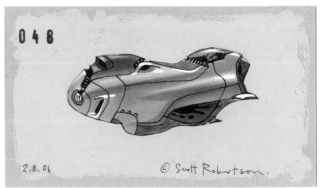
2.8.06 © Scott Robertson.

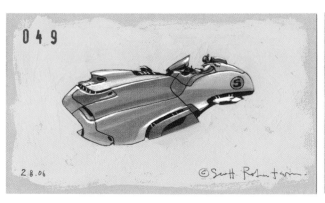

049
2.8.06
© Scott Robertson.

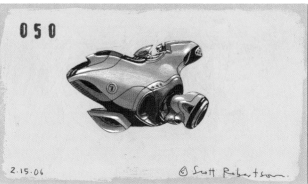

050
2.15.06
© Scott Robertson.

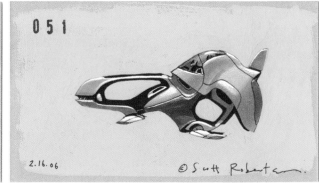

051
2.16.06
© Scott Robertson.

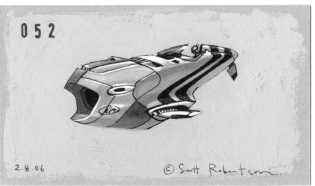

052
2.8.06
© Scott Robertson.

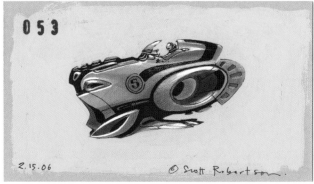

053
2.15.06
© Scott Robertson.

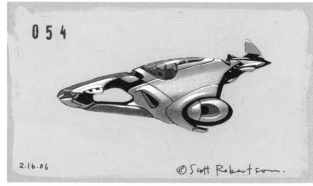

054
2.16.06
© Scott Robertson.

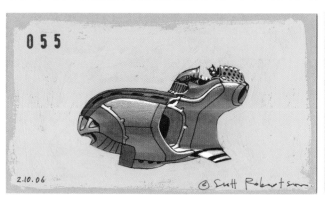

055
2.10.06
© Scott Robertson.

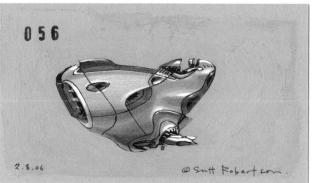

056
2.8.06
© Scott Robertson.

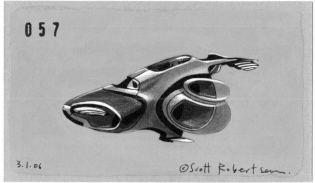

057
3.1.06
© Scott Robertson.

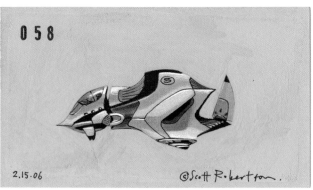

058
2.15.06
© Scott Robertson.

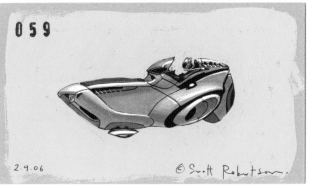

059
2.9.06
© Scott Robertson.

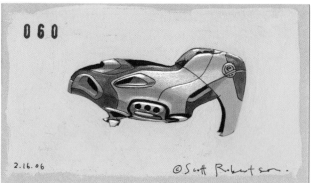

060
2.16.06
© Scott Robertson.

061

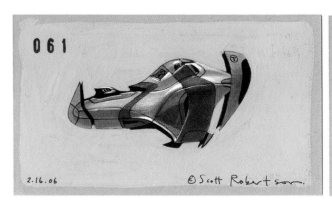

2.16.06 ©Scott Robertson.

062

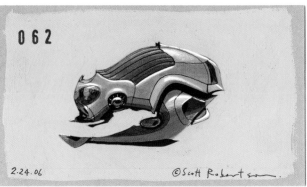

2.24.06 ©Scott Robertson.

063

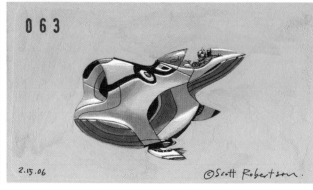

2.15.06 ©Scott Robertson.

064

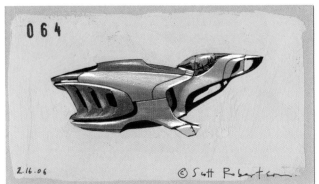

2.16.06 ©Scott Robertson.

065

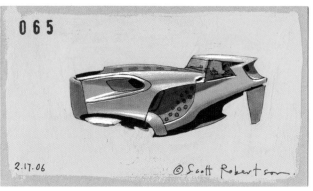

2.17.06 ©Scott Robertson.

066

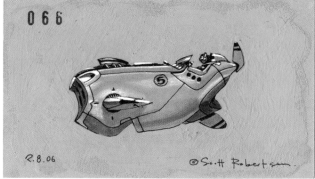

2.8.06 ©Scott Robertson.

067

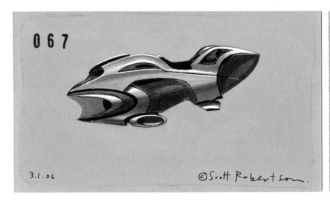

3.1.06 ©Scott Robertson.

068

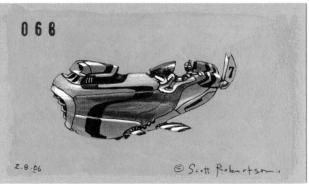

2.8.06 ©Scott Robertson.

069

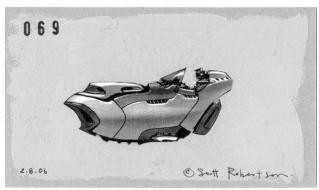

2.8.06 ©Scott Robertson.

070

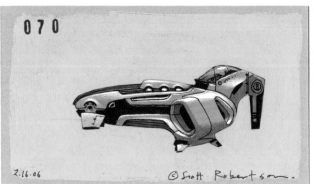

2.16.06 ©Scott Robertson.

071

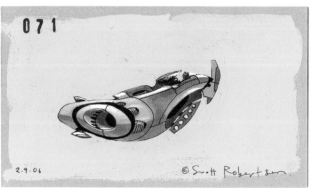

2.9.06 ©Scott Robertson.

072

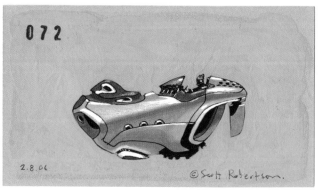

2.8.06 ©Scott Robertson.

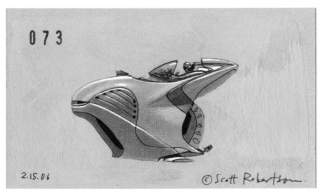

073

2.15.06

© Scott Robertson.

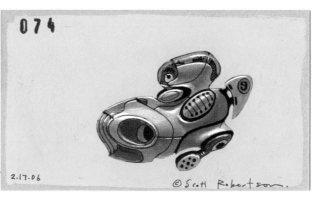

074

2.17.06

© Scott Robertson.

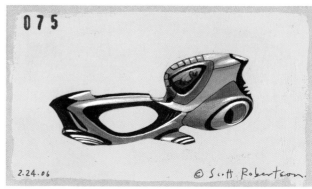

075

2.24.06

© Scott Robertson.

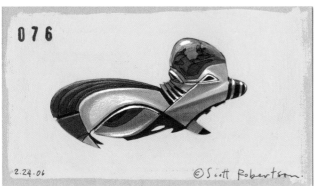

076

2.24.06

© Scott Robertson.

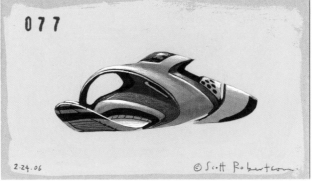

077

2.24.06

© Scott Robertson.

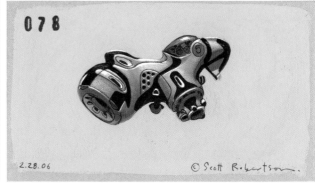

078

2.28.06

© Scott Robertson.

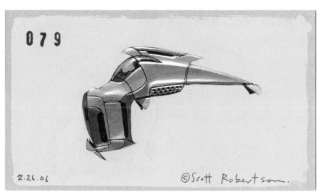

079

2.26.06

© Scott Robertson.

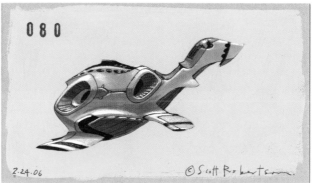

080

2.24.06

© Scott Robertson.

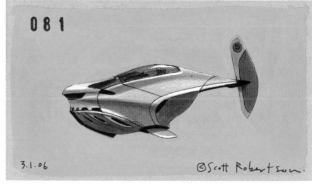

081

3.1.06

© Scott Robertson.

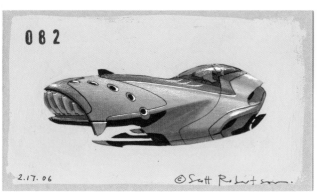

082

2.17.06

© Scott Robertson.

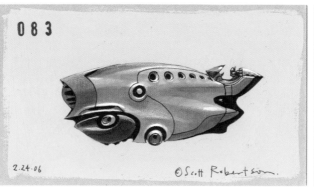

083

2.24.06

© Scott Robertson.

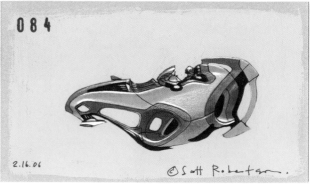

084

2.16.06

© Scott Robertson.

085
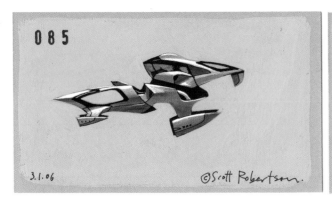
3.1.06 ©Scott Robertson.

086
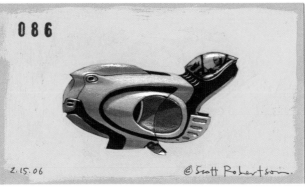
2.15.06 ©Scott Robertson.

087
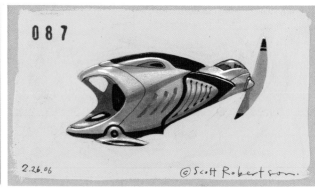
2.26.06 ©Scott Robertson.

088
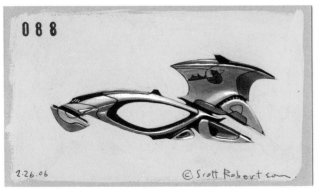
2.26.06 ©Scott Robertson.

089
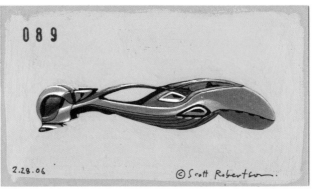
2.28.06 ©Scott Robertson.

090
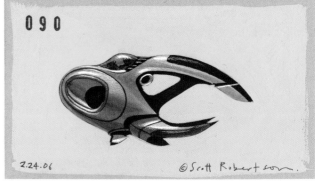
2.24.06 ©Scott Robertson.

091
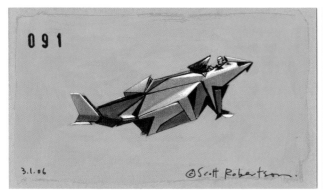
3.1.06 ©Scott Robertson.

092
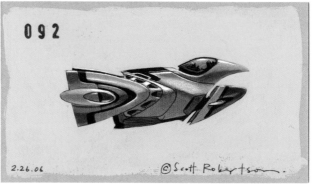
2.26.06 ©Scott Robertson.

093
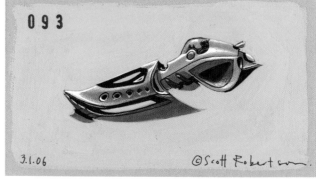
3.1.06 ©Scott Robertson.

094
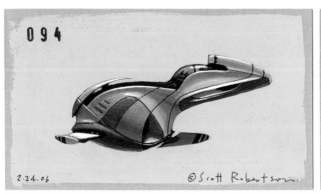
2.24.06 ©Scott Robertson.

095
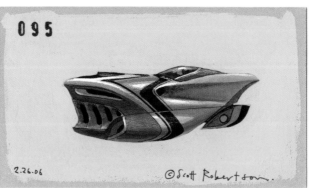
2.26.06 ©Scott Robertson.

096
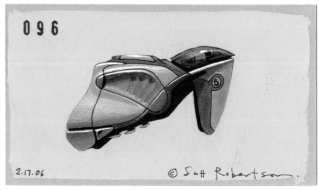
2.17.06 © Scott Robertson.

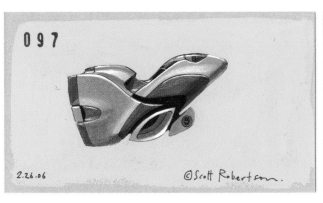

097

2.26.06

©Scott Robertson.

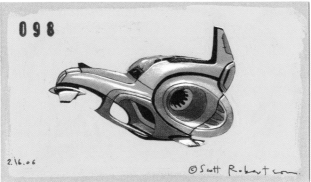

098

2.16.06

©Scott Robertson.

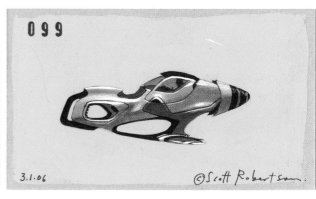

099

3.1.06

©Scott Robertson.

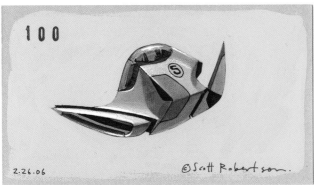

100

2.26.06

©Scott Robertson.

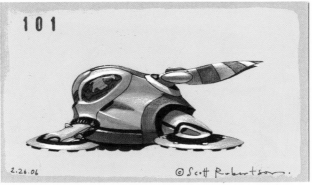

101

2.26.06

©Scott Robertson.

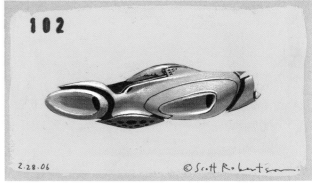

102

2.28.06

©Scott Robertson.

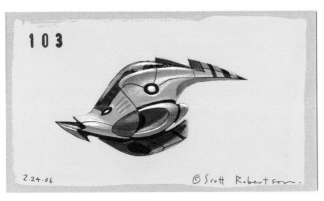

103

2.24.06

©Scott Robertson.

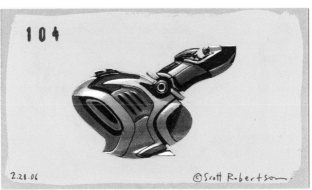

104

2.28.06

©Scott Robertson.

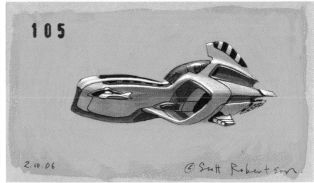

105

2.10.06

©Scott Robertson.

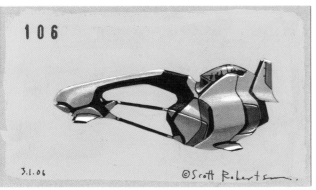

106

3.1.06

©Scott Robertson.

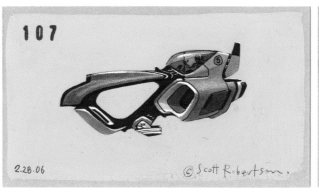

107

2.28.06

©Scott Robertson.

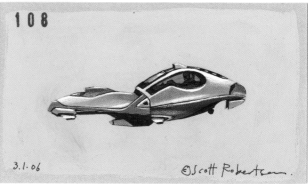

108

3.1.06

©Scott Robertson.

other areas and things of interest by Scott Robertson and design studio press:

To learn about upcoming lectures, workshops and to be kept up to speed on all of Scott's latest news and view work-in-progress of his next book, *DRIVE*, please visit his website: **www.drawthrough.com**

To order additional copies of this book and to view other books we offer, please visit: **www.designstudiopress.com**

For volume purchases and resale inquiries please e-mail:

info@designstudiopress.com

Or you can write to:

**Design Studio Press
8577 Higuera Street
Culver City, CA 90232**

tel 310.836.3116
fax 310.836.1136

Buy the companion book to *Lift Off*:

Start Your Engines:
surface vehicle sketches & renderings from the drawthrough collection

ISBN-10: 1-9334-9213-9 paperback
ISBN-13: 978-1-933492-13-1

ISBN-10: 1-9334-9214-7 hardcover
ISBN-13: 978-1-933492-14-8

Instructional DVDs by **design studio press** and **the gnomon workshop**:

Authored by **Scott Robertson**

To order these DVDs and to view other DVDs we offer, please visit:

www.designstudiopress.com